For you know, we always learn from others and end up teaching ourselves.
— James Beard

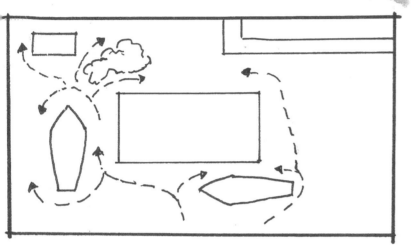

Art conveys what the artist knows about feeling.
— Suzanne Langer

All art constantly aspires toward the condition of music.
— Walter Pater

Beholding beauty with the eye of the mind he will be enabled to bring forth not images of beauty, but realities because he has hold not of an image but of a reality.
— Plato

Beauty is brought about by judgment of the eye.
— Shakespeare

There are two reasons to put paint on paper:
— to communicate an idea or an emotion
— to decorate a surface.
The more interesting and more important goal is a synthesis of both.
— Ed Whitney

CONVERSATIONS IN PAINT

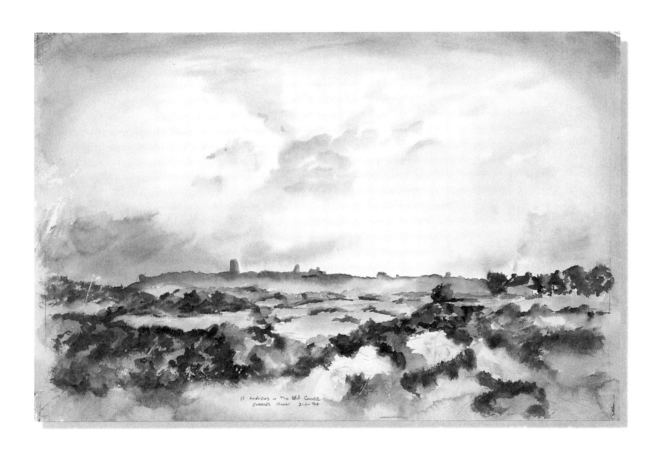

A NOTEBOOK OF FUNDAMENTALS

CHARLES DUNN

Workman Publishing, New York

Credits
Every effort has been made to acknowledge permission to quote from copyrighted material where applicable. We regret any error or oversight. For picture credits see page 205.

Josef Albers (p. 98): *Interaction of Color.* ©1963 by Josef Albers. Reprinted by permission of Yale University Press. • Jacques Barzun (pp. 190, 194, 196, 202): *Teacher in America.* ©1945 by Jacques Barzun. Reprinted by permission of Little, Brown, & Company. • Rex Brandt (pp. 32, 44, 90, 102, 112) *Seeing With a Painter's Eye.* ©1984 by Rex Brandt; (p. 188) *Watercolor Landscape.* ©1963 by Rex Brandt; (pp. 30, 110, 186) *The Winning Ways of Watercolor.* ©1973 by Rex Brandt. Published by Van Nostrand Reinhold. Reprinted by permission of Simon & Schuster/Prentice-Hall Inc.; (pp. 28, 104, 122, 136, 164) *Notes on the Composition of Landscape Painting.* ©1959 by Rex Brandt. Reprinted by permission of the author. • E. H. Gombrich (p. 110): *The Story of Art,* 11th ed. ©1966 by E. H. Gombrich. Reprinted by permission of Phaidon Press Ltd. • Donald W. Graham (pp. 92, 106, 114, 120, 126, 136, 146, 156): *Composing Pictures.* ©1970 by Donald W. Graham. Reprinted by permission of Van Nostrand Reinhold. • Stan Lee and John Buscema (pp. 44, 162, 182): *How to Draw Comics the Marvel Way.* ©1978 by Stan Lee and John Buscema. Reprinted by permission of Simon & Schuster. • John Marin (pp. 10, 14, 30, 42, 70, 152, 172, 174, 176): *John Marin by John Marin.* Reprinted by permission of Holt, Rinehart and Winston, Inc. • Harvey Penick with Bud Shrake (pp. 36, 193, 198, 202): *Harvey Penick's Little Red Book.* ©1992 by Harvey Penick and Bud Shrake, and Helen Penick. Reprinted by permission of Simon & Schuster. • Stephen C. Pepper (pp. 16, 38, 54, 56, 60, 68, 72, 76, 114, 116, 138, 188): *Principles of Art Appreciation.* ©1949 by Stephen C. Pepper. Reprinted by permission of Harcourt, Brace and Company. • Adam Robinson (pp. 193, 200): *What Smart Students Know.* ©1993 by Adam Robinson. Reprinted by permission of Crown Publishers, Inc. • Edward R. Tufte (pp. 30, 36, 156, 170): *Envisioning Information.* ©1990 by Edward Rolf Tufte. Reprinted by permission of Graphics Press. • Helen Van Wyk (pp. 30, 32, 36, 40, 62, 68, 74, 76, 118, 136, 140, 155, 156, 170, 172, 176, 178, 188): *Welcome to My Studio.* ©1989, 1990 by Helen Van Wyk. Reprinted by permission of Art Instruction Associates. • Edgar A. Whitney (pp. 14, 44, 178, 186): *Complete Guide to Watercolor Painting.* ©1974 by Edgar A. Whitney. Reprinted by permission of Watson-Guptill Publications.

Library of Congress Cataloging-in-Publication Data

Dunn, Charles, 1932-
Conversations In Paint: A Notebook of Fundamentals
Charles Dunn.
p. cm.
Includes bibliographical references.
ISBN 1-56305-664-X (alk. paper)
1. Painting—Technique. I. Title.
ND 1473.D86 1995
750.'1'1—dc20 95-21366
 CIP

Printed in Hong Kong
First printing October 1995
10 9 8 7 6 5 4 3 2 1

Workman books are available at special discounts when purchased in bulk for premiums and sales promotions as well as for fund-raising or educational use. Special editions or book excerpts can also be created to specification. For details, contact the Special Sales Director at the address below.

Workman Publishing Company
708 Broadway
New York, New York 10003

Acknowledgments

There are some people behind the scenes of this book to whom I owe thanks beyond words:

All my teachers, especially Margaret Kennard Johnson, Ed Whitney, Rex Goreleigh, and Rex Brandt. I continue to learn from them every day. Even at the end of his life, Cézanne occasionally signed his paintings "élève du Pissarro." I would be proud to sign my work as "élève de Maggie, Ed, and the Rexes."

My colleagues, especially my class, who for more than 20 years have generously tolerated and encouraged me. I learned far more from you than I could ever hope to teach you.

Jerome Tarshis and Joyce Engleson, generous guides into the unknown waters of publishing. My editors, Anne Kostick and Liz Pratt, who, as the loyal opposition, challenged every assumption and conclusion they disagreed with. (Eliot O' Hara said, "It takes two people to paint a picture—one to paint it and the other to hit him on the head with a hammer when he's finished." Thanks for the hammer, Anne. This book is far better for it.) Flamur Tonuzi, who somehow transformed a sketchbook into something handsomer than I imagined possible. Peter Workman, a publisher who cares deeply about books and ideas. Sheilah Scully, Sam McGarrity, and Barbaralynn Altorfer of Workman Publishing. My agent, Nancy Yost, for her efforts.

Bill Singletary, Walter Mitchell, and Larry Ginsberg, who give new meaning to the word "friend."

Mary Kearns, for sharing her life with me and being who she is. Without Mary and Tom Brady this book would still be just a sketchbook.

And special thanks to those who for reasons of space or memory lapse will not receive the public credit that is due them.

Contents

Introduction

This is a book about painting, but it is actually a book of ideas that relate to painting. There are five main ideas that fuel this book.

Painting is a language: It is a preverbal language and, as such, can be read fluently by people everywhere without special training. An African mask, a child's drawing, a Rembrandt portrait, and a cubist portrait by Picasso may each depict the human face. Although they look very different, we understand that each represents the same thing. We speak many languages, not just the verbal language of our native tongue. For instance, mathematics is an abstract, symbolic language in which two means two and nothing else. There are other languages too, like body language. A traffic cop holds his hand up with his palm facing you, and you know he means "Stop!"

Since this book is about visual images, it must rely heavily on pictures. Side-by-side comparisons help but by themselves, aren't enough. Watching Fred Astaire dance alongside Nureyev on a split screen isn't enough to explain dance. If you understand the language of dance, you'll be able to explain any dance you see. The images in this book are paired with captions and text, creating a sort of phrase book for painting which, instead of translating from English to French and French to English, translates from pictures to English and English to pictures.

Painting is a macrocosm: That is, painting, like our planet, is a large system made up of smaller subsystems. Once you understand the earth as a globe or a system, you've got the big picture. You can see where your continent, your country, your city, your street, your house, and you fit in. I've tried to create a macrocosm, a map that explains painting the same way a globe explains the planet.

Once you understand painting this way, you'll better

understand the differences among painters and paintings, and why artists as diverse as Van Eyck and Pollack are both so highly respected. And, if you're a painter or want to become one, understanding painting as a system will speed your development.

Painting is governed by a set of fixed, natural laws: These laws are as immutable and as true as the law of arithmetic that says two plus two equals four. When I began to study painting, I was astonished to discover this fact. I tried breaking the laws because they seemed old-fashioned and corny, but the results were terrible. Ultimately, I found that the more I followed and applied the rules, the better my work became.

In this way, painting is unlike life. Life doesn't provide you with a key to the correct answers. You make what you think is the right choice at the time, and it may turn out to be a disaster. That's not true in painting. Follow the rules and you'll get good work, although maybe not fame and fortune (which follow the more mysterious rules of life). The laws of painting are strict, but they allow plenty of latitude for individuality and creativity.

There are experts in every field: If you want to know more about something, it makes sense to ask an expert. Throughout the book you'll find the words of the experts I relied on in my almost 30 years of painting and teaching— remarkable people, such as Leonardo da Vinci, Albert Einstein, Harvey Penick, and dozens of others. Quotations are like intellectual peanuts; as snack food, they can't possibly do justice to the thought and work of these giants, but I hope they will serve at least to introduce you to them.

Talent is a myth: Most people think the ability to paint and draw is some sort of miraculous gift, reserved for a chosen few. That's not true. Any adult can learn to express himself or herself articulately in paintings. Some of us would rather do than be done for. I'd rather play golf, however badly, than watch it live or on television, no matter how well the pros

Take an object. Do something to it. Do something else to it.

—Jasper Johns

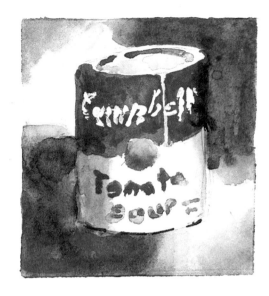

The Campbell's soup can is a recurring visual theme throughout these pages. A while back, I decided to work on my drawing. The combination of curves and straight lines in the soup can appealed to me as a good starting place.

As it turned out, the familiar red-and-white can proved to be a remarkable object with which to study the underlying ideas in painting. For instance, it has darks and lights as well as darks within the light area and lights contained in the dark area. Because the Campbell's can is familiar to the point of being mundane, it presents the fundamental artistic challenge of trying to make the ordinary extraordinary, and permitted me to experiment and to explore the larger issues of painting.

The examples in this book are meant to demonstrate the ideas or principles involved and are deliberately abstract and mundane. It is up to the reader to apply them to the subject matter that specifically interests him or her. If an idea is presented as a landscape idea, it is equally applicable to still life, floral, nonobjective, figure, and portrait art.

play. I think making pictures is something worth doing and I only regret I didn't start sooner. Interest is the real gift. If you have always wanted to paint or draw but haven't yet tried, I hope this book will encourage you to do so.

The Magic Number: Back in the late Fifties, Harvard psychologist George Miller studied short-term memory and discovered what he called "the magic number," the number of separate things a normal person can remember without any special help. The magic number, Dr. Miller found, is seven, plus or minus two. In other words, most people can remember seven different things with a little effort, some people can remember as many as nine different things and almost anyone can remember five.

Miller's discovery was nothing new. The same idea occurs in one of the ancient Chinese treatises on painting as the Rule of Five. It's such a useful learning tool that I've organized this book according to the Rule of Five. There are five main sections, each one divided into no more than five chapters.

Learning: If you want to learn to paint or to improve your painting, the book's last section explains the basic principles of learning. There are better, more efficient ways to learn than trial and error. The results you want will arrive sooner if you follow the suggestions in that section. You'll be able to apply this information to every area of your life, not just painting. Learning a golf swing, a new computer program, or a foreign language are all similar problems.

This book first took shape as a sketchbook. Many of the pages here are from the original. They aren't perfect, but then, neither am I. I hope the illustrations are accessible enough to make you think, "I can do that." I know you can do as well, or even better. Let the book encourage you to pick up a pencil, brush, or charcoal, and try.

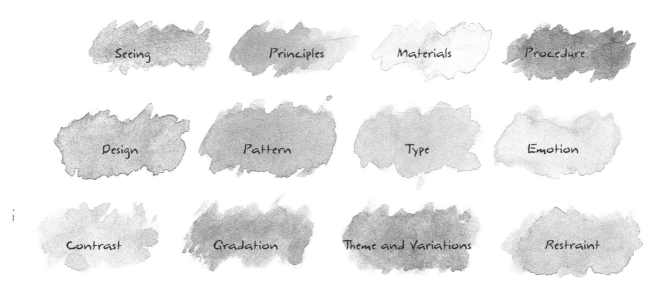

Seeing Principles Materials Procedure

Design Pattern Type Emotion

Contrast Gradation Theme and Variations Restraint

There are four main sections in this book. Each section is broken into subsections; for instance, the section on principles covers four areas. In turn, the subsections are further broken down into topics. When you organize material this way, it's called "chunking," and it makes it easy to remember everything.

Another way to understand the structure of this book is to think of it as a sort of organization chart. What the M.B.A.'s call "the span of command" in their organization charts often follows the Rule of Five.:

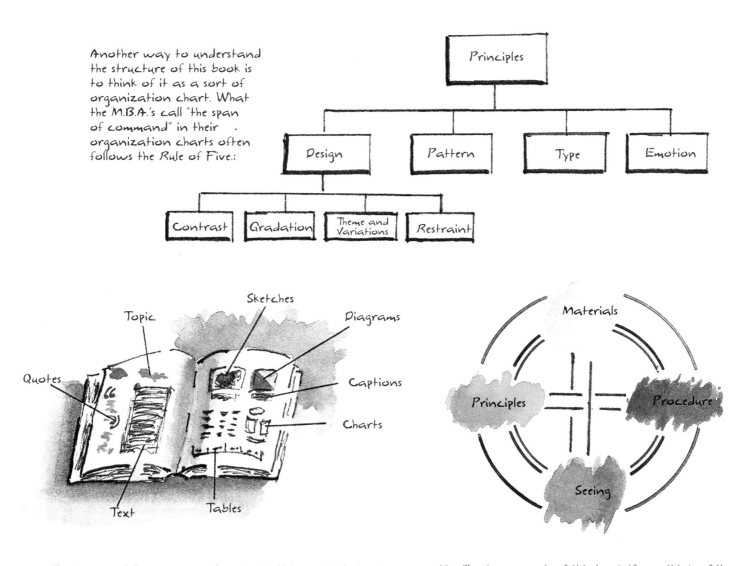

Each pair of facing pages devotes itself to a single topic. On the left-hand page, you'll find pertinent thoughts to accent the text. Right-hand pages explain the topic in sketches, diagrams, tables, and charts and thus introduce different ways to present ideas.

You'll get more out of this book if you think of it as a sort of closed system, like a map, in which every part relates to every other part. You can start anywhere and read in any order and, as long as you keep the big picture in mind, you won't get lost.

Seeing

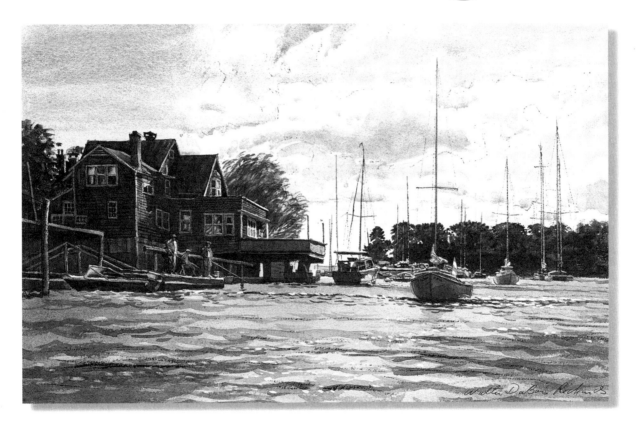

To see is to forget the name of the thing one sees.

—Paul Valéry

The effort to see and really represent is no idle business in the face of the constant force that makes for muddlement.

—Henry James

Art is mostly a matter of seeing.

—Rex Brandt

What a life, seeing!

—John Marin

See for Yourself

Every artist sees the world in a very different way from every other artist. Each is positive that his is the only right way to see, and each is right. It's true. There is only one right way to see. The trouble is, every painter's idea of the right way to see is different. That's why it's often easy to become confused when you read books or attend classes or workshops given by different instructors. This section will help you see in the way that's most natural for you.

Even before he sets out his colors, the mature artist has a very good idea of how his finished picture will look. His ideas about vision, which determine how he will represent what he sees, are more important than anything he gets from looking at his subject. Even his talent is less important than his idea of how to see.

Each artist sees in a specific, personal way because he has a specific idea about seeing and he always imposes that idea on nature. That's what makes a Rembrandt a Rembrandt and a Monet a Monet. The subject does not dictate to the artist how he will see it or paint it. The artist sees his subject as he thinks it should be seen and paints it as he wants it to look.

When you learn to see with the eye of an artist, painting and drawing become almost as natural as conversation.

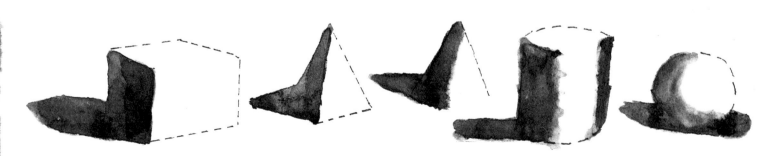

Types of Seeing

<u>Practical seeing</u> is useful seeing. It is everyday seeing, and it keeps us alive. We learned practical seeing when we were children, when everything had to have a name. We recognize an object as a table and we walk around it, not into it. Practical seeing enables us to tell the difference between Betty and Carol. It tells us if fruit is ripe or not. It keeps us from driving on the sidewalk. Unfortunately, practical seeing doesn't hold much value for the artist when he paints his picture. The first step in understanding art, or in becoming an artist, is to learn to see as the artist sees.

<u>Expert seeing:</u> Put a farmer, a real estate developer, a botanist, and an ecologist in an overgrown field. Each will see something different. The farmer sees a place to grow wheat or corn. The real estate developer sees a shopping mall or subdivision. The botanist sees a rich variety of plant life and the ecologist sees a complex ecosystem. That's expert seeing. It is the result of each person's experience. For the artist, expert seeing lies primarily in his ability to see things in nature as <u>innate standard forms:</u> cubes, cylinders, cones, pyramids, and spheres. He then elaborates upon these simple shapes to create the human figure, trees, buildings.

Seeing
See for Yourself

It is a dilettantish notion to think that an artist could ever set up his easel before nature without any preconceived ideas. But what he has taken over as a concept works in him, and is much more important than anything he takes from direct observation.

—Heinrich Wölfflin

Because a painter must put actual shapes on a flat surface, the painter must commit himself. The painter is forced to declare himself as to just how nature appears to him, or, at least, as he wishes it to appear to the spectator.

—Stephen C. Pepper

An artist is paid for his vision, not his reporting.

—Tom Lynch

Seven Ways the Artist Sees

When you compare a Rembrandt to a Vermeer, it's hard to believe they were practically neighbors, living at exactly the same time in a little country about twice the size of New Jersey. Although both painted light, they saw the light of Holland very differently. Not only do artists see differently, but often an artist will see differently at different times in his life. If you didn't know better, you might find it hard to believe that the works of Picasso's Rose period were from the same man who painted his Cubist works. As long as we're capable of growth, our opinions are subject to change.

The artist must always be specific about how he wants you to see nature in his painting. He really has no choice; a painting is merely an arrangement of fixed areas of color on a flat surface. The artist must lay down definite shapes that can never move once his painting is finished. If he wants you to see nature in more than one way, he must paint more than one picture. That's why many artists, like Monet, paint in series.

When you look at a painting, you do not see the subject as the artist saw it; you see the subject *as the artist wanted you to see it.* The artist has an idea about what constitutes the reality of vision. Understand other artists' ideas of vision so that you can find a way of seeing that's right for you. Whatever idea of vision is true for you is as valid as any other.

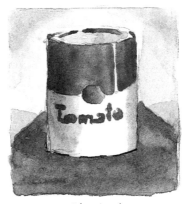
Classical

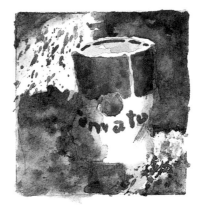
Romantic

16

There are at least seven different ideas about
what constitutes the reality of vision.

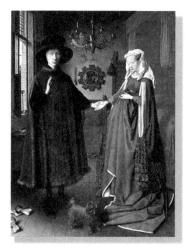

Through-the-Window Realism

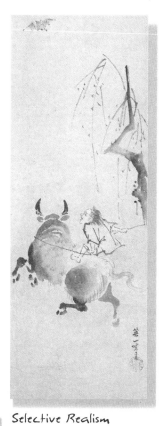

Selective Realism

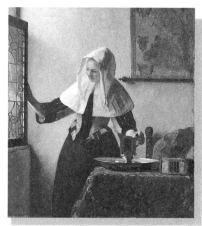

Light-and-Shade Realism

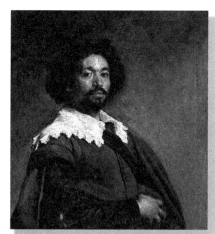

Focus-and-Fringe Realism

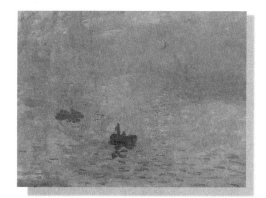

Fringe Realism/Impressionism

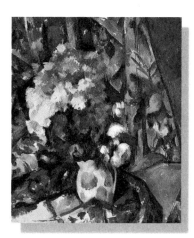

Dynamic Realism

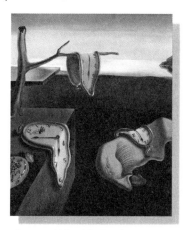

Dream-World Realism

Through-the-Window Realism

What you see is what you paint. The picture represents everything you would see exactly as you would see it through a window or a door. The highlight on a button becomes as important as the highlight on an eye. This approach yields a Van Eyck or a photo-realist.

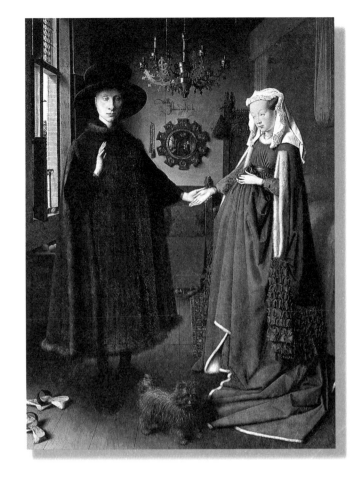

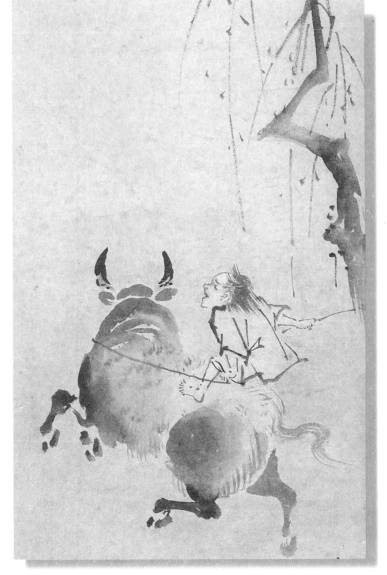

Selective Realism

The selective realist says you can't possibly see every single object that's in front of you, let alone paint it. There's just too much. Only three or four objects may stand out, so that's all you paint. You are hardly aware of all the thousands of other objects within the sweep of your vision, so they don't count. True visual realism, then, is selective; you paint only what's important to you and leave out the unimportant elements.

Light-and-Shade Realism

Unless you're a bat, you can't "see" in the dark. The only reason we see is because light strikes the retina. Vision is just light and dark, and what we perceive as dark is simply the absence of light. Therefore, the only way to paint is to capture the way light falls on a surface and is reflected to the eye. Light-and-Shade Realism culminates in Vermeer.

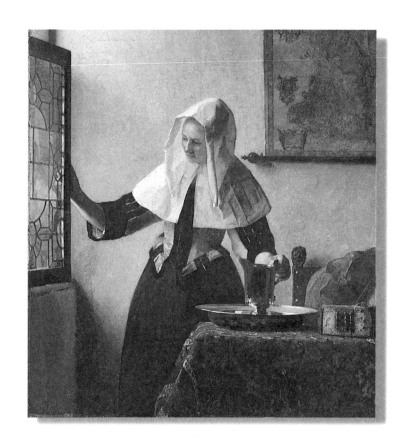

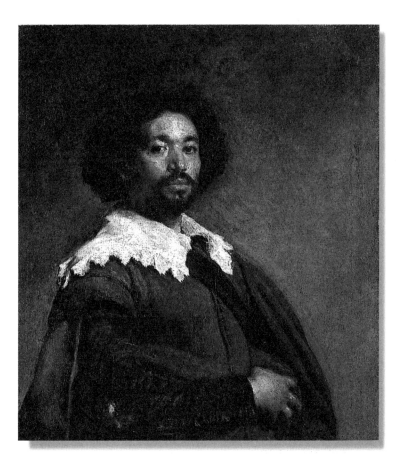

Focus-and-Fringe Realism

The actual image you perceive on the retina is clear only in the middle of the field. Surrounding this clear center of sharp-edged interest is a blurred fringe that grows increasingly blurred toward the edges. Thus, visual realism demands a clear center of interest at the focal point, which then shades off into less clarity. Velázquez is considered the father of this style.

Fringe Realism/ Impressionism

Vision results from the stimulation of the eye, says the impressionist. Since light is the only thing that stimulates the eye, to be true to vision, paint only the pattern of light that impinges on the retina. In impressionism there are no "things," only light-reflecting surfaces. An impressionist painting is virtually a painting of the fringe without any focus. Monet's late work is the exemplar of impressionism.

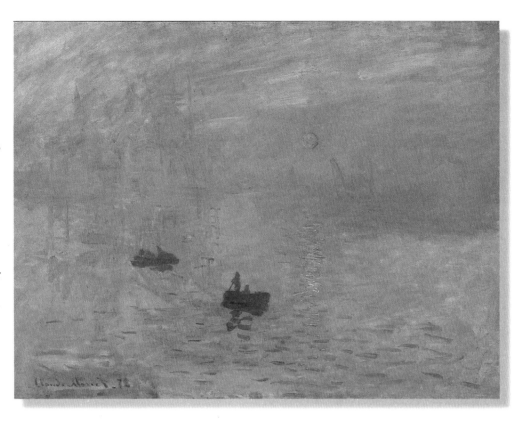

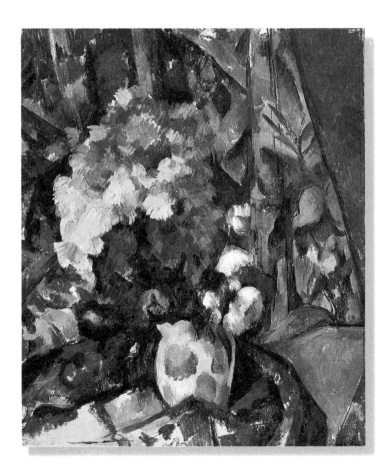

Dynamic Realism

The dynamic realist sees nature as being in constant change. Vision is primarily the perception of linear forms or masses and the tensions between them. Dynamic realism is similar to impressionism in that it is not about objects as things. It's not about boats, trees, buildings, or people. To the dynamic realist, objects are just planes with a tensional relationship to each other. Cézanne is the founder of dynamic realism.

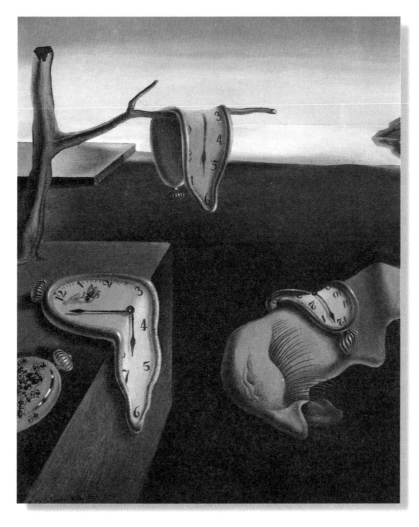

Dream-World Realism

What's real? How do you know that the world of your dreams isn't the real world? Are you sure that your daytime world isn't a dream? The Dream-World Realist paints what he sees in his mind. One result is surrealism, of which Dali is the prime example.

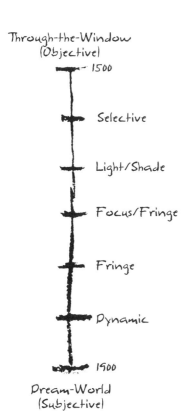

Through-the-Window
(Objective)

— 1500

Selective

Light/Shade

Focus/Fringe

Fringe

Dynamic

1900

Dream-World
(Subjective)

There is a progression, or scale, to this arrangement of seeing, from the dispassionate objectivity of the through-the-window realist to the intense subjectivity of the dream-world realist. The scale follows a sort of historical path that reflects the influence of optical and psychological discoveries on the visual artist.

Painting is a sort of code. Even children read this code easily enough, as if it came to them completely naturally, but only on condition that it conforms to ancestral practice and common usage.

— Robert Rey

This is a different language. Your painting must be a translation into this different language of paint—God help you if you don't understand that!

— Ed Whitney

The art of painting, although it has little to do with words, is a language which you have to learn to read. Some pictures are easy, like a primer; some are hard, with long words and complex ideas; some are prose; others are poetry; and still others are like algebra or geometry.

—Alfred H. Barr, Jr.

The Language of Painting

Painting is a language much like English, Latin, French, or mathematics. It just happens to be a language you learned, without even trying, when you were very young. Today you are as fluent in reading paintings as you are in reading English. You look at a picture and know what it's a picture of. You take the language of painting for granted.

You had to learn the conventions of English, build your vocabulary and learn grammar in order to communicate effectively. In this regard, painting is no different from English or any language. In painting, aesthetic conventions are the vocabulary and composition is the syntax.

Aesthetic Conventions

The only way we can represent a three-dimensional object on a two-dimensional surface is by using aesthetic conventions. There are very specific rules about how to represent a tree. If the artist doesn't follow these rules, or aesthetic conventions, the picture won't read as a picture of a tree. Of course, there is considerable latitude within these rules. A tree by Monet looks nothing like a tree by Claude Lorrain, but both read as trees, maybe even the same species, because both artists followed the rules for painting trees.

Two painters painting the same subject will produce two very different pictures because each uses different aesthetic conventions.

Making a painting is a lot simpler once you start to think in terms of aesthetic conventions instead of trying to duplicate what you see. Then all you have to do is find a way to make paint stand for what you see. Much of what you may now find difficult about painting disappears almost magically because you have no longer set yourself an impossible task.

Aesthetic conventions are the accepted ways of using the limited resources of paint to represent the unlimited world of nature. They are to painting what social conventions are to polite society— the good manners of painting.

	Nature	Painting
Line:	No	Yes
Value:	Unlimited	Limited
Hue:	Unlimited	Limited
Volume:	3 dimensions Actual	2 dimensions Represented
Space	Actual	Represented
Movement:	Actual	Represented

Range of Value in Nature

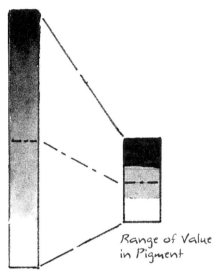

Range of Value in Pigment

Range of Hue in Nature

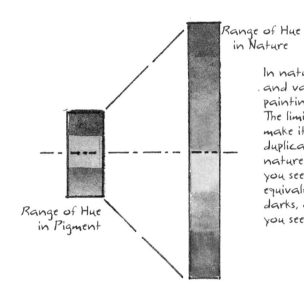

Range of Hue in Pigment

In nature, the range of hues and values is infinite; in painting, extremely limited. The limitations of pigment make it impossible to duplicate what you see in nature. You can't get what you see; you can only find equivalents for the lights, darks, and midtones that you see.

Represented Mass: The cylinder may look three-dimensional but it's not. That quality of the cylinder can only be represented, never duplicated.

Volume is represented space. Since the painting's surface has only two dimensions, the blue area may read as space or atmosphere.

Represented Movement: There is a sense of movement to these curves, even though they don't move.

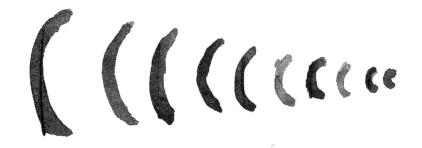

The sea that I paint may not be the sea, but it is a sea.

—John Marin

Art and nature, being two different things, cannot be the same.

—Pablo Picasso

And these symbols of his own creation (being of his own particular seeings) give him a greater pleasure than the object seen. He reforms them, he rearranges them, he focuses them to his own inner seeings and longings.

—John Marin

It is well known that all art, in advancing, seeks to make the task of the eye increasingly difficult.

—Heinrich Wölfflin

You are symbol collectors.

—Ed Whitney

An idea, in the highest sense of that word, cannot be conveyed except by a symbol.

—Samuel Taylor Coleridge

Seeing in Symbols

Every two-dimensional representation of a three-dimensional object, even a photograph, no matter how realistic, is an aesthetic convention. It is not the thing itself but something that stands for something else because of resemblance, association or convention. Because they stand for things, symbols are the nouns in the vocabulary of vision.

Think of a ruler (a scale or progression) with the abstractionist at one end and the photo-realist at the other. Painters to whom accurate representation of their subject is paramount are image-related painters. Thus commercial portrait painters are usually image-related painters or painters of content. The more accurately his symbol resembles his subject, the closer the artist is to the scale's photo-realist end.

The nonobjective painter stands nearer the concept-related end of the scale. He is more interested in his picture's underlying design structure, or form, than in any specifics of a particular subject, even though he may draw or paint very skillfully. The concept-related painter is more concerned that his symbol represent the idea of his subject than that it be specific to that particular motif.

Degree of Finish: The experienced painter, no matter which end of the scale he prefers, usually starts with the simplest of shapes: rectangles, triangles, and circles. The technical term for these simplified beginnings is schemata. The image-related artist, because he is more interested in how his subject looks than its decorative potential, stresses detail and surface textures. We say his painting has a high degree of finish. The designer, on the other hand, is more concerned with his painting's decorative potential, so he brushes off detail as less important and puts his emphasis on large, simple shapes.

Arbitrary	Concept-Related	Subject-Specific	Illustrative

Concept-Related Image-Related

Symbols develop from schemata — concept-related, innate, standard shapes and forms.

Dark against light	Light against dark	Dark and light in midtone	Checkerboard

 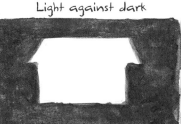 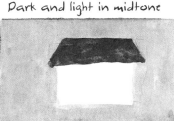

Any symbol can be translated into pattern. Here, the concept-related symbol.

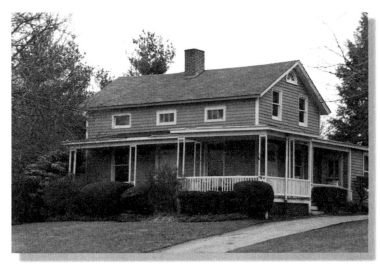

A photo can be a starting place in developing personal symbols. Once you develop a symbol, you know what to look for in nature and how to translate it into pictorial terms. One house symbol, a schema, serves as the starting point for all your house symbols.

Form Content

Design Illustration

Generalized Specific

Nonobjective Photo-Realism

Painterly Linear

· · · | · · · | · · · | · · ·

Concept-Related Image-Related

Most paintings develop back and forth, starting with form (for example) and zigzagging between form and content, usually ending with content.

Adding details detracts from the impact of the shapes; the viewer gets caught up in the details and fails to see the forest that is the painting for the trees that are the details.

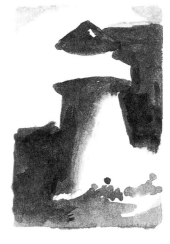 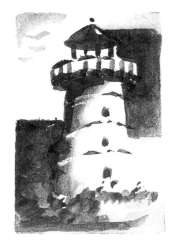

Think of this scale as a gradation, not as a series of compartments. Find a range on the scale where you fit comfortably.

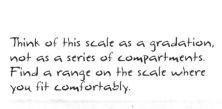

Nonobjective	Concept-Related	Image-Related	Illustrative

25

Form ever follows function.
—Louis Sullivan

One must not always think that feeling is everything. Art is nothing without form.
—Gustave Flaubert

I once had to pilot a yacht into strange waters. The yacht's owner handed me a wonderful chart which some gas company had given him. Let me tell you, that chart was a beautiful thing. It showed every gas dock on Long Island Sound and had wondrous, full-color pictures of sea serpents, pirate ships, mermaids, and the like. The only problem was, the chart maker didn't bother with such trifling details as where the reefs, underwater rocks, buoys, and lighthouses were, or how deep the water was. That I'm here to tell you this tale is no thanks to the Commodore's free chart.

Form Follows Function

The principles never change; the application of the principles does change.

Painting is only one facet of the visual arts. Architecture, mapmaking, poster design, as well as book, package, furniture, textile, and advertising design are some of the others.

How the principles are applied depends on the use for which the work is created. As you will see in the section on type, the primary function of a painting is to decorate a wall. Thus the painting's decorative function is most important. It must look good. If it doesn't, nobody will hang it and nobody will see it. This is not to say that the painting may not have other agendas; it may, but they are all secondary to the painting's decorative function.

A map, on the other hand, must not only be dense with information, but it must be absolutely clear. A map doesn't have to look good, but it must be clear, accurate, and up-to-date. This is not to say that a map, framed on a wall, cannot be handsome, but beauty must take a back seat to the map's informational function.

The blueprint for a house serves a function much different from that of a painting of the house. The principles are the same, but they are applied differently. Because they have been trained to apply the principles to serve specific, non-decorative functions, many architects, illustrators and commercial artists often have trouble "loosening up" when they take a painting class.

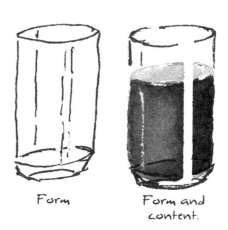

Form Form and
 content.

How a picture looks is determined not only by how its subject looks, but by the use for which the picture is intended.

Information

Some pictures (for example, maps, charts, graphs, and tables) give us information. To serve their purpose they must be clear before they are anything else. Certainly, a map or chart may be handsome enough to frame and hang on the wall as a decoration, but primarily it must help us get from here to there or, if we are lost, to show us where "here" is.

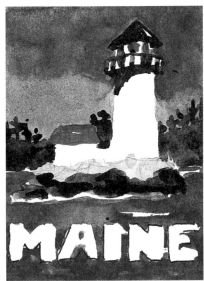

Action

Other pictures serve as a form of propaganda. The purpose of an advertisement or poster is to spur the viewer to some sort of action which will benefit the sponsor. _Recognition is primary._ The advertiser's first requirement is that the viewer recognize the package in the supermarket. An advertisement for, say, Campbell's soup that doesn't show the can of soup hardly serves Mr. Campbell's purpose—you might buy somebody else's soup.

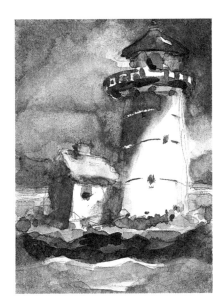

Painting

If the artist gets too hung up in clarity and recognition of his subject, his painting may become boring because it tells too much. The spectator doesn't need to look at the painting more than once since it revealed everything it had to say in the first glance. That's fine for maps and posters but not for painting.

Style

Linear artists are square pegs
and painterly artists are round
pegs. If you're a painterly artist
but you work in the linear style,
you're a round peg trying to fit
into a square hole. Maybe you
can squeeze in, but you won't
be very comfortable. A linear
personality can waste a lot of
time studying with a painterly
instructor unless he is willing to
change his personality.

The sooner the painter decides which school is more compatible to his personality, the better. A romantic can waste a lot of time and become frustrated and confused by studying with a classical instructor and vice versa.

Many instructors hold that style emerges in its own good time; it can't be taught. Eventually, if you paint long enough, you'll hit on your style. Obviously, I disagree. I prefer that the painter understand the two camps and make an informed choice, as early as possible, based on how he wants his pictures to look. He may change his mind later as he grows, but it's a lot easier to get somewhere if you have a destination.

Western art has two major traditions: the linear and the painterly styles. The linear or classical style reached its apotheosis in the High Renaissance of Raphael and Leonardo. The contrasting painterly style, called Baroque or Romantic, emerged around 1500 and shows itself clearly in Rembrandt.

The linear artist sees the world (or at least the world he wants to depict) as orderly, symmetrical, and balanced. His is the art of multiplicity and perfect clarity. He stresses contrast, boundary edges, and the separation of subject and background. The objects in his paintings look like what they are. They are isolated and seen as independent units. Therefore, we say his shapes are "closed." Linear composition is based on horizontals and verticals; the eye moves parallel to the flat picture plane, left or right, up or down.

The painterly artist sees the world he wants to depict as dynamic, asymmetrical, and a little cockeyed. His is the art of unity and relative clarity. Therefore he stresses pattern, lost edges, and the merging of subject and background. The objects in his paintings look the way they look. Therefore, we say his shapes are "open." Painterly composition is based on obliques and the diagonal in depth. The eye moves backward and forward in the represented space of the picture box.

Linear

Two-dimensional shapes are delineated with line. Because we read along a line, progression along edges is stressed.

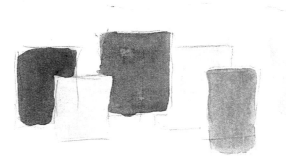

<u>Parallel surface organization:</u> We read the picture up and down and side-to-side on the picture plane. The flat picture plane is emphasized.

Closed forms or shapes
Absolute clarity/separateness
Contrast/counterchange

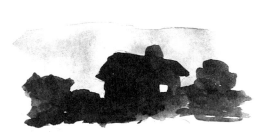

Dark figure, light ground
Dark subject, light background

Unity achieved through the harmony of the separate parts. The parts remain identifiable as discrete elements.

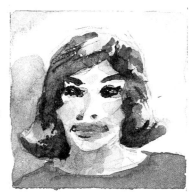

Painterly

Three-dimensional shapes create mass. Unlike line, shapes spread. The three-dimensional quality of mass is stressed.

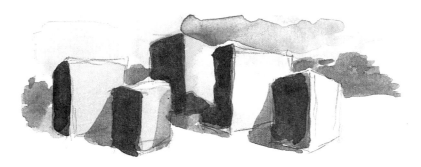

<u>Diagonal surface organization:</u> We read the painting forward and back in the imaginary space of the picture box. The sense of depth within the picture box is emphasized.

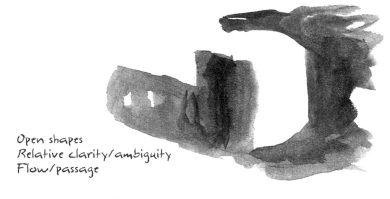

Open shapes
Relative clarity/ambiguity
Flow/passage

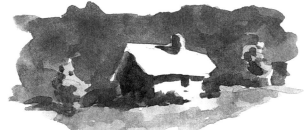

Light figure, dark ground
Light subject, dark background

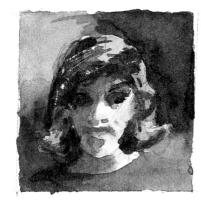

Parts are subordinated to the unity of the composition. Elements merge to create the whole and are not independent of one another.

29

Seeing
Style

The wonderful becomes familiar and the familiar wonderful.
—Edward R. Tufte

I have traveled a good deal in Concord.
—Henry David Thoreau

Most people see only what they are taught to see. Art is going beyond the obvious.
—Rex Brandt

I would suggest (as an exercise) that sometime you take your two eyes along with you and leave your intellect—and your friends' intellects—at home. You might, with these handicaps, see things that would surprise you.
—John Marin

Discovery consists of seeing what everybody has seen and thinking what nobody has thought.
—Albert Szent-Györgyi

Exotic Locations and Local Equivalents

Neither beauty nor art comes ready-made.

Thoughts of exotic locations seduce us. We know we'd paint better if only we lived in Paris or Tahiti where everything is so beautiful. So we journey to picturesque parts of the world or remote parts of our own country seeking out exotic motifs.

However, most great artists painted their own backyards. Often the only reason we know something is beautiful is because an artist told us it was. The Midi is not inherently beautiful; however, we find it lovely because Cézanne and Van Gogh showed us its beauty. The Impressionists were reviled for painting the 19th-century French equivalent of Levittown; the mundane suburbs of Paris. Contemporary photos demonstrate that their subject was not beautiful; their paintings demonstrate that their vision was.

Still, if the idea of exotic locations intrigues you, look for equivalents close to home. A little investigation will show that your neighborhood is every bit as beautiful and exotic as Paris, Venice, or Tahiti. All you have to do is see it. A rain-washed city pavement provides a suitable visual substitute for a canal in Venice. That's what Rembrandt, Monet, Cézanne, and Corot did; they taught us to see beauty where no one had ever seen it before. It's what art does. It's not what the artist sees that interests us, it's how he sees it.

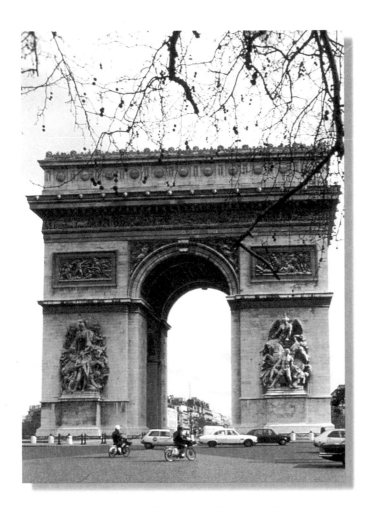
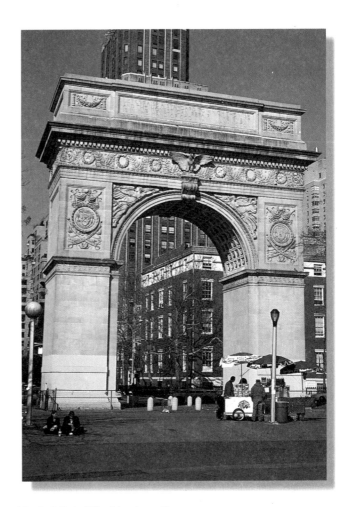

The Arc de Triomphe finds its echo in New York City's Washington Square. Contemporary photos demonstrate that the Impressionists took the mundane and made something beautiful out of not much. Would you have seen the beauty there if Monet, Pissarro, and Sisley hadn't pointed it out to you?

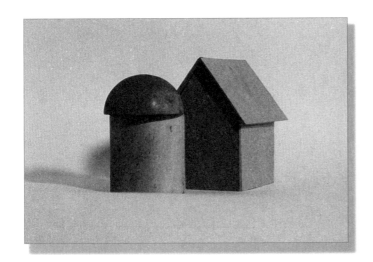
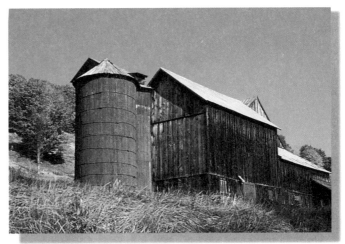

If you have trouble seeing the underlying form in your subject, try this: Next time you paint, take some simple white solids with you — a cube, a sphere, a cylinder, and a cone. Set them up between you and your subject and be sure the light falls on them the same way it falls on your subject. Paint your subject using the same lights and darks you see on the solids.

Learning From the Masters

Instead of mechanically copying a masterpiece in the studio, take a reproduction of a favorite painting (a postcard is fine) to your next painting session. The subject matter of the masterpiece should be similar to what you plan to paint. But instead of copying the reproduction, use it as a point of departure for your painting. Look at the master's painting to see how he saw a subject similar to yours. Use the reproduction as a guide to try to see and paint your subject as he would have seen and painted it.

Looking at Paintings

Most people look at paintings in one of three ways:

Recognition or "imitation of nature": This is how most people see paintings—recognition of subject matter is primary. Of course, people respond differently to subjects; you may prefer florals while your friend prefers landscapes or seascapes.

Communication: Does the painting speak to you? Does it prompt your memory or trigger any kind of emotional response in you?

Formal Properties: How is it composed? How does it use color? What is its organizing structure?

Most of us can't look at a painting in more than one way at a time. (I know I can't.) We can of course look at a painting sequentially in each of these three ways, or at different times we may look at the same painting in different ways. So when I critique work in a class, I usually concentrate on the formal aspect. However, my first reaction is almost always to subject matter; my second reaction is an emotional response to the painting.

One of these scenes is painterly; one, linear. Which do you prefer?

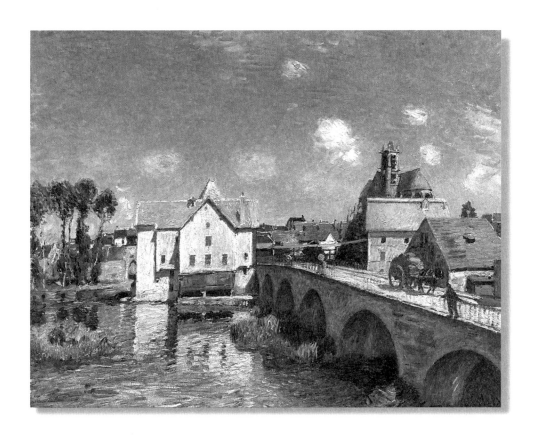

The road was new to me, as roads always are, going back.
-Sarah Orne Jewett

One ought, every day, to hear a little song, read a good poem, see a fine picture, and, if it were possible, to speak a few reasonable words.

—Goethe

I would define, in brief, the Poetry of Words, as the Rhythmical Creation of Beauty. Its sole arbiter is taste.

—Edgar Allan Poe

The wild vicissitudes of taste.

—Samuel Johnson

These questions of taste, of feeling, of inheritance, need no settlement. Everyone carries his own inch-rule of taste, and amuses himself by applying it, triumphantly, wherever he travels.

—Henry Adams

Tastes Change

Our tastes change; it's the habituation mutation. In time, the thing least disliked becomes the thing most liked. At the same time, the thing you most liked previously joins the things less liked. ("I used to like Rockwell more than I do now.")

Once you liked Norman Rockwell's paintings, but now you like Andrew Wyeth's better. Perhaps you don't much care for Monet and you positively can't stand Cézanne. In time, with minimal exposure, Monet becomes your enthusiasm and Wyeth is now relegated, along with Rockwell, to the category of things less liked. Cézanne is not as bad as you thought. He becomes only mildly disliked as a new disliked artist enters your life—maybe Jackson Pollack. When you tire of Monet, whom do you think will be your new favorite?

What's surprising about the habituation mutation is that the movement is not orderly or gradational—the thing least disliked does not become one of the things least liked, but the thing most liked.

The habituation mutation explains a lot. For instance, it explains the otherwise startling stylistic changes so many artists go through.

To speed your growth (and if you can bear it), put the habituation mutation to work for you by exposing yourself more often to things for which you have a mild dislike.

- Design
- Pattern
- Type
- Emotion

Principles

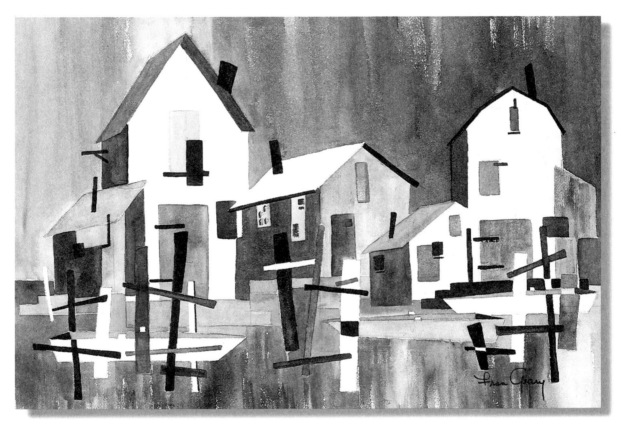

I am a bear of very little brain and long words bother me.

—Winnie-the-Pooh

Good Heavens! For more than 40 years I have been speaking prose without knowing it.

—Le Bourgeois Gentilhomme

Principles

Principles

Visual principles tell us how to put the right mark in the right place. The principles of design are universal—like mathematics—and are not tied to the unique features of a particular language or culture.

—Edward R. Tufte

There rise authors now and then who seem proof against the mutability of language, because they have rooted themselves in the unchanging principles of human nature.

—Washington Irving

Important principles may and must be inflexible.

—Abraham Lincoln

Practically all the awkwardness and odd ways people have come as the result of the misunderstanding of a few simple principles.

—Harvey Penick

The principles of painting really paint your picture. If you learn the basic principles, you can paint anything. If you understand it, you can do it.

—Helen Van Wyk

A painting can only decorate a wall or communicate an emotion. When it serves both functions, it's usually a pretty good painting.

What your painting says, is its content; how your painting says it, is its form. Type and emotion, because they are mostly about subject matter, are the principles of content. Pattern and design, because they are mostly about structure, organization, and composition, are the principles of form.

Usually, when an artist makes a painting, he wants to communicate the emotional response the subject provoked in him. Conversely, when someone first likes a painting, it's usually because he likes the way it looks.

The viewer cares much less than you think he does that the painting is an accurate rendering of what you saw. He cares much more that the painting is a decoration that pleases him every time he looks at it. When a painting doesn't look good on the wall, it fails as a decoration. When a painting fails as a decoration, it will usually also fail to find an audience.

Much of the pleasure the viewer takes in a painting lies in his recognition of the painting as the fulfillment of a difficult type. Type simply means a series of associations which you read as a whole. A type is the real thing: For instance, a perfectly formed tree would be a difficult type. The symbol of a type is called a negative type: A painting of a duck may look like a duck, but it isn't a duck, it's a painting.

To someone who doesn't paint and draw, almost any effort seems remarkable. These good people think of any painting as a difficult type because they feel it's something they could never do. (That's not true, of course. Still, the inevitable response of family and friends to the neophyte's first efforts is always enthusiastic: "I never knew you were so talented!" and sometimes even, "I wish I could do that, but I have no talent.")

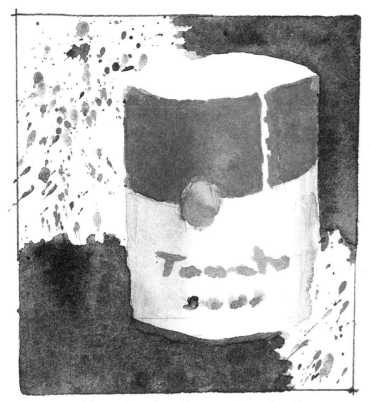

Areas of light contrast with areas of dark; the area of texture contrasts with untextured areas.

A successful painting fuses the opposites of pattern and design. Thus, to be successful, a painting must achieve two opposite things:

It must have unity. It must be a single, well-organized, understandable thing. Pattern is unity: black against black or white against white, or a lost edge, is pattern.

It must be interesting. The painting cannot bore the viewer. Design holds the spectator's attention and prevents him from becoming bored. Design is contrast: black against white, or a found edge, is design.

Four areas make up the picture; three dark and one light. The diagram shows how abstract the shapes are.

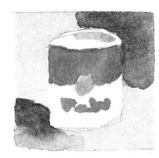

Color in the positives contrasts with neutrals in the negative space of the background.

Principle	Based on the Psychology of:
Design	Sensory and Attentive Fatigue
Pattern	Span of Human Attention
Type	Recognition (conditioning)
Emotion	Feelings (sensation, reaction)

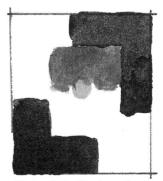

Restraint: The local color of the positive is muted.

You are my host in that rectangle. You mustn't bore me. Change is the only antidote to boredom.

—Ed Whitney

Gradualness, gradualness, and gradualness. From the very beginning of your work, school yourselves to severe gradualness in the accumulation of knowledge.

—Ivan Pavlov

The inevitability of gradualness.
—Beatrice Webb

Against boredom even the gods themselves struggle in vain.
—Nietzsche

The most general survey shows that the foes of human happiness are pain and boredom.
—Schopenhauer

Fatigue has no effect on our underlying preferences.
—Stephen C. Pepper

The Fatigue Mutations

Mutation is just a fancy word for change or the process of change. The artist's aim is to get the viewer to look at the painting for as long as possible. But powerful forces, the fatigue mutations (sensory and attentive fatigue), work against that goal.

Sensory Fatigue: When we become physically tired, or our senses become jaded from too much stimulation—that's sensory fatigue. Continued exposure to any stimulus dulls the senses. The apple never tastes better than on the first bite. That first bite is delicious. You take another bite and it isn't quite as good. That's sensory fatigue. However, if you follow the bite of apple with a bite of cheese, you are aware of how the cheese tastes. If you now go back to the apple, it tastes as good as before, maybe better. The contrast of the two tastes keeps your taste buds from becoming dulled.

Or, you've been in a museum all morning. Your eyes are tired, your feet hurt, and you don't see the paintings anymore. You take a break and have a cup of coffee. After your break, you're refreshed and ready for more. This is a qualitative change. The taste of the apple is different from the taste of the cheese; it has a different quality. Having a cup of coffee is different from looking at paintings. Qualitative change restores interest and attention. Contrast is the painter's word for qualitative change.

Attentive Fatigue: Imagine you're at a workshop eager for it to begin. Your instructor starts to talk and, before long, your mind starts to wander. Is he ever going to get to the demonstration? Yes, finally! You're alert and excited again. Soon his demonstration starts to drag. It no longer holds your attention. Will he ever finish? What's taking him so long? You're experiencing attentive fatigue, the mutation from interest to boredom.

Interest

Time

Interest quickly changes to fatigue unless something happens to rekindle that interest. Performing the same physical act over and over leads to physical fatigue. Too much similarity of color fatigues the eye. Endless repetition leads to boredom, mental fatigue. A good painting is never boring. The artist employs various devices to keep the eye alert and the mind entertained.

The top bar of unvarying hue, intensity, and value rapidly becomes boring.

Even a little gradation adds interest to the band of color. Here the color changes from green-blue to purple-blue in a gradation. The effect is subtle but more interesting than the band above it.

The gradation of three analogous colors (green, blue, and purple) is even more interesting.

Qualitative contrast changes the subject for the viewer. But too much qualitative contrast can destroy the picture's unity. Without qualitative contrast, boredom is the inevitable result. (The danger of too much design is too much contrast, resulting in utter chaos. On the other hand, perfect unity results in utter boredom.) Neither extreme is very desirable. How do you prevent boredom without getting too far off the track? One solution is the design principle of gradation. A slight series of almost imperceptible changes that follow one another sequentially will hold your attention for a long time without destroying the sense of unity.

Anything is dramatized by its opposite. Even the best marriage is filled with conflict. Conflict's function is to dramatize dominance, but it mustn't challenge it.

—Ed Whitney

There is no quality in this world that is not what it is (except) merely by contrast. Nothing exists in itself.

—Herman Melville

It is in the contrast of light and dark that design happens.

—Helen Van Wyk

Contrast is as essential to design as unity.

—Maitland Graves

No pleasure endures unseasoned by variety.

—Publilius Syrus

The four principles of design are:
 Contrast
 Gradation
 Theme and Variations
 Restraint

Design

The principles of design grow out of the demands of the fatigue mutations. It is the design that holds the viewer's interest and keeps the painting from becoming boring.

Contrast

Light and dark are contrasts, as are red and green. Any time two or more qualities are opposites, the result is contrast. Contrast is the easiest and most effective way to relieve sensory or attentive fatigue. The trouble with contrast is that if you use too much, your painting becomes confusing, and no one spends much time deciphering a painting that's confusing.

Gradation

When closely related qualities are organized progressively in a logical sequence, it's a gradation. A gradation shares a basic characteristic with line, which is movement. The eye moves along a line, therefore the character of a line is always progressive. Similarly, the eye moves along a gradation.

Although we usually think of a gradation as being a series of almost imperceptible transitions, the intervals between the elements in the gradational line may be suprisingly wide as long as the sequence is orderly. Red-orange-yellow is a close gradation. Red-yellow-blue is also a gradation because the intervals are equal. You've merely skipped the secondaries.

As long as the line of a gradation is clear, there's no limit to how many different sense qualities it can contain. For example, a single area may gradate from dark to light, warm to cool, neutral to intense and from larger to smaller. Four different things are happening along the single gradational line.

While the unifying power of contrast is limited to only four or five elements before confusion sets in, gradation is virtually unlimited in its unifying power.

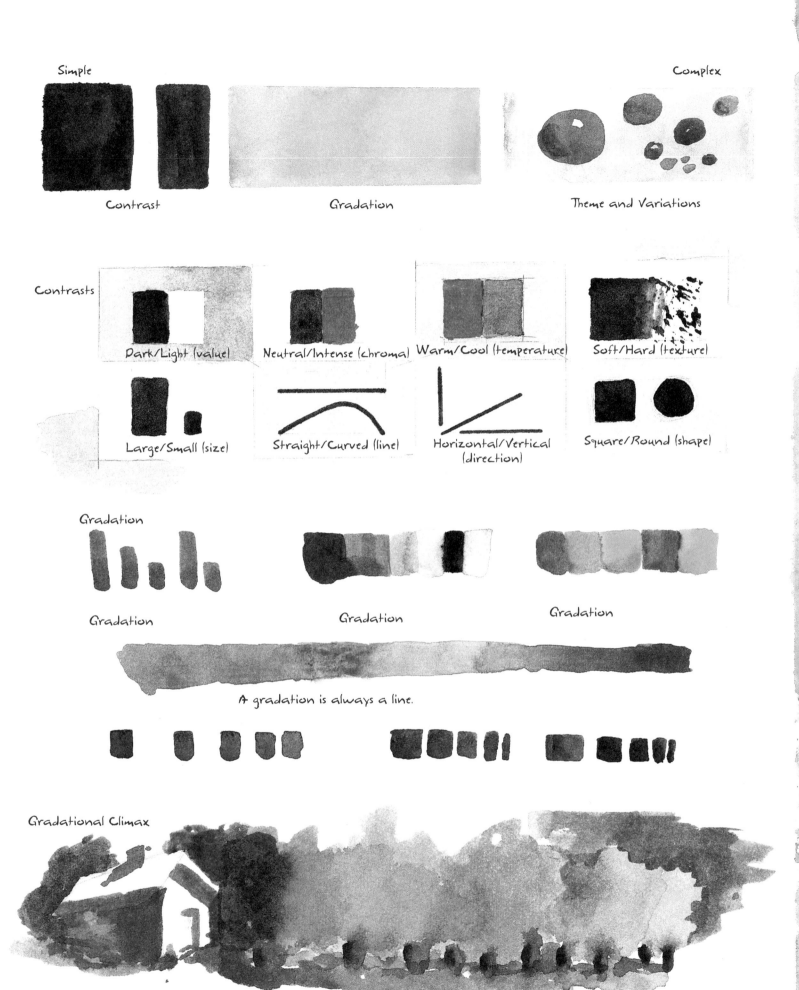

Simple

Contrast

Gradation

Complex

Theme and Variations

Contrasts

Dark/Light (value)

Neutral/Intense (chroma)

Warm/Cool (temperature)

Soft/Hard (texture)

Large/Small (size)

Straight/Curved (line)

Horizontal/Vertical (direction)

Square/Round (shape)

Gradation

Gradation

Gradation

Gradation

A gradation is always a line.

Gradational Climax

One end of the gradational line is almost always more interesting than the other. You plan your gradation so the climax is where you want the viewer's interest. Putting something that's more interesting at one end of the gradational line either shifts or increases the gradation's climax.

41

Theme and variation is simply the combination into a single principle of the effects of contrast and repetition. Once a theme is stated, it may then be given a series of restatements, each recognizably the same, though each works a variation on the theme.

—John F.A. Taylor

Repetitions within a picture play a great role. They are brothers and sisters nodding to each other.

—John Marin

All art is thematic, the arbitrary imposition of a theme on a motif. If you don't have an expressive theme, you are saying that you'd rather listen to a tape recording of a beehive than "The Flight of the Bumblebee."

—Ed Whitney

Once is an accident; twice is a coincidence. But three times and you have to recognize they're the best in their arena.

—Jeffrey Katzenberg

When you don't know what to do, put in your theme. The one thing you can't have too much of is your theme.

—Ed Whitney

Theme and Variations

Theme and variations begins with the artist selecting an easily recognized pattern, a group of lines or a simple shape. This pattern becomes his expressive design theme. For flowers, the theme might be ovals; for architecture, squares. Once an artist has chosen his theme, he can vary it any way he wants.

The theme must be recognizable in each variation. When he recognizes the variation, the viewer feels clever. If he doesn't recognize them, he loses the connection between the variations and the theme, and the result is confusion, not enjoyment.

However, you don't need to be obvious or heavy-handed about your variations. As long as the viewer senses them, your theme and variations can be suprisingly subtle.

The minimum number for variations is three. Once is an accident, twice is coincidence, but add the second repeat (in other words, do it three times, and make it slightly different each time) and there is no mistaking your intention.

There is no limit to the amount of material you can organize with theme and variations. It is infinitely more versatile, flexible, and creative than either contrast or gradation as a way to organize your painting.

Major and Minor Themes

A painting may have more than one theme. However, one theme must always be dominant and any others subordinate. The subordinate theme provides the contrast necessary for interest. Thus, a street scene can be seen as TREES and HOUSES, with spherical forms dominant and cubic forms subordinate. Or, it can also be seen as HOUSES and TREES, with cubic forms dominant and spherical forms subordinate. In both cases there will be variations on the themes, different houses and different trees.

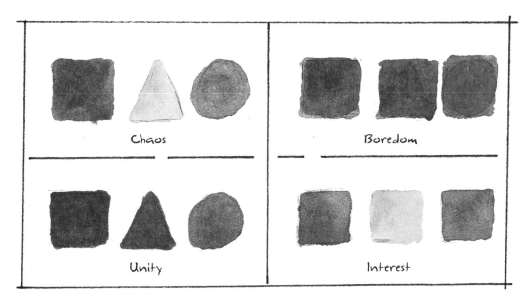

Chaos

Boredom

Unity

Interest

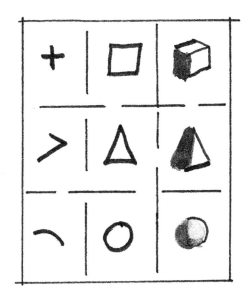

If the shapes are different, the colors should be close; if the shapes are similar, the colors should be different.

Rectangles or boxes, triangles or pyramids, and circles or spheres are the only shape themes the artist has.

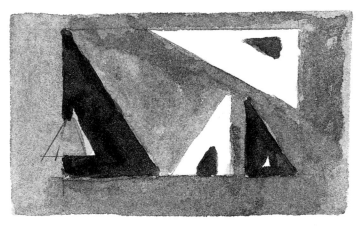

The theme is triangles. At least eight triangles are readily seen. Other triangles are suggested in the negative space.

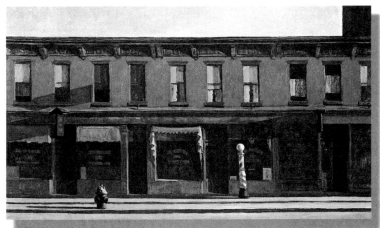

Edward Hopper's theme is rectangles. I counted 118 before I gave up. Study the row of ten apparently identical windows on the second floor.

We see four groups of closely spaced objects, not 17 blue dots.

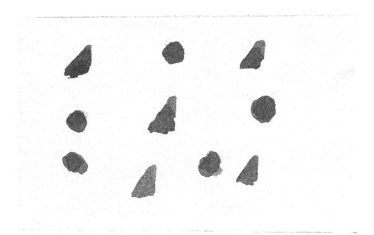

We see either five red triangles or five blue dots. It is almost impossible to really see both the triangles and the dots at the same time.

The Law of Similarity: When similar and dissimilar objects are mingled together, we see the similar objects as groups.

Principles
Design

Restraint

All areas must be interesting, but some areas must be more interesting than others. As a painter, you want your viewer to spend as much time as possible looking at your painting. You also want the viewer to spend more time looking at your center of interest than the background. That's where restraint comes in. Restraint conserves the viewer's expenditure of interest so that it is appropriately distributed throughout the painting for however long he looks at it.

The principle of restraint is probably easier to understand in the performing arts, such as music and drama. A play opens with strong interest to capture the audience's attention. The interest then relaxes a little as the necessary background is developed; we are no longer so much on the edge of our seats. Our interest rises again to the climax at the first-act curtain. The second act opens with interest and builds to the final climax. Thanks to restraint, the performance holds our attention from start to finish.

It's the same in painting. A picture that is equally interesting in every area will be disturbing or confusing to the viewer. If your picture is to have a clear center of interest you must exercise restraint elsewhere in your painting. Restraint provides the "rest areas" necessary for the eye. (Some painters argue that every area should be equally interesting. In practice this never happens, of course. But if every area were equally interesting, the picture would have neither centers of interest nor rest areas.)

Restraint not only avoids that sort of monotony, but it becomes a positive source of pleasure because it puts the emphasis where it belongs—on the center of interest. Even there, restraint can make the painting more interesting. If you omit obvious details in the center of interest, the viewer's imagination provides the missing details and he becomes an active participant in the picture-making process.

Restraint and Climax in the Performing Arts

Act I First Act Curtain Act II

Opening Curtain Final Curtain

Boy meets girl (pattern)

Boy loses girl (center of interest)

Boy gets girl (interest in the negatives)

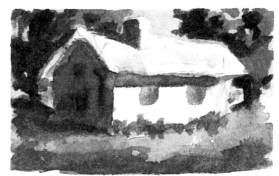

Your viewer has a natural interest in your subject matter, the positives. But too much interest in subject matter on your part can be dangerous to your painting's health. Only when the emphasis is on the negatives does a picture become a painting. If, as Matisse often did, you stress the negatives, the entire picture automatically becomes interesting.

Dominance is often called a design principle. But dominance is simply an extension of, and the application of, restraint. For example, when a painting has a color dominance, one color takes over and the use of other colors is severely restricted or even omitted.

Contrast = Complementary Color

Gradation = Analogous Color

Restraint = Monochromatic Color

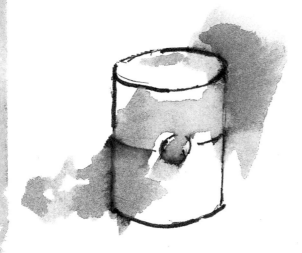

To say of a picture, as is often said in its praise, that it shows great and earnest effort, is to say that it is incomplete and unfit for view

Art should be independent of claptrap—should stand alone, and appeal to the artistic sense of eye and ear, without confounding this with conditions entirely foreign to it, as devotion, pity, love, patriotism, and the like. All these have no kind of concern with art

The imitator is a poor kind of creature. If the man who paints only the tree or flower, or other surface he sees before him, were an artist, the king of artists would be the photographer. It is for the artist to do something more than the face the model wears for that one day; to paint the man, in short, as well as his features.

—James McNeill Whistler

Every Picture Is Not a Painting

You don't go to a museum to see apples and oranges. You can see all the apples and oranges you want at the supermarket. You go to the museum to see the Cézannes and the Chardins (and perhaps be moved by them).

If subject matter were a requirement for a painting, nonobjective paintings would not qualify as paintings and the Museum of Modern Art would be out of business. Although many of us prefer paintings with recognizable subject matter, that's not what painting is about. Painting is always about painting.

Within each painting there is always a duality; for instance, subject and background. One difference between commercial and fine art is that commercial art focuses on the subject, the positives, at the expense of the negatives. The aim of commercial art is always immediate identity. You must recognize that the apple is an apple or, perhaps more to the point, that the soup can is a Campbell's soup can; otherwise, you might run down to the supermarket and buy a different brand. On the other hand, a painting must be clear, but only relatively clear. This relative clarity is one thing that makes good paintings so endlessly fascinating.

Spreading the interest appropriately throughout the painting gives the painting its unity. When you tire of looking at the subject, your eye wanders to the background and discovers interest there. If the background is plain or nonexistent, like the studio photographer's seamless paper, it's called a null context. The null context holds no interest for the viewer; all his attention is focused on the model and that lasts only so long. In a painting the background holds interest as well as the subject.

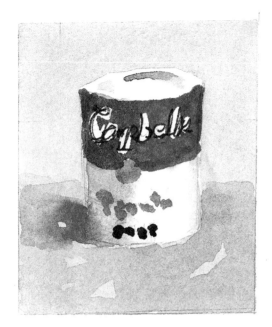

It's a picture. We recognize the object but there is not much visual interest beyond that.

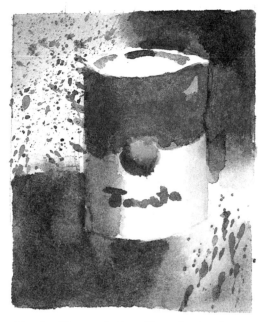

Maybe it's a painting. There is visual interest here beyond recognition, although you could still go to the store and pick up the right item. If you also find some sort of emotional impact or delicacy—then it's probably a painting.

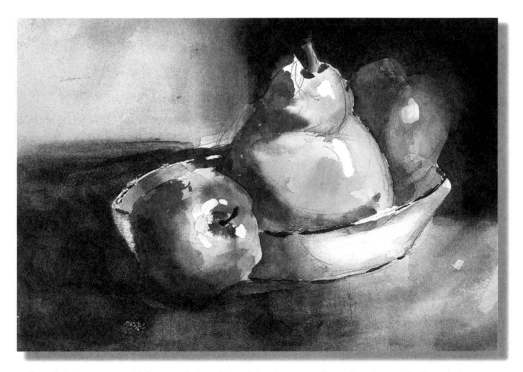

Don't let anyone kid you. Subject matter is appealing. Most people like pictures of things with which they are familiar or which hold sentimental attachment for them. Your viewer is already familiar with your subject matter. He knows what a tree, a boat, a flower, or a building looks like; you don't have to tell him what he already knows. His imagination will fill in any missing details in the positives better than you or any painter can paint them.

It's the thing that makes me stop the car and get out my paint box.

—George Post

A painting is always about two things: the dancing pairs—sea and sky, light and dark, warm and cool. Only the painting itself is a single thing.

—Rex Brandt

A different measure from each edge and not too close to any one edge. Prefer the upper right quadrant.

One thing that makes the center of interest different from everything else is that it's different from everything else.

Center of Interest

Before you recognize things, you see contrasts. You see light against dark before you recognize the sail against the sky or the daisy against the leaves. It's this contrast that becomes the center of interest, or focal point, of your painting.

Beginning painters have at least one thing in common with great artists—their paintings always have a clear center of interest. It is somewhere in the intermediate and advanced levels that the center of interest seems to get lost. This seems especially true for landscape painters.

A painting must have a center of interest because a painting, unlike life, is clearly organized. A painting is a hierarchy (a synonym for composition), thus one thing is always more important than everything else.

The center of interest is usually an island of excitement in a sea of restraint. (Sometimes, though, it becomes an island of restraint in a sea of excitement, a simple subject displayed against a complex background.) The center of interest must always be interesting. Usually a cluster, or group, is more interesting than a single thing.

Here are a few rules that apply to the center of interest:

1. It must be a thing.

2. It should be lighter than its surroundings.

3. It usually belongs in the painting's upper right-hand quadrant because negative space seems less demanding when it's at the picture's lower edge; the lit side of the center of interest should be on the side of the painting closest to the light source, usually on the right.

4. Its total area should be somewhere between an eighth and a fourth of the painting's total surface area.

5. It should be supported by a holding dark behind it, which may be a positive.

6. It should be interesting. (You'd be surprised how often even experienced painters fail to make their center of interest visually interesting.)

Don't	Do
Separate lightest light and darkest dark.	Keep lightest light and darkest dark close together (proximity).
	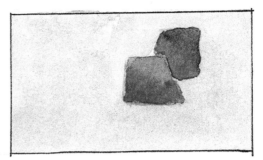
Separate hottest hot and coldest cold.	Keep hottest hot and coldest cold close together (proximity).
Make the center of interest darker than the background; have more negative space at the top of the picture.	Keep the center of interest lighter than the background; have more negative space at the bottom of the picture.
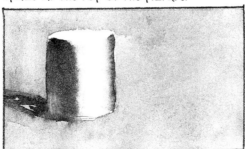	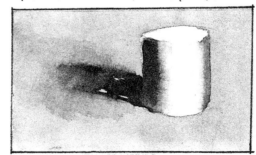
Place the lit side of the center of interest on the side of the picture away from the light source.	Have the lit side of the center of interest on the side of the picture closest to the light source.
	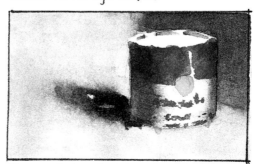
Ignore the holding dark or the secondary pattern.	Use a gripping dark to set up the lights on the center of interest. Create an interesting secondary pattern.

Things should be made as simple
as possible, but not simpler.
 —Albert Einstein

In art what appears simplest
and least demonstrably good is
often the most enduring....does
a flower, a bird, a river have to
"prove" itself?
 —Harold Clurman

All work is condensing.
 —Peter Brook

The difficult unity of inclusion
or the easy unity of exclusion.
Where simplicity cannot work,
simpleness results. Less is a bore.
 —Robert Venturi

Everything is deeply intertwingled.
 —Ted Nelson

Design Principles May Combine

Although it is useful to look at the four principles of design individually, they are not mutually exclusive. On the contrary, they are mutually cooperative, and every substantial work of art uses them all. Think of a painting as being like a submarine sandwich; they're both fusions. A submarine sandwich is a fusion of tastes, while a painting is a fusion of graphic elements and principles; it's an aesthetic fusion.

In fact, the combination of theme and variations with contrast is the ham-and-cheese sandwich of design principles. It's so effective and used so often that it's almost a fifth design principle, called segregation.

Segregation may be easier to understand in music, where the composer introduces a theme and then develops it with variations until monotony threatens. At that point he introduces a counter-theme and again develops it through variations until again monotony threatens. He then returns to his original theme and bookends the piece.

In painting, segregation consists of contrasting a major theme and variations with a minor theme and variations. Variations avoid monotony within each theme. Finally, all areas combine to make up a larger pattern.

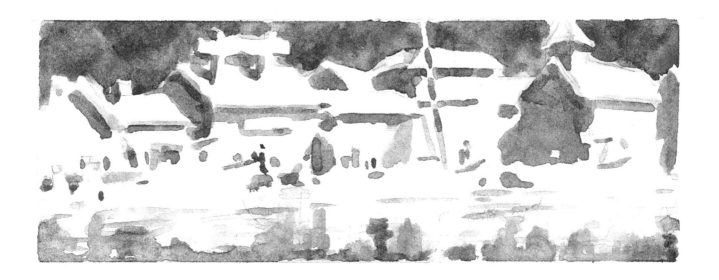

Contrast of Values

Contrast of Color

Contrast of Edges

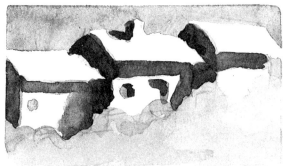

Contrast of Detail

A core is a 3-D object in space.

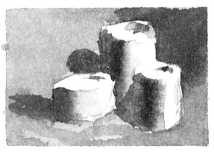

A cluster is a group of cores that reads as a unit.

A dark that touches the light area of a center of interest may challenge it.

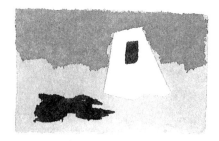

To pull something forward, but not challenge the center of interest, add darks in the midtone. which do not touch the center of interest.

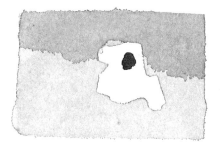

Rule for center of interest; Lightest light/ darkest dark.

Pattern

If life were organized there would be no need for art.

— André Gide

Art is the imposing of a pattern on experience, and our aesthetic enjoyment in the recognition of the pattern.

— Alfred North Whitehead

Art is a way of lending the random, messy business of life a sense of order and harmony and form.

— The New York Times

A mathematician, like a painter or a poet, is a maker of patterns. If his patterns are more permanent than theirs it is because they are made with ideas.

— Godfrey Harold Hardy

Subject matter is not nearly as important in picture-making as the arrangement of the elements into a pattern. Thus the abstraction which contains no recognizable object may be a satisfying work of art.

— Ted Kautsky

Pattern

Of all the things that go into a painting, pattern is perhaps the least understood. Many people understand the words "pattern" and "design" to mean the same thing, but they do not.

Design is contrast, light against dark or dark against light. It's the found edge. It's the design that gives the painting its interest. The design is what you see.

Pattern is unity, light against light and dark against dark. It's the lost edge. Pattern holds the painting together. Unless you look for it, you don't see the pattern.

Pattern and design can be separated from the painting's subject matter or from any emotional message the painting may hold. Of the four general aesthetic principles, design and pattern are the abstract structural principles upon which the artist hangs the more tangible principles of type and emotion.

Think of a painting as a house; once a house is built, you don't notice its skeleton. You see the walls, roof, doors, and windows, not the supporting structure. In the same way, once a painting is completed, you see its subject matter; its structure becomes invisible. You respond to whatever message the painting holds for you. Unless you look for them, you're not even aware of the pattern and design. But they make the necessary framework that holds the painting together.

All the experts agree that the one thing a great work of art has is unity; no unity, no art. And unity is just another way of saying that the painting is organized. If a painting is disorganized it is confusing, and there's no unity where there's confusion or chaos.

A good painting must have both good design and good pattern.
They are two sides of the single coin that is the painting.

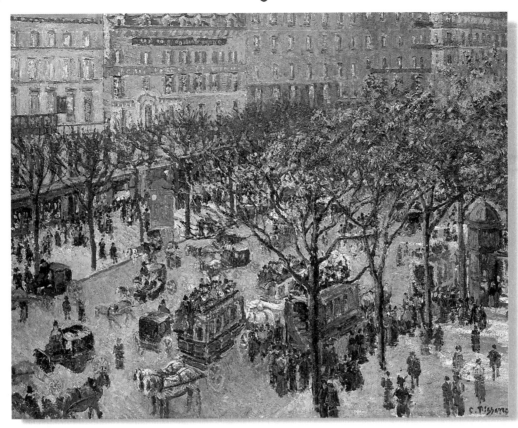

Someone said Pissarro saw diversity in unity, whereas Seurat saw unity in diversity. He meant that faced with his subject, Pissarro saw the big pattern first, then the details. He saw the tree before he saw the leaves and painted from the general to the specific. Pissarro saw as the painterly painter sees.

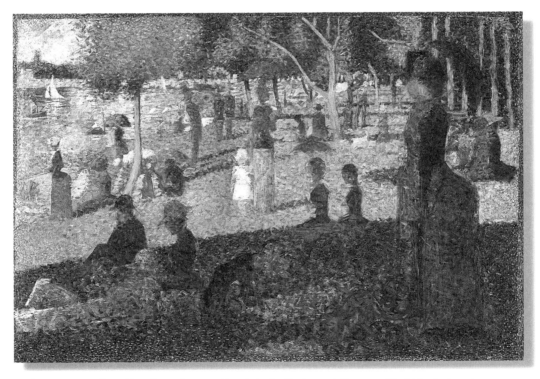

Seurat, on the other hand, saw the details first and then unified his design by imposing pattern on it. He saw as the linear painter sees. He worked from the specific to the general. But the result for each was the same: unity.

You are judged by the big pattern. Nothing is more important to your picture than your pattern. If your painting does not have a distinguished pattern, it will be mediocre, no matter how accomplished you are otherwise. Think pattern first, then drawing, then color. The character of the painting is resolved in the pattern scheme. A good pattern scheme is success insurance for your painting. If you wind up with a good pattern, you've got a successful painting.

—Ed Whitney

A pattern is particularly pleasing when it fits the natural impulse of the viewer's attention.

—Stephen C. Pepper

Organizing Principles

The principles of pattern are the principles of organization. The artist organizes his design with pattern. The principles of pattern rest on two simple psychological premises:

The limited span of human attention: The psychologists call it short-term memory and it's this: we can easily grasp or remember up to five separate things. However, when the number of elements or things we have to remember exceeds eight or nine, we get confused. Nine is the absolute outer limit of short-term memory for a normal human being. Not even Einstein could remember ten things unless he wrote them down.

The selectivity of vision: You don't see every blade of grass; you see the lawn. Your vision automatically restricts itself to only as much as your mind can hold. When the number of elements exceeds the limits of your attention, your eye (or more properly, your mind) combines them into groups which fall within your span of attention.

Design—the principles of contrast—gives the painting its interest. If the painter overemphasizes design and ignores the limits of human attention, the painting will be confusing, too much trouble for anyone to look at. Or conversely, if pattern is overemphasized at the expense of design, the picture becomes boring. So the painter must walk the very narrow path between monotony and confusion to balance the conflicting demands of design and pattern.

As long as you follow the Rule of Five, you can organize as much material as you want or explain extremely complicated structures very clearly. If the tree has five branches and each branch has five twigs, and each twig has five leaves, the whole structure will be crystal-clear to your viewer.

Five elements against a simple ground constitute a pattern. You could close this book right now and accurately copy this pattern because it falls easily within your span of attention.

Seven elements against a simple ground also constitute a pattern. The two additional elements make this pattern a little more complex, so you might have to study it for a minute or two before you could make a copy of it with the book closed. But you can do it.

Nine individual elements represent the outer limit of the span of attention. You probably can make a copy of this pattern with the book closed, but it will be more difficult than copying either of the two simpler patterns. Many of us will not be able to do this without breaking it into two smaller patterns of four and five elements.

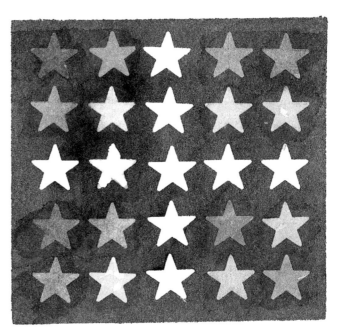

Although this pattern uses twenty-five separate elements, each element reads as clearly as any element did in the simple five-element pattern. That's because the elements are arranged in two groups of five, a horizontal row and a vertical column. Because the pattern is organized using the *Rule of Five* it is completely legible even though the number of elements far exceeds the span of attention.

We Orientals find beauty not only in the thing itself but in the pattern of the shadows, the light and darkness which that thing provides.

 —Jun'ichiro Tanizaki

It is a minimum requirement of all objects of delight and beauty that they should avoid confusion. Accordingly they must have pattern.

 —Stephen C. Pepper

Aesthetic Alert: When you have to call a simple pattern like the one above a "qualitative, crossed heterogenous pattern" you're in big word trouble. But that's what it is. Ben Shahn said, "Aesthetics is for the artist like ornithology is for the birds." He was being funny, of course. After all, Shahn's book, The Content of Form, was about aesthetics. Ben was one bird who was wise enough to know the value ornithology held for the birds.

Element Patterns

When a pattern is so obvious that we recognize it immediately as a pattern, it is called an objective pattern. Objective patterns are the patterns you usually see in textile design and decorative paintings. Subjective patterns are subtler in their repetitions, but they follow the same laws of organization. Any pattern we are aware of as a pattern is always an element pattern. An element pattern never contains more things (or elements) than we can take in at one grasp of the attention with no special grouping or other aide-memoire.

Every pattern starts with a line or a simple shape; in fact, a line or a simple shape *is* an element pattern. A complex pattern is just a grouping of simple element patterns.

There are two different element patterns: the homogeneous pattern and the heterogeneous pattern.

Homogeneous Pattern: When the elements are identical, the pattern is homogeneous. A homogeneous pattern could be used in a decorative painting of a forest interior or a sailboat race. The tree trunks, or the sails of the boats, form repeating identical elements.

Heterogeneous Pattern: Most paintings don't just repeat the same elements over and over again. When the elements are different in some respect, the pattern is heterogeneous. For example, if we introduced a rushing stream into all those tree trunks of our forest interior, the painting would then be composed of different elements. The resulting pattern is heterogeneous because the elements are different. Heterogeneous patterns can be either qualitative or quantitative patterns, depending on whether the elements differ in shape, or only in size and number.

Pattern: The span of human attention is somewhere between five and nine. Because there are only five elements of pattern, you see each element clearly. The result is a pattern.

Texture: The only way the mind can handle large numbers of elements is by combining them into groups which fit comfortably into the span of attention. We read this as an area of texture, not as a pattern of circles.

Homogeneous Patterns: The elements are the same in every respect.

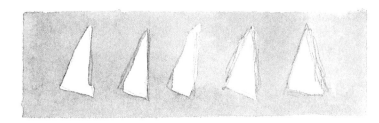

Homogeneous Pattern: The elements are the same, however, gradation in the negatives adds interest and movement to the pattern.

Quantitative Heterogeneous Pattern: The elements vary in some regard to quantity. Here they vary in size.

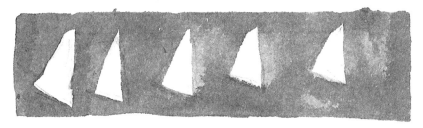

Qualitative Heterogeneous Pattern: The elements vary in regard to quality, not quantity. Here they vary in shape.

An element pattern, whether homogeneous or heterogeneous, may be either congruent or crossed. Every pattern always has a point or points of emphasis, an accent or accents.

Congruent Pattern: The accents are where you expect them. A unit you expect to be strong is strong and a unit you expect to be weak is weak. The congruent pattern is also a homogeneous pattern.

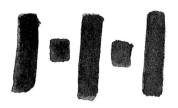

Crossed Pattern: When the accents do not occur where you expect them, they are crossed. In a crossed pattern, a unit you expect to be weak is strong and vice versa. This pattern is like syncopation in music.

57

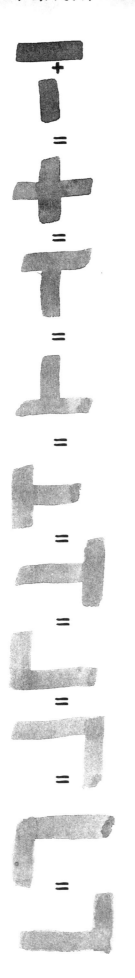

Combining Patterns

The combining pattern is the next step up from the element pattern. When you combine two or more patterns, the result is a combining pattern or a fusion.

What's a fusion? A peanut-butter-and-jelly sandwich is a fusion; so is a gin-and-tonic. They are both fusions of tastes. A gin-and-tonic tastes different from straight gin and different from straight tonic, although you can taste both the gin and the tonic in each sip. The effect of a fusion is different from the effect of any of the elements in the fusion by itself—even though you can distinguish each element in the fusion. Thus a fusion is a gestalt in which the whole is different from the sum of the parts. The two combining patterns are:

Combination by Extension: The element patterns are combined side-by-side. Most extended patterns are also metric patterns. A metric pattern results from the simple repetition of an identical element pattern. The repeat may be homogeneous, quantitative, or qualitative. Metric patterns are often the basis of fabric and wallpaper design. Repetitions give these patterns their rhythm.

When the combined element patterns are different, the result is a free pattern. Most paintings use free patterns.

Combination by Overlap: Two element patterns are combined into a single pattern by putting one pattern over the other. When the two patterns are similar it's qualitative overlap. When the two patterns are different it's quantitative overlap.

The rule is: When similar things or shapes are overlapped, make them different for the sake of clarity; when different things are overlapped, make them as similar as possible in order to preserve the pattern. Explore this rule with subject matter that interests you.

As above, a simple vertical against its background is an element pattern. Adding a second vertical makes the pattern somewhat more complex; it becomes a combining pattern because it combines two elements. It is a pattern by extension because the vertical is extended. Obviously, the distance between the elements and their placement on the picture's surface are important factors.

A combining pattern by extension may become quite complicated.

Extension is just one way to create a pattern. Overlapping or superimposed shapes also create a pattern (see below). Most pictures employ both patterns by extension and overlap.

The lines are similar. You can't tell if the verticals are in front or if the horizontals are in front. The pattern is confusing.

The lines are different, but because one set is lighter than the other, they separate too much in the picture's imaginary space; unity is lost.

There are two squares here (they might represent two houses or something else), but you can't tell which square is in front of the other or even if they form one shape.

Making the different shapes different colors and values separates them too much in the picture's imaginary space. The sense of pattern is lost.

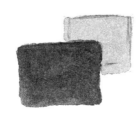

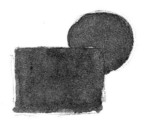

The lines are similar. But because the horizontals are lighter than the verticals you understand that they are behind the verticals. The pattern is clear.

The lines are different. Because their color and value is similar, separation is minimized and the pattern is unified.

Making the two squares different clarifies their relationship in the picture's imaginary space. You know which square is in front and which is behind.

The shapes are different, a square and a circle. (They could be a house and a tree). Keeping them close in color and value unifies the pattern.

59

A pattern that holds other patterns together is an organizing pattern. Each group is held within the limits of attention so the total system forms a single whole, easily comprehended within this attention span.

— Stephen C. Pepper

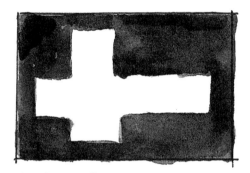

Closed Axial Pattern

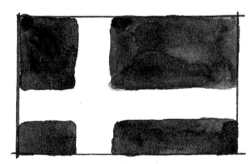

Open Axial Pattern

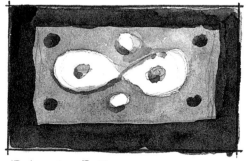

Embracing Pattern

Immature poets imitate, mature poets steal.

— T.S. Eliot

Organizing Patterns

Think of pattern making as a kitchen step stool with three steps. The first step is always an element pattern, and some patterns never need to get beyond this step. When two or more simple element patterns are combined—either by putting them side-to-side (extension) or laying one pattern on top of the other (overlap)—the two element patterns fuse into a combining pattern; that's the middle level.

When combining patterns are arranged into a system, that system becomes an organizing pattern—the highest rung of the pattern-making ladder.

The two basic organizing patterns are the embracing or matrix pattern and the skeletal or axial pattern.

An embracing or matrix pattern is one that holds other patterns within it. Think of how a pound cake holds raisins; the cake is the matrix which holds the raisins, the elements of the pattern.

A skeletal or axial pattern brings order out of complexity by organizing the painting the same way a human skeleton organizes the anatomy. Axial patterns are usually created around a strong vertical line, which functions the way the spine of a standing person or the trunk of a tree does. Elements branch off the central spine and then branch off again. As long as the branching elements fit comfortably within the span of attention, the pattern will be perfectly clear no matter how many branchings there are.

The dominant form of any composition controls it, and the dominant form of a painting is always its format. In every rectangular picture, the major vertical axis is right down the middle. Painters accept this powerful axis and find ways to make it work for them.

Within a painting, the biggest positive shape becomes the dominant form. The dominant form or group of forms in a composition determines the picture's vertical axis of balance. I don't look for the axial pattern to go out of style as long as humans stand on two legs.

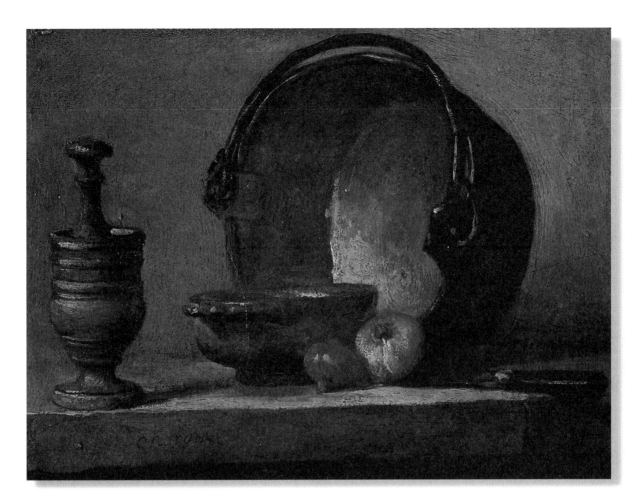

This painting by Chardin combines a vertical closed axis with an open horizontal axis against an embracing midtone. Chardin didn't have to go very far to find the subject matter for a great painting: It was right there in his kitchen. It's all in how he arranged and painted it. Take Eliot's advice: Go out in the kitchen and steal Chardin's composition. (You may want to try it first without the object on the left.)

Patterns

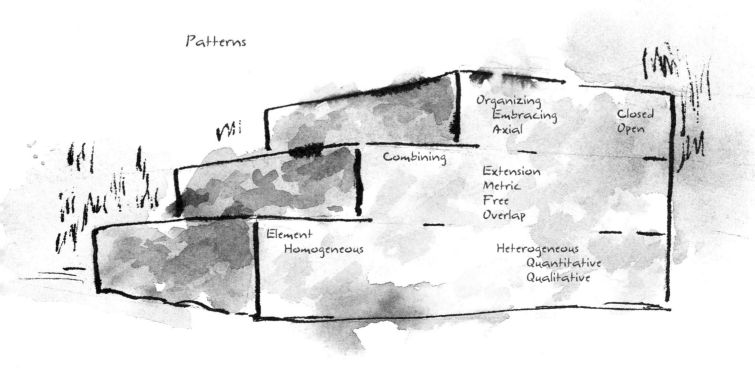

Mi

Organizing
Embracing
Axial

Closed
Open

Combining

Extension
Metric
Free
Overlap

Element
Homogeneous

Heterogeneous
Quantitative
Qualitative

Principles
Pattern

Composition consists of:
1. Unity (pattern)
2. Variety (design)
 No exact repeats. (Theme and variations.) The shapes enjoy each other.
3. Balance (of the two). The most important part of composition.

— Helen Van Wyk

Three-Dimensional Balance

M=Mass B=Balance

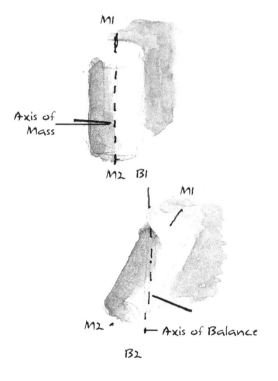

Balance

Perhaps we require that every pattern have balance (and we do require it) because we're human. Maybe this need for balance stems from the fact that we have only two legs to stand on. We don't like being "caught off-balance." Perhaps it's this need that makes us so quick to notice when anything is off-balance and about to fall. We project into the unstable object the same sort of emotional upset we feel when we stumble and lose our own balance.

Take my cousin Peter: The only time he ever gets upset is when he sees a picture that's hanging off-balance. That somewhat askew picture disturbs him so much that he can't even carry on a conversation or drink a beer, the two things he loves to do most, until he's straightened it. In his almost obsessive need for balance, Peter is not unusual; many people react the same way.

On the other hand, I read that Picasso used to go around making sure his pictures were hung a little off-plumb. He hated it when the verticals and horizontals paralleled the walls and corners of the room. When pressed for an explanation, Picasso explained that hanging his pictures askew forced people to notice them.

There are three types of pictorial balance:
1. Symmetrical balance
2. Teeter-totter or asymmetrical balance
3. Unbalance.

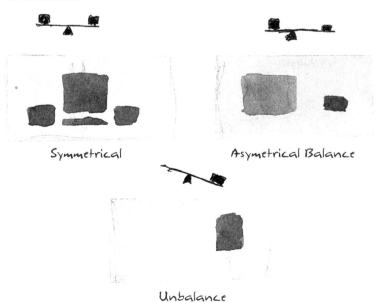

Symmetrical Asymmetrical Balance

Unbalance

Pictorial Balance

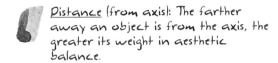 **Distance** (from axis): The farther away an object is from the axis, the greater its weight in aesthetic balance.

Size: All other things being equal, a large area or object is heavier in aesthetic balance than a smaller one.

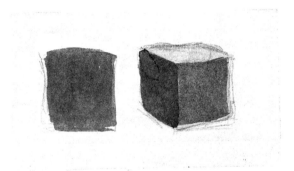

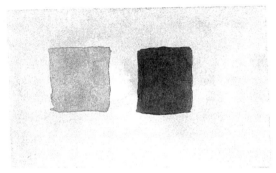

Depth: Any suggestion or presence of depth in a visual composition gives a feeling of weight. Even if both drawings are the same size, a drawing of a cube seems heavier than one of a playing card.

Color: Dark colors appear heavier than light colors.

Movement: When movement is away from the central axis, it makes objects seem heavier. If the movement is toward the central axis, the object appears lighter. The arrow pointing toward the center of the composition seems lighter than the one pointing out of the picture.

Interest: The more interesting an object is in a composition, the greater weight it has in balance. The head appears heavier than the circular shape.

Principles
Pattern

Passage and Counterchange

No one visualizes very well. That's why every professional artist finds it necessary to make pattern schemes before he begins a painting. Pattern schemes are also called thumbnails, roughs, or sketches.

A pattern scheme is a black-and-white plan that shows the value relationships of the painting's major areas. Since the areas must fit within the span of attention, there will usually be no more than five areas and rarely more than nine.

There's no way to tell if your first pattern scheme is any good until you have another one with which to compare it. Therefore, make all your pattern schemes on the same sheet or on the same page of your sketchbook.

Counterchange patterns are based on the contrast of light and dark in subject and background. They are strong designs which read beautifully. But if the shapes are closed, you may find them harsh, edgy, and not very convincing. In nature there are always places along the edge of an object where the value or color of the object is the same as the value or color of its background. Here, where light meets light, dark meets dark, or color meets color, the edge is lost, no longer defining the form. These are *passages* of light into light, dark into dark, or color into color.

In your next pattern scheme, break the forms in each area into a light and dark side. Your new pattern should display both passage and counterchange. Then in succeeding pattern schemes, rearrange this flow or linkage of light and dark until you have a pleasing, balanced pattern.

A good way to begin a pattern scheme is to make a simple diagram in which you use ovals to locate the major areas. Then just draw your subject's outlines inside each oval.

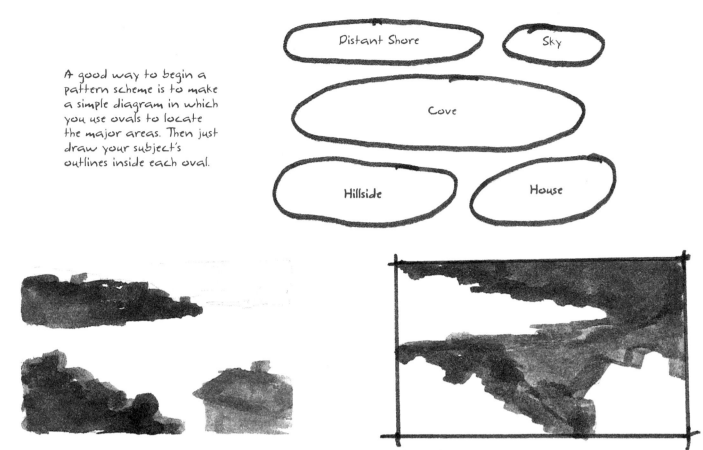

An easy way to start a series of pattern schemes is to paint the dark silhouette of the positives in a <u>contra jour</u>, or against-the-light, effect. Next, paint a second pattern scheme in which you leave the positive areas white, paint the negatives dark, and carry on from there.

Just as contrast is the basis of design, so passage is the basis of pattern. Passage creates pattern and gives the painting its unity.

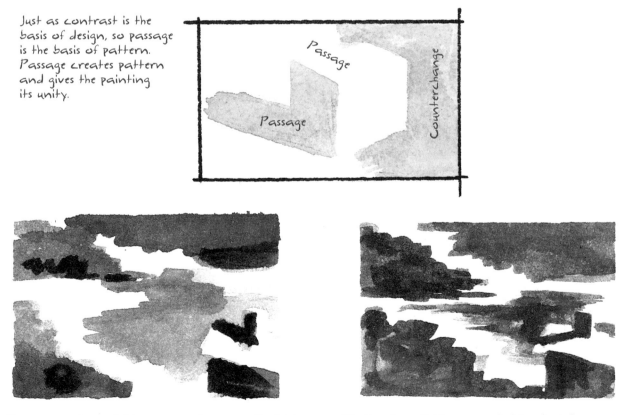

Since we only see light, our eyes focus on the light areas. That's why a light surrounded by dark becomes a target for the eye. It may also trap the eye, making it difficult to see the whole painting. However, a light merging into a light creates a pathway for the eye, encouraging it to move throughout the painting.

65

The first rule of color composition: Pure, bright, or very strong colors have loud, unbearable effects when they stand unrelieved over large areas adjacent to each other, but extraordinary effects can be achieved when they are used sparingly on or between dull background tones.

—Eduard Imhof

A good picture is fundamentally an arrangement of three or four large masses or large blocks of color—light, dark, and half-light or half-dark.

—John F. Carlson

Clarity is the first aim, economy the second, grace the third.

—Sheridan Baker

Patterns of Clarity and Interest

A pattern is simply a recognizable arrangement of lights, darks, and midtones (or of other contrasting qualities) that fits the span of attention. There are two kinds of patterns—the patterns of clarity and the patterns of interest.

Patterns of Clarity: The requirements of pattern together with the limitations of pigment and skill mean that we must change what we see in nature to fit the pattern. If the pattern scheme is dark against light, the light values of the subject must be reported as a midtone, otherwise they are invisible, lost in the null context of the negatives, and the pattern doesn't read. The reverse holds for light against dark: the dark values must be reported as a midtone. A third possible pattern sets both darks and lights against a midtone. The patterns of clarity are favored by linear painters and commercial artists, for whom recognition of the subject is paramount.

Patterns of Interest: Any clear, alternating pattern of opposites (such as light and dark, or warm and cool, or textured and smooth) used as a background becomes, in effect, a checkerboard. Even a pattern of stripes breaks up when positives are laid down on top of it. The checkerboard, then, is the pattern of interest, and it is favored by painterly painters.

The Null Context: The dark-against-light pattern of clarity carries a special risk for the fine artist. An untouched background usually becomes a null context, or, as the dictionary puts it, "amounts to nothing." The ground serves no function other than to prop up the subject. (In commercial work, such as advertising and book design, the white paper serves as a carrier for the type, and therefore should be nothing. But a painting is always about figure *and* ground, positive *and* negative, or subject *and* background; never only about figure, positive, and subject.) The artist must fill in these potential dead spots in the pattern without breaking the pattern.

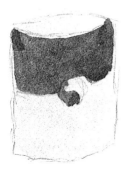

Null Context

Patterns of Clarity

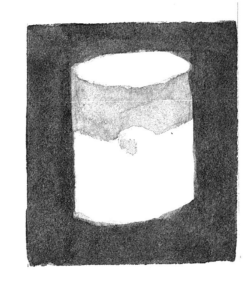

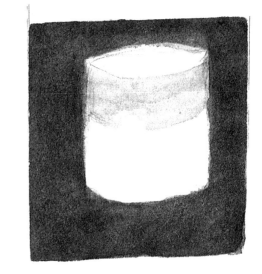

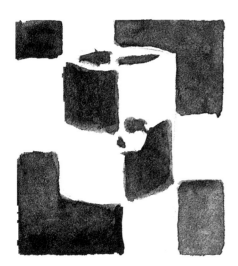

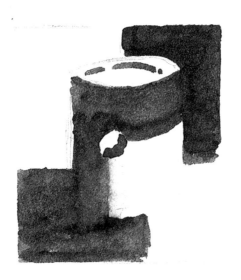

Paint a checkerboard. On a separate piece of paper or on water-media acetate, paint the shade and shadow of your subject. Move the acetate around over the checkerboard until the position makes a pleasing pattern.

Patterns of Interest

The Law of Field Size: The smaller a white area surrounded by a darker area, the more brilliant it appears.

Type

A type is any system or group of associations that we recognize as a whole. Think of a tree. You don't picture it in your mind as a system of roots, trunk, branches, twigs, and leaves; you simply visualize a tree.

Type is either fulfilled or not. As long as a dog is a dog, it fulfills its type. Because mixed breeds are so common, they are a common type. On the other hand, there are not that many prize-winning show dogs because they are so hard to breed. Therefore, the blue-ribbon dog is a difficult type.

Fulfillment of Type: The fulfillment of a difficult type always gives us great aesthetic pleasure. Failure to fulfill common type results in great displeasure. For example, if you go to a fine restaurant and everything lives up to or exceeds your expectations, you have had a wonderful aesthetic experience. A fine restaurant is the fulfillment of a difficult type.

On the other hand, say you go to a fast-food joint and not only is the food awful, but the place is dirty and the help surly. This dump fails to fulfill even the minimum requirement of common type. Your aesthetic response is negative.

Our reaction to the nonfulfillment of a difficult type is one of neutrality. This time you go to the great restaurant and everything is perfect except that they serve your coffee in a chipped cup. Your response to the experience is one of neutrality or even slight displeasure. The restaurant failed to fulfill the difficult type to which it aspired. On the other hand, you can go to a fast-food place where they do everything right. The food is hardly *haute cuisine*, but the place is clean and the service civil. Your reaction to the fulfillment of common type is one of neutrality or slight pleasure.

	Difficult Type	Common Type
Fulfillment of Type	Great Pleasure	Neutrality or Slight Pleasure
Nonfulfillment of Type	Neutrality or Slight Displeasure	Great Displeasure

Fulfillment of type is a scale of likes and dislikes: great pleasure in the fulfillment of a difficult type; neutrality or slight pleasure in the fulfillment of a common type; neutrality or slight displeasure in the nonfulfillment of a difficult type; and great displeasure in the nonfulfillment of a common type. A painter who understands type can use it to help identify and attain achievable goals. This chart makes it obvious where the artist's efforts should be aimed.

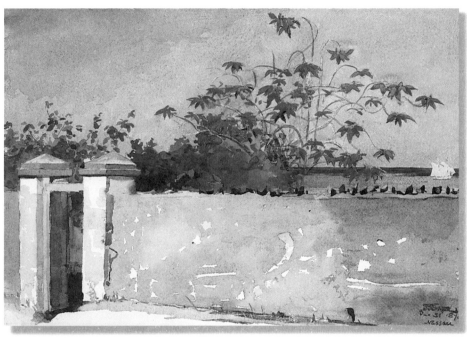

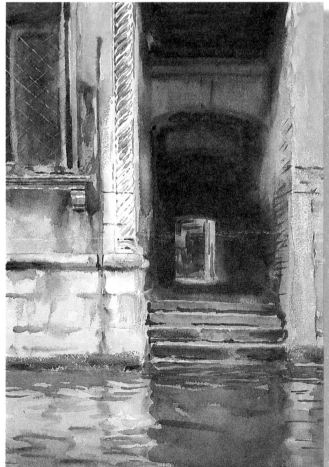

An easy type is a painting that is well within the limit of the painter's ability. Look at Sargent's watercolors of Venice or Homer's late watercolors. These are very simple paintings of very simple subjects. There's nothing in them that's beyond the ability of anyone who has painted for a month or two. But they are hardly common. Even though they are easy paintings to execute, they fulfill very difficult type, that of an excellent painting.

Principles
Type

Aesthetics is not limited to the arts. Anyone who develops a superior appreciation for what's beautiful about something is an aesthete. Because they appreciate the fine points of the game, sports fans are just as much aesthetes as any art critic. The only difference is their area of interest. An aesthete is someone who has a superior appreciation of type.

Instinctive Types

An instinctive type is one we don't have to learn; it's in the genes. For example, no one teaches us what constitutes physical beauty in another person. However, these inborn types are always influenced by culture. Ideas about who's good looking or what foods taste good differ from age to age and among cultures. There are two instinctive types:

Goals of Basic Drives: One sure way to recognize a basic drive is to note that when it acts up, you can't think about anything else. If you're truly cold, for instance, all you can think about is getting warm. That's basic.

Subject matter is most powerful and universal when it represents the goals of basic drives. For example, a still life of fruits and vegetables may relate to the goal of satisfying the hunger drive.

Innate Standard Forms: Nothing in the world looks quite like anything else and many things look very complicated. The way we understand these different forms in art is by mentally reducing them to certain familiar forms the five innate standard forms (cube, pyramid, cylinder, cone, and sphere) or the three simple shapes from which they derive (squares, triangles, and circles).

The innate standard forms function mainly as patterns that simplify perception and produce order. There's usually not much aesthetic pleasure in recognizing them because they are so common. They avoid the unpleasantness of nonfulfillment more than they give any positive pleasure.

 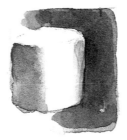 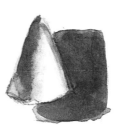

| Cube | Pyramid | Cylinder | Cone | Sphere |

Even when he suggests mass or volume, the artist is always aware that he is putting shape on the flat picture. Color expert Faber Birren assigns primary colors to the primary shapes. Warm colors take strong angles because the eye can focus on them sharply. Cool colors lose clarity at a distance and are therefore associated with softer, curved shapes.

As an organizing form the circle is weak within the rectangle. The difference between the two shapes is too great; unity is lost.

The square or rectangle provides a repeat of the format, but may seem too obvious and ultimately become boring.

Many artists find the triangle the best compromise as the central organizing shape of their composition.

Here the triangle is the central organizing shape even though the composition features circular shapes.

A triangle organizes the rectangular shapes of the skyline. Because they are instinctive, goals of basic drives and innate standard forms have great aesthetic power when we recognize their hidden use in a picture. They signal to the visually sophisticated that the picture has been intentionally composed.

We have distinguished five kinds of natural types:

1. The class to which every individual of a species conforms, since it consists simply in the sum of the traits common to the species

2. The common average, made up of all individuals who are not abnormal nor ideal

3. The median, which is the good specimen sought by the collector, those specimens at or near the center of the spread of variation for the species

4. The perfect specimen, which is the conception of a superlatively good specimen

5. The emotional ideal, which is a cultural modification of natural objects in conformity with emotional interests.

—Stephen C. Pepper

Acquired Types

You weren't born knowing the difference between a marshmallow and a rock. You had to learn it. Most of what you now take for granted you had to learn at one time, and these associations that you take for granted about natural objects are acquired types. Three categories of acquired types are important to good painting: functional, technical, and formal.

Functional Type: You don't have to drive a car to appreciate the design of an automobile. Even when you have no personal use for a thing, you can still admire its design. This is the aesthetic pleasure of the functional type.

The function of any object is the purpose for which it was made. Your pleasure in the fulfillment of functional type is the satisfaction you get when you recognize that the object's structure agrees with your idea of its purpose.

A thing should do what it's supposed to do; if it doesn't, it fails to fulfill its function, no matter how good it looks.

The functional type of a painting is decoration. A painting fulfills its functional type when it looks better than the wall it hangs on. If the painting fails to meet at least the minimum requirements of good decoration, it will not be displayed, and everything else that's in it, no matter how good, counts for nothing.

Technical Type: Technical types are the skill requirements needed to produce an object or a result. Someone who uses things usually has a fuller appreciation of functional type than someone who doesn't, just as a person who has tried to do something usually has a fuller appreciation of technical type than someone who hasn't. If you visit a museum with someone who is not a painter, most of his comments will be about the subject matter. Go there with a painter and his comments will likely be about color relationships, patterns and design, and technical virtuosity. The painter is more interested in technical types than subject matter.

If an etching looks like a woodcut, it does not fulfill the requirements of technical type because those requirements derive from the materials and tools used. Each medium has its own requirements. To start your thinking about your favorite medium, here are the technical requirements of one medium: transparent watercolor.

Transparent watercolor is one of the few mediums that uses the ground as a color.

Transparent watercolor is the only medium that uses water as a vehicle. The wetter the better. Wet-in-wet, blended edges, and gradation express transparent watercolor.

Transparency: Things are best understood or appreciated when contrasted with their opposites. A glazed broken wash or dark opaques demonstrates transparency. Notice how much more transparent these washes appear than the examples above.

Great technicians always know their limitations and work within them. Whatever your technical skill level, there's no reason why you can't be a great technician in this sense, as long as you know what you can do and restrict yourself to doing it. If you can't control four values, use three. If you can't control three values, use two.

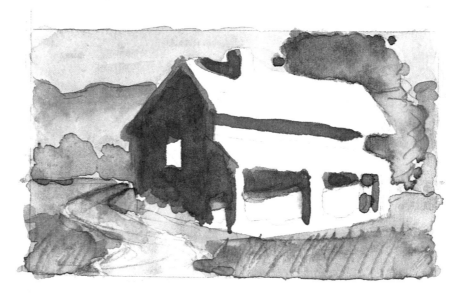

Principles

See it in terms of paint. We don't learn subject matter; we learn paint. The musician can play any score that is set before him.

 —Helen Van Wyk

Never promise more than you can perform.

 —Publilius Syrus

It is an important thing in golf architecture to make the holes look much more difficult than they really are. People take great pleasure in challenging a hole that looks virtually impossible and yet is not so difficult as it appears.

 —Alister Mackensie

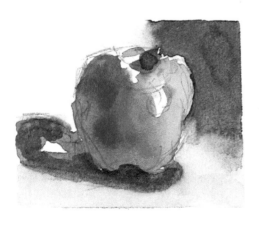

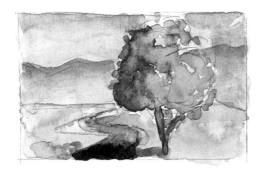

Formal Types

A formal type is always a formula or stereotype. It is an organizing pattern that, once discovered to be particularly successful, gets used over and over again. For example, a sandwich is a formal type. The stereotype or formula for a sandwich is two pieces of bread with something in the middle. The fillings, and maybe even the breads, change, but the formula never changes.

Every art form has its formal types; in music, for example, the sonnet, the symphony and the fugue. (Impressionist or cubist paintings are formal types.) Because formal types follow strict rules, they are difficult to fulfill with distinction. (An intrinsically beautiful pattern is usually an indicator of formal type.)

A Rembrandt that looks like a Rembrandt fulfills the requirements of formal type. When we recognize the fulfillment of a formal type, it adds for us another layer of beauty to the painting besides the beauty of its materials, its pattern, and its design.

Doesn't the fulfillment of a formal type result in formula painting? Yes, in one sense. Every good painting is a formula painting in the same way all good cooking is recipe cooking. A recipe is just a formula. Even if you don't follow the recipes in the cookbook, you still have to make them up.

But in the end, it's not the recipe that's important. It's what you do with it. Every portrait painter knows the formula for the full length portrait and follows it. (Picasso followed the same formula in his cubist portraits that Raphael did in his Renaissance portraits.)

A formal type is an aesthetic sandwich. Its fillings (subject matter) may be different, but the artist's pattern, conventions of drawing, and use of color are consistent. Despite differences in subject matter, his pictures look more alike than different. The artist with a consistent style imposes a similar look on all of his pictures, regardless of subject matter.

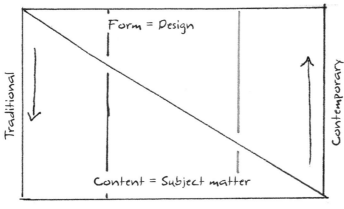

Form/Content Matrix:

Traditional → Contemporary

Form = Design

Content = Subject matter

A formal type is an organizing pattern that, having been found particularly successful, is used over and over again with different fillings—it's an aesthetic sandwich. When we recognize an artist's style or vision as consistent, we are acknowledging the fulfillment of formal type.

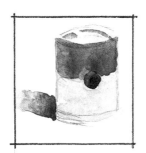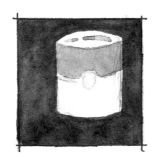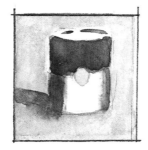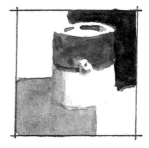

Similar subject matter, composition, pattern, and format serve to unify the display; contrasting colors provide variety. (Imagine the impact of a show of Monet's Haystacks.)

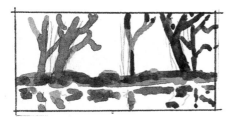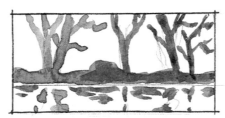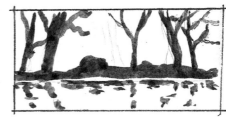

Similar subject matter, composition, color, and format unify the display. Contrasting patterns provide variety.

Different subject matter is unified with similar pattern, color, and format. Any work always looks better in a unified context. A show of, say, portraits will have more unity and the individual pieces will look better than if they were in a group show. Take one example from each row and you see the "group show" effect.

Using Type

Perfect fulfillment of type is life, not art. Nonfulfillment of type is the basis of all the arts. We expect a *painting* of an oak tree from an artist, not an actual tree. We don't want to see Fred Astaire run for the bus; we want to watch him dance. Our pleasure in the arts comes from the fulfillment of aesthetic conventions, which are actually negative types. If you don't have some aesthetic distance, you don't have art.

The more types you fulfill in your painting the better it will be. If you fulfill enough types as easy, or common types, the resulting painting may be that most difficult of all types: a fine painting.

Innate Standard Forms: Base your compostion on the innate standard shapes—the square, the triangle, or the circle; prefer the triangle. If you organize your composition with the square or rectangle, use the diagonal transfer (opposite page) to determine the relative size of the secondary rectangles. Base your volumes on the innate standard volumes—the cube, the cylinder, the cone, and the sphere.

Functional: A painting's function is to decorate a wall, therefore your painting has to look better than the wall upon which it hangs. And that's all; don't overwork it.

Technical: The painting should fulfill the technical requirements of skill in its use of materials and drawing to the best of your ability.

Formal: In the end, every good painting is a formula painting, or formal type. Three things make a formal type: the artist's choice of organizing pattern; the way he selects and represents his subject; and his use of color. Consistency in these is the hallmark of any individual's style.

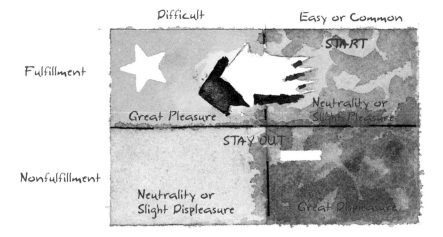

Difficult Easy or Common

START

Fulfillment

Great Pleasure Neutrality or Slight Pleasure

STAY OUT

Nonfulfillment

Neutrality or Slight Displeasure Great Displeasure

Fulfill the easy type first, then improve it to make it look like a difficult type. Avoid the common type.

Organize your painting using innate standard shapes—preferably the triangle.

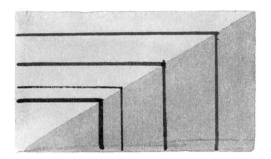

The Diagonal Transfer (Scaling). A vertical that intersects the diagonal and is, in turn, intersected by a horizontal generates a smaller rectangle which is in exact proportion to the larger rectangle. Painters use it to scale up their pattern schemes.

Functional Type: The painting should look at least as good as the wall on which it hangs—if not better.

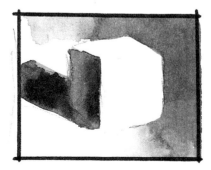
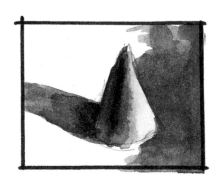
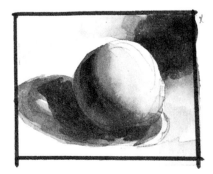

Formal Type: A successful organizing type and specific mode of seeing repeated with different fillings.

Emotion

Accurate portrayal of subject matter in painting may have been important before the camera was invented, but no longer. The camera reports the way something looked more accurately than any artist ever could. More important, then, is communicating something of how the artist felt about the subject.

But how can the painter be sure his spectator will have the intended emotional reaction to his painting? After all, emotion is subjective. You can't see it, touch it, or taste it. It's not like using color: if you put down an area of blue, you're confident that most viewers will see it as blue. However, it is possible, even easy, to communicate the emotion your subject prompted in you with almost the same certainty with which you can communicate line, color, or shape.

Before you can try to communicate an emotion, it's a good idea to know what constitutes an emotion. Emotions are classified as either sensory fusion, instinctive drives, or moods.

Sensory Fusion: Any time two or more things combine to affect one of the senses, it's a sensory fusion. A banana split is a sensory fusion. It is a combination of ice cream, sauce, and bananas. We can distinguish the taste of each element of the mixture, but the banana split has its own characteristic flavor.

Instinctive Drives: These are our basic human instincts. Drive emotions include hunger, thirst, sex, rest, nurturing, fright, etc. When we're cold, tired, and hungry, we experience a combination of drives, or compound drive emotions.

Moods: Moods are simple conditions, never fusions. There are two mood gradations: exciting to calm; strong to delicate. These two mood gradations can exist simultaneously.

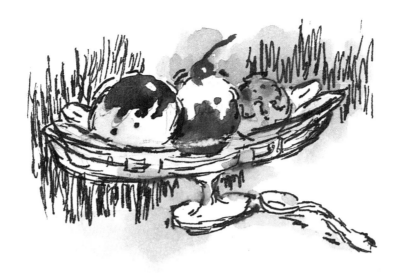

Sensory Fusion and Instinctive Drives

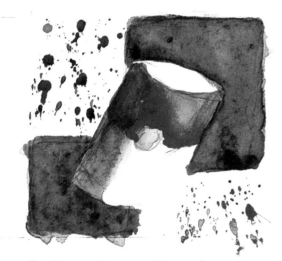

Exciting pattern, exciting color

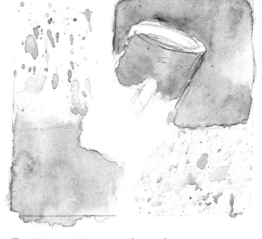

Exciting pattern, calm color

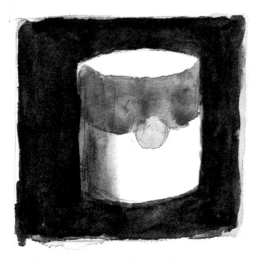

Calm pattern, exciting color

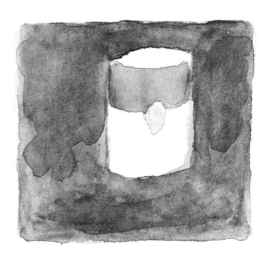

Calm pattern, calm color

<u>Linear Directional Signals:</u>

We read the direction of a line in relation to bodily line.

Horizontal=Repose, calm

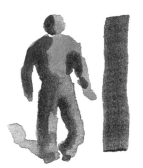

Vertical=Erect, dignified

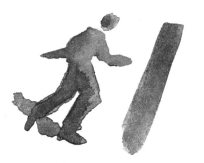

Oblique=Dynamic, movement

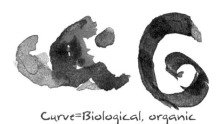

Curve=Biological, organic

Mood

When an artist paints a blue area, he is confident that someone looking at his picture will see the area as the blue he painted. Using certain aesthetic conventions, the artist can be almost as confident that he will be able to stimulate a mood in his viewer with the same precision that he can stimulate a sense quality like blue.

The exciting-to-calm gradation suggests those familiar opposites of style—painterly and linear. The painterly or romantic painter will most likely want his paintings to be exciting while the linear or classical painter will usually prefer that his paintings express calm.

Exciting	Calm
Bright colors	Grays and neutral colors
Diagonal or zigzag lines	Horizontals and gentle curves
Dissonances	Consonances
Complementary colors	Analogous colors
Complementary values	Analogous values
Extreme contrasts	Gradations
Rapid rhythms	Slow rhythms
Unbalance	Symmetry
Suspense	Regular fulfillment of type

The strong-to-delicate gradation suggests the familiar opposites of value—dark and light.

Strong	Delicate
Dark colors or values	Tints
Low key	High key
Broad, heavy lines	Narrow, light lines
Large masses	Small masses
Solidity	Thinness and lightness
Deliberate, impeded movement of rhythm or line	Floating, easy movement of rhythm or line

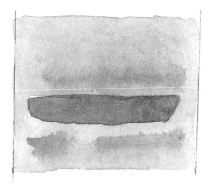

Exciting:
Zig zag lines
Contrast of complementary
 colors
Wide value contrast
Intense/neutral contrast
Strong contrast

In-between:
Curves make for slower rhythm
Hues and values are analogous
Red moves to purple; green to blue

Calm:
Horizontal lines
Cool monochromatic
Close values
Weak contrast

Exciting to Calm: a mood gradation

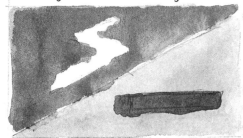

The gradation can be visualized as
a scale. There's a dominant mood
and a smaller, contrasting mood
balancing it.

Warms are exciting.
Cools are calm.

Intense colors are exciting.
Neutral colors are calm.

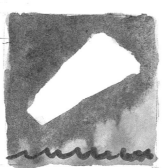

Obliques are exciting.
Horizontals are calm.

Rapid rhythms are exciting.
Long slow rhythms are calm.

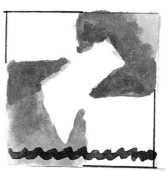

Assymetrical balance is
exciting. Regular fulfillment
of type is calm.

Suspense (closure) is exciting.
Regular fulfillment of type is
calm.

Principles
Emotion

Universal symbols include objects that have clear association with our responses to basic drives.

Ways to Stimulate Emotion

1. Direct stimulation (mood)
2. Emotional meaning (symbols)
3. Representation of emotional behavior
4. Expression of the artist's emotion through:
 a. Brushstrokes
 b. Emotionally dictated selection of, or suppression of, details
 c. Expressive distortion
 d. Breaks in pattern

We are not that much interested in what you say: we are more interested in how you say it; what interests us even more is how you feel.

Stimulating Emotion

There are four ways the visual artist can prompt an emotional response in his viewer. The first three are the devices of the objective artist. When the artist adds to these by expressing his own emotion in any or all of the four ways listed at left, he is considered an expressionist.

Direct Stimulation: When a painting expresses a mood, it stimulates the same mood in the spectator.

Emotional Meaning: When an object is universally associated with an emotion, it becomes a symbol for that emotion, much as the knife and fork represent food or eating.

Universal symbols also include things that ordinarily directly stimulate our basic drives, such as fear. If you are afraid of alligators, you may respond emotionally to Sargent's *Muddy Alligators* as if they were real alligators. When a viewer sees something in a picture that ordinarily provokes an emotional response in him, he will probably project that emotional response into the picture.

If an object that provokes an emotional response is universal, such as lightning, its emotional meaning is most likely to be universal. An artist can use such emotional meanings with considerable reliability, as Winslow Homer did in *The Gulf Stream*.

Representation of Emotional Behavior: We cry at weddings. We may also want to cry at the picture of a wedding. The most powerful stimulus to any emotion is seeing that emotion in others, provided we are open to it and don't shut ourselves off from it. We respond to the emotions portrayed with a sort of sympathetic vibration.

The Expressionist: When the artist emphasizes the emotional response his subject aroused in him or imposes his own emotional response on his subject, he is an expressionist. The expressionist has four aesthetic conventions available to him in addition to those used by the objective artist.

82

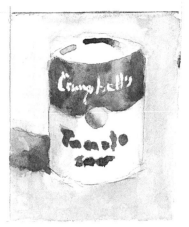

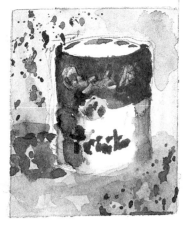

Any time the brushwork is obvious, as in impasto, wet-in-wet, or a heavily textured surface, it signifies an expressionist painting.

Explore the expressive posibilities of body language with matchstick figures. Develop them as elaborately as you wish.

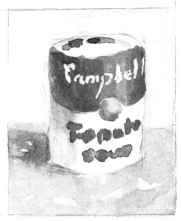

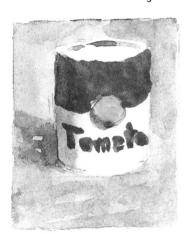

Making a painting always means selecting some things and ignoring others in the motif. When the selection of details to be included, or obviously suppressed, is emotionally dictated, the artist is an expressionist.

The figure on the left is attracted to the figure in the center. The figure on the right could care less about the other two figures. In figure groups interval makes a difference in the expression.

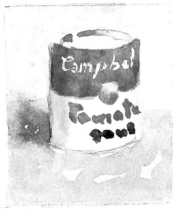

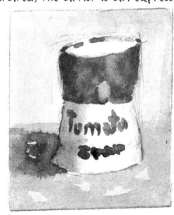

When the artist deliberately distorts his drawing for expressive purposes, as in El Greco's figures, the artist is an expressionist.

The figure on the right seems to hurry away from the figure on the left, which follows at a more leisurely pace.

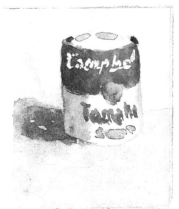

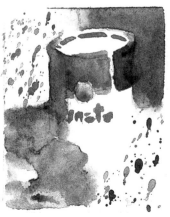

When the artist relies on closure with open shapes and broken or implied lines, he is an expressionist.

Principles
Emotion

With the sense of sight the idea communicates the emotion, whereas, with sound, the emotion communicates the idea, which is more direct and therefore more powerful.

—Alfred North Whitehead

All the bystanders at an event worthy of note adopt various gestures of admiration when contemplating the occurrence.

—Leonardo da Vinci

We become painters in order to express something we can't express in words, gestures, or sound. Otherwise, we would write, dance, or make music. That original need is more to express something of what we felt to others than to explain to them what we saw.

As the artist concentrates on improving his skills, it is easy to get sidetracked and lose sight of the original purpose—to communicate an emotion or feeling. Two questions should be uppermost in the artist's mind when he paints:
(1) Will it look good on the wall? That is, does it fulfill the functional type of a painting?
(2) Does it communicate an emotion, feeling, or mood? When a painting does these two things, it fulfills the minimum requirements for a good painting.

Organizing Emotion

Design principles organize every aspect of a picture, including emotion. When two or more emotions are embedded in a painting, the artist organizes them using one of four principles: contrast, gradation, dominant emotion, or natural emotional sequence.

Contrast: Emotional contrast is easy to identify in the performing arts. In drama there are good guys and bad guys. Still, many paintings contain considerable emotional contrast. Emotional contrast, like any other contrast, wards off monotony and makes the experience more vivid, more dramatic.

Gradation: In a work of art, an emotional climax is almost always a gradational climax. For example, mood can build across a painting through gradation of line, value, or color temperature.

Dominant Emotion: Dominant emotion is a variety of theme and variations, since each response to the dominant emotional stimulus is a variation on the emotional theme. It's what Leonardo meant when he said that everyone in the crowd should respond to the major event. (His *Last Supper* is an example.) With a dominant emotional stimulus, all the emotions are organized so that everything points to a single mood or instinctive-drive emotion. As in any composition based on dominance, every part of the design echoes and reechoes every other part. Like any dominant element, dominant emotion is almost powerful enough to unify a work of art by itself.

Natural Emotional Sequence: The emotions naturally follow one another in a story or in real life. This is more often used in the performing arts than in painting. We recognize a situation or a mood and the different emotions it can provoke. As long as we empathize with what we see, we genuinely feel the same emotion.

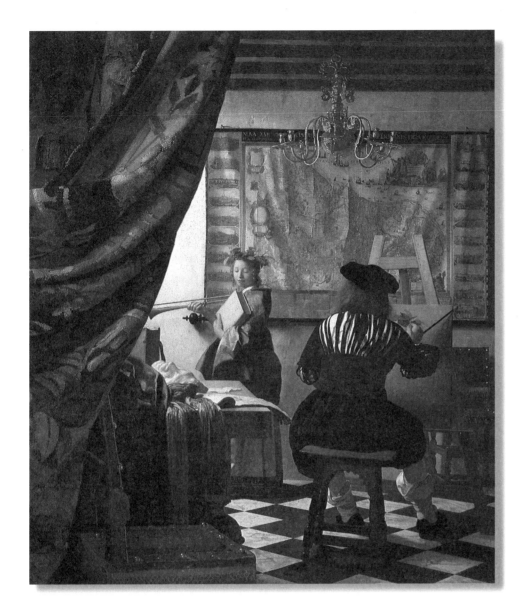

Vermeer is the prototypical objective artist. Here we know precisely how the interior of Vermeer's studio looked; even more important, we know how he felt about it. He uses extreme contrasts of value to directly stimulate a mood of strength and then reinforces it by repeating the architecturally stable horizontals and verticals. Warm neutrals dominate, giving the room and the painting a cozy feeling. The mundane paraphernalia of everyday life further signals the calm mood the artist wishes to instill in us. Even the restrained gestures of his figures project a feeling of strength and calm.

Van Gogh is another story entirely. Here we feel a very different mood and a very different personality at work. It's more important to an expressionist like Van Gogh that you know how he felt about his bedroom than how it looked. Even in reproduction, his brushwork and heavy impasto directly communicate the powerful feeling he held for this little room. He deliberately distorts his drawing, selects details, and breaks the line and pattern to heighten the emotional emphasis. In the Van Gogh, unlike the Vermeer, you don't have to read between the lines to know how the artist felt and to understand him.

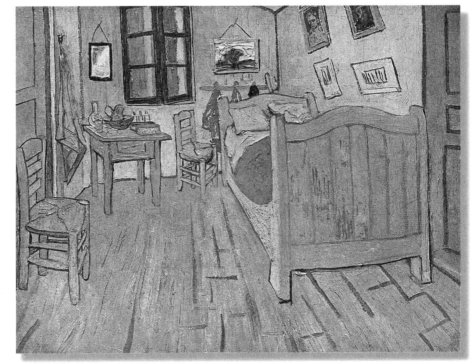

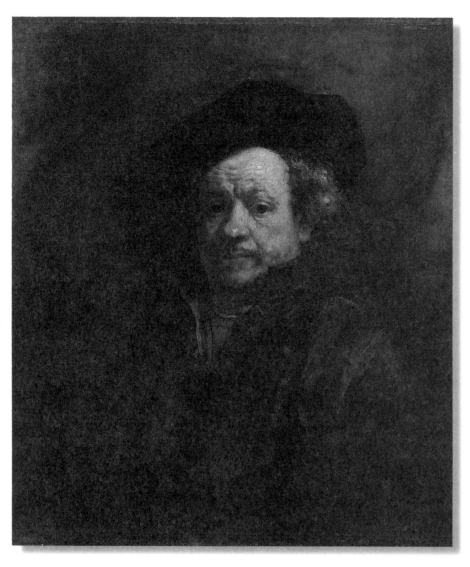

One of these self-portraits is painterly; one, linear. Both are objective. Which do you prefer?

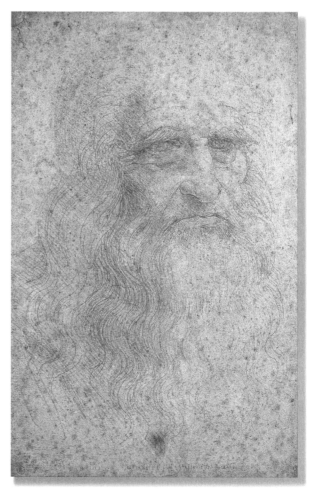

- Color
- Line
- Mass
- Volume

Materials

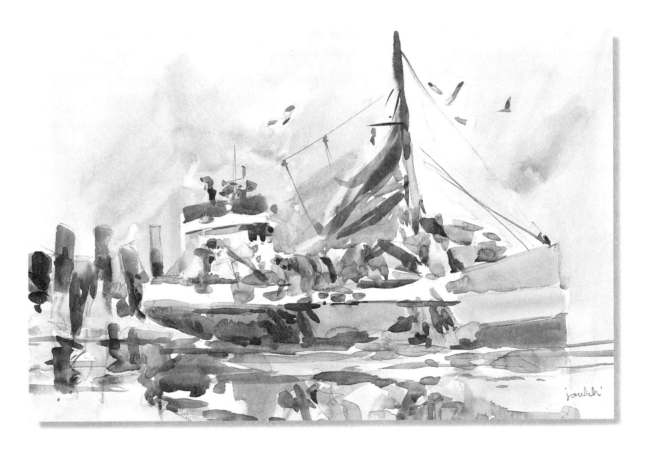

The painter's line is an edge.

—André L'Hote

To paint well is simply this: to put the right color in the right place.

—Paul Klee

Color

These colors are visual complements.
They are sometimes called the
physiological, or true, complements.

Red: Blue-Green

Yellow: Blue

Green: Purple

Everyone loves color. But everyone seems to have a problem with color. It doesn't have to be that way; despite what you may have heard, you don't have to be born a colorist to use color well.

Psychological Primaries: You learned that there are only three primary colors—red, yellow, and blue—and that was correct as far as it went. Red, yellow, and blue are the chemical primaries. They are the only colors the paint chemist cannot mix and the only colors you need to buy to create the full range of colors. But red, yellow, blue, and green are the psychological primaries. When you explain that orange is a mixture of red and yellow, most people can see the two colors in the orange. That's also true for purple, a mixture of red and blue. But, although green is a mixture of yellow and blue, most people see it as a separate color. Even if they know green is made up of blue and yellow, they don't see the ingredients; they see the color as green.

Visual Complements: You learned that complementary colors are opposites, and that the complement of a primary color is mixed from the other two chemical primaries. This is true for the paint chemist, but not for the artist.

Green is not the complement of red, purple is not the complement of yellow, and orange is not the complement of blue. For most people, blue is the visual complement of yellow. Most people perceive the visual complements as: yellow/blue; red/blue-green; green/purple. You can prove this to yourself by conducting the simple experiments on the opposite page.

Trust the evidence of your own eyes and use the complementary pairs that are true to your vision when you paint.

<u>Successive Contrast:</u> Stare at the colored square for a time, then quickly look away to the plain gray square. When you stare at a color, the afterimage is always the visual or physiological complement, which does not correspond to the chemical complement. The visual complement of yellow is blue for most people, not purple.

<u>Simultaneous Contrast:</u> Look again at the color areas and this time pay attention to the edges of the squares. For most people, a bluish halo seems to develop around the yellow square. It's another familiar visual experience, called halation. Painters use it to intensify colors, to bridge two colors and to generate space. Simultaneous contrast is the effect of two adjacent colors on each other. For example, yellow looks more orange next to green and greenish next to orange.

Materials
Color

The untrained eye can distinguish 17,000 different colors; the trained eye, 27,000.

—Rex Brandt

Any ground subtracts its own hue from the colors which it carries.

—Josef Albers

Color Notation: On reference sketches put color notation in a circle. Use letters as shorthand for the name of the hue.

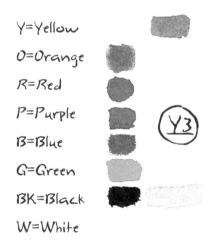

Y=Yellow

O=Orange

R=Red

P=Purple

B=Blue

G=Green

BK=Black

W=White

If a hue has more than one component, the last color named is the mixture's dominant color, the family name. If you tell me a color is blue-green, it has more green in it than blue. BG=more green than blue. GB=more blue than green. Brown is neutralized yellow. Grays are lighter values of black. Value:
White 0 - - - - - - - - - - - - 10 Black
Intensity:
Y underscore for intense

Y overscore for neutral

90

Basic Characteristics

Color has three basic properties: hue, value, and intensity.

Hue is the name of the color: yellow, orange, red, purple, blue, or green. Blue, green, and purple are considered cool colors because we associate them with cold things; red, yellow, and orange are warm because we associate them with warm things.

Value is simply how light or dark the hue is. Most neutrals, like ivory black, lamp black, Payne's gray, and neutral tint, come out of the tube dark. Cool colors and the reds usually start as middle values. Oranges and yellows are light. To make a value lighter, add white to oil colors; add water to transparent watercolors. To make a value darker, add the complement or a darker color.

Intensity is the relative brilliance or dullness of the hue. A color is never more intense than when it first comes out of the tube. Neutralize colors by adding the complement.

Intensity, hue, and value are independent of one another. Any hue can be light, midtone, or dark. Any hue can be intense or neutral. A painting that uses only one hue is considered monochromatic although it may use several values and intensities.

Color in Nature and Paint

The average person can see about 17,000 different colors. But there are only about 130 different artists' colors sold, so even if you had a tube of every color manufactured, you still couldn't duplicate the range of colors you see in nature.

That's also true for value. The darkest dark you see in nature is very much darker than the darkest pigment you can buy. The darkest black paint is about equivalent to a midtone in nature, and the most brilliant white at your command is darker than most of the light values in nature.

Since it's impossible to duplicate in paint the range of hues, values, and intensities found in nature, the artist uses his color to stand for a color in nature.

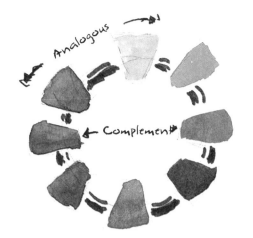

Complementary colors lie <u>opposite</u> each other on the color circle. <u>Analogous colors</u> lie <u>next</u> to each other on the color circle.

<u>Simultaneous contrast of hue:</u> The reds are identical.

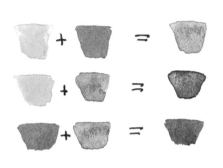

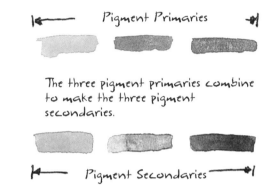

The three pigment primaries combine to make the three pigment secondaries.

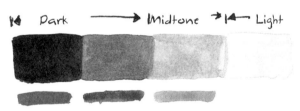

Sometimes hue makes it difficult to see the values. A little color chart in which you duplicate each of the values with hue can help.

<u>Simultaneous contrast of value:</u> The white paper appears more brilliant against the dark background.

<u>Simultaneous contrast of hue:</u> Yellow surrounded by green is forced toward the orange; surrounded by orange, toward the green.

A color is forced away from its adjacent hue toward the adjacent hue on the other side.

<u>Simultaneous contrast of intensity:</u> Yellow ochre appears more brilliant against the neutral background.

Never use too many values
in a picture.

 —Donald Graham

We see the lights; feel the darks.

 —Rex Brandt

Put a strong dark in early, near
your center of interest, to serve
as a value scale. Nothing can be
darker.

 —Tom Lynch

Learn to see in three values. Make a
little three-value scale and carry it
around with you for a week or so
comparing the lights, darks, and
midtones you see in nature to the
lights, darks, and midtones on your
card. Among the things you'll discover
is that the darks you see are much
darker than any dark you can paint.
It won't take long before you're seeing
in three values and you can throw
away the card.

#2

#6

The Three-Value System

Since you can't duplicate the range and subtlety of the values you see in nature, you must reduce the values you see in nature to a number that you can control and that your viewer can easily read.

Just how many is that? The minimum is two, black and white. The two-value system is often called notan, which means the pattern of shade and shadow, gripping darks, and dark local values. Five values is about the maximum.

But let's start somewhere in between, with three values. A three-value system is closer to vision than notan, and it seems more realistic. It is still easy to control and the viewer will find it both interesting and understandable.

In the three-value system, you see and record nature as three values: light, dark, and midtone. Use any middle-value pigment as your dark. (Save black for accents and details within the dark pattern.) Use any light-value pigment as your midtone and pure white paint or paper as your lights.

Value Areas: A useful formula for determining how much midtone, dark, and light to use derives from the Golden Section. Put simply, it suggests that about 60 percent of the painting's total area should be in the midtone, 25 percent either light or dark, and the remaining 15 percent in the remaining value (either light or dark).

If most of the painting is in the midtones and lights, it is a high-key painting. If most of the painting is in the midtones and darks, it is a low-key painting.

It's always easier to make a value darker than to make it lighter, so if you can't decide whether a value is a midtone or a dark, make it a midtone. If you can't decide between a midtone or a light, make it a light; you can always darken it later.

Once you start to see nature as three values, you'll realize that often the value of the object and part of the background are the same. It's called a passage, or lost edge, and it occurs in any value.

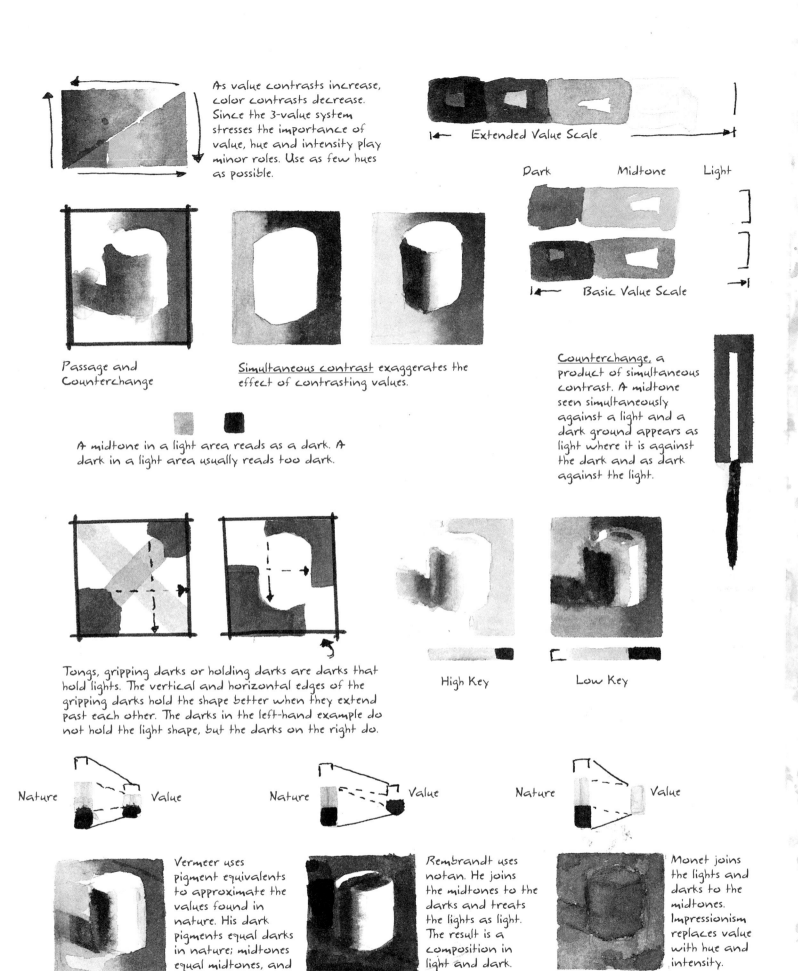

As value contrasts increase, color contrasts decrease. Since the 3-value system stresses the importance of value, hue and intensity play minor roles. Use as few hues as possible.

Extended Value Scale

Dark Midtone Light

Basic Value Scale

Passage and Counterchange

Simultaneous contrast exaggerates the effect of contrasting values.

Counterchange, a product of simultaneous contrast. A midtone seen simultaneously against a light and a dark ground appears as light where it is against the dark and as dark against the light.

A midtone in a light area reads as a dark. A dark in a light area usually reads too dark.

Tongs, gripping darks or holding darks are darks that hold lights. The vertical and horizontal edges of the gripping darks hold the shape better when they extend past each other. The darks in the left-hand example do not hold the light shape, but the darks on the right do.

High Key Low Key

Nature Value Nature Value Nature Value

Value Scales

Vermeer uses pigment equivalents to approximate the values found in nature. His dark pigments equal darks in nature; midtones equal midtones, and lights equal lights.

Rembrandt uses notan. He joins the midtones to the darks and treats the lights as light. The result is a composition in light and dark.

Monet joins the lights and darks to the midtones. Impressionism replaces value with hue and intensity.

The aesthetic conventions by which artists "see" values in terms of pigment.

Materials
Color

White
#1
#2
#3
#4
#5
#6
#7
#8
Black

Relative Clarity

Given the limitations of pigment, some loss of clarity is inevitable. Also the human eye, like the camera, can only distinguish value differences in either the lights or the darks at one time—not both. So the artist must choose where he wishes to be clear and where he wishes to be unclear.

In what appear to be equal value steps from light to dark, the steps are far from even. For instance, you would expect a 50-percent value to absorb half the light and reflect the other half. That's not the case, however. A 50-percent value absorbs almost all the light and reflects only a small percentage of it. The 50-percent value is actually closer to 90 percent. That's why it's so difficult to achieve clarity among the darks.

We are color-blind in the darks. There is only a difference of 2 percent in value between a #8 gray and a black, so little that the eye cannot distinguish between them.

Burnt sienna from the tube is a #5 value. Even though it is the midpoint on the value scale, burnt sienna absorbs 85 percent more light than white. It is truly a dark. Yellow ochre is a #3 value. It is about 40 percent darker than white and 40 percent lighter than burnt sienna. The values of white, yellow ochre, and burnt sienna not only read clearly as lights, darks and midtones, but they meet the requirements of the 40 Percent Rule, which says you must paint the shade side of any light object 40 percent darker than the lit side, regardless of how dark or light it appears in nature, to make the form look solid in the painting.

Once your painting is blocked in and you start to refine it, it's easy enough to extend the three values to five. A strong dark like black will still read against the #5 dark if you need it.

Local value, or body tone, is a midtone.

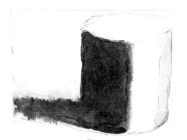

When light splits an object into two values (light and dark), and you can discriminate two values within the light area, the dark area remains only one value.

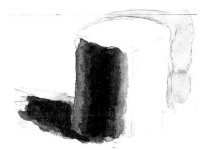

Similarly, if you can discriminate two values in the dark area, the light area registers as only one value, like an overexposed photograph.

Discrimination among the dark values is more difficult than discrimination among the light values. With each succeeding layer of paint, the painting reflects less light.

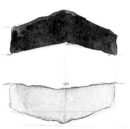

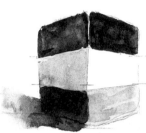

When an object has three local values (light, midtone, and dark), the shade side of the light area becomes midtone and the shade side of the midtone area becomes dark. The dark area is explained with a highlight where the plane changes.

Similarly, if the dark area is reported as midtone in the light side, the light area reads as one value and the midtone area joins the light area.

Value	Light Absorbed	Light Reflected
White		
1 Gray (10%)	27%	73%
2 Gray (20%)	46%	54%
3 Gray (30%)	61%	39%
4 Gray (40%)	73%	27%
5 Gray (50%)	82%	18%
6 Gray (60%)	11%	11%
7 Gray (70%)	6%	6%
8 Gray (80%)	3%	3%
Black	1%	1%

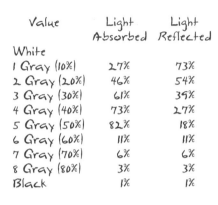

A light can be seen only against dark.

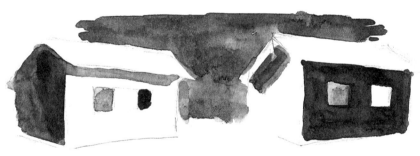

Use either dark spots in light areas or light spots in dark areas (but not both) for details on an object. If you use dark details in the light areas, use a midtone. Choose a midtone over a light in dark areas.

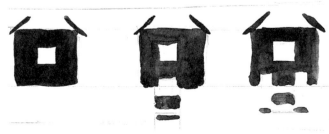

<u>Optical Pull:</u> One solution to the problem of an overly aggressive spot is optical pull. This is done by creating other shapes that clearly relate to the aggressive shape along the extensions of that shape's borders; in other words, line them up.

<u>Double-Duty Darks:</u> When a dark shape represents a positive (a thing) and, at the same time, holds or defines an overlapping light positive, the dark does double duty.

It is the eye of ignorance that assigns a fixed and unchangeable color to every object; beware of this stumbling block.

—Paul Gauguin

A predominantly warm-toned painting will outsell a cool one, two to one.

—Dalzell Hatfield

The use of color distinguishes painting from drawing.
If a painting is about color, then the whole art of painting is found in simultaneous contrast, the mutual effect two adjacent colors exert on each other.
A hue, value, or intensity subtracts itself from the hue, value, or intensity which is next to it.

—The Law of Simultaneous Contrast

Flat

Color Quality

Secondary Characteristics

Color Quality: This is the effect of two or more colors reflected from the same surface. Of all the properties of color, color quality is the most appealing to the senses.

Color quality brings color to life and makes it look rich. If you weave a piece of cloth using only gray thread, the cloth will look gray. If you weave it with white thread in one direction and black in the other, the result will also be a gray cloth, but a different gray from the first cloth. The second piece of cloth will have color quality—an intermingling that falls somewhere between a plain color and a checkerboard-like combination of distinct patches of color.

Apparent Temperature: Each hue carries an expressive emotional weight; reds, oranges, and yellows appear warm while blues and greens seem cool. Actual warmth carries many emotional connotations, like fire, comfort, friendship, and love, and warm colors express these emotional associations with extraordinary immediacy. Cool colors express rest, calm, and dignity. The opposition of warm to cool offers another means of increasing the contrast of hue, value, and intensity.

Apparent Distance: In general, warm colors appear to come forward while cool colors seem to recede. However, if the edges are hard, the cool comes forward because it reads as a figure overlapping a ground. If the edges are blended, a cool on a warm surface clearly recedes. These effects of apparent distance are not all that strong and they are easily overcome with other visual clues showing that one surface is in front of another.

Apparent Weight: Roughly speaking, the darker a color appears, the heavier it feels. Weight has two main uses; for balance, and to express the moods of delicacy and strength. The darker, heavier colors express strength while lighter colors or tints express delicacy.

No →

No →

Color quality, the effect of two colors simultaneously reflecting from an apparently monochromatic surface, may be the most important aesthetic characteristic of color because it engages the viewer and provides more visual interest than value, hue, or intensity alone.

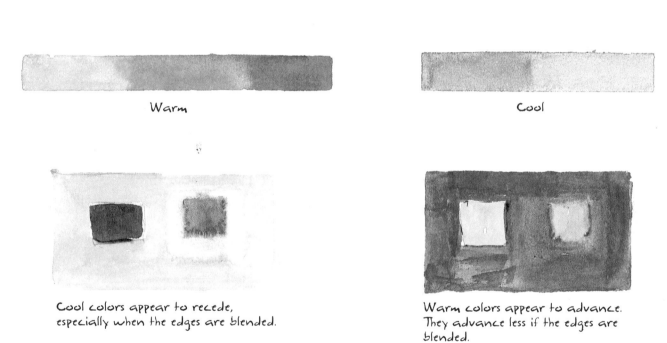

Warm

Cool

Cool colors appear to recede, especially when the edges are blended.

Warm colors appear to advance. They advance less if the edges are blended.

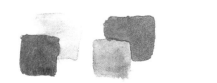

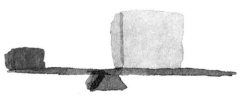

Cools don't always recede, and warms don't always advance.

Dark colors are heavier than light colors or tints. A small dark balances a large light.

Painting is completely and entirely a matter of relationships—and nothing else.
—Ed Whitney

Simultaneous contrast is not just a curious optical phenomenon—it is the very heart of painting. Repeated experiments with adjacent colors will show that any ground subtracts its own hue from the colors which it carries and therefore influences. For a proper comparison, we must see them (the two spots to be compared) simultaneously, not alternately. The latter way, a repeated looking back and forth, produces changing and disturbing afterimages, which make a comparison under equal conditions impossible. For simultaneous comparison, therefore, we must focus at a center between the two rectangles and for a sufficient length of time.

—Josef Albers

Strong Weak

Color Relationships

Every relationship in a painting is an adjacent relationship. Every color lies flat on the picture plane next to another color, no matter how convincing the illusion of three dimensions may be. The relationship reads horizontally across the picture plane and vertically up and down the picture plane. The spatial relationship between two areas is ambiguous. We don't really know which is in front and which is behind.

Simultaneous Contrast: If you put a true green next to a true yellow both colors are affected. Not one, but two shifts take place along the edge. Neither color reads as true where they are next to each other. The green subtracts itself from the yellow. Thus, even though the yellow is a true yellow, it appears more orange when it is next to a green and more green when it is next to an orange.

The effect of the simultaneous contrast can be emphasized by exaggerating the shift; or the colors can be made to appear true by shifting them closer to the adjacent color. To make a true yellow next to a green appear as a true yellow, you must add a little green to the yellow at the point of tangency to compensate for the effect of the simultaneous contrast.

Overlap Relationships: One color or area seems to be in front of another. We read the overlapping color as partially blocking our view of the color it overlaps. Therefore we read the overlapping color as closer to us. Despite the illusion of depth, the two colors are next to each other on the picture plane.

Mutual Transparency: This is the result of glazing a transparent color over part of another color area. The two colors mix optically to create a third color area.

When two positives are separated by a negative area, the negative area creates an interval between the two positives. The width of the negative area, or interval, determines the strength of the relationship, or attraction, between the two positives.

The circle and the square have a tangential or adjacent relationship. We read them horizontally across the picture plane, not from front to back in the depth of the picture box. The two colors below also have a tangential relationship to each other.

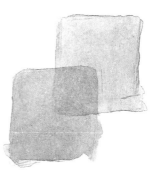

Overlap relationships read from front to back in the (imaginary) depth of the picture box. The spatial relationship between the two color areas is clear.

Where the red and the blue overlap each other, they are mutually transparent. We cannot be sure if the red overlaps the blue or the blue overlaps the red. Space is ambiguous.

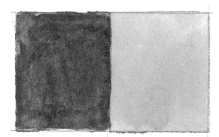

Interval Relationships: The interval between two positives is the negative space between them. The less the negative space between any two positives, the stronger the relationship between them.

The analogous colors are pure. Where the green meets the yellow, the yellow appears orangish, and the green, bluish.

Simultaneous Contrast

Here the center has been adjusted to emphasize the effect of simultaneous contrast. Where the green meets the blue, it becomes yellowish and the blue turns a little purplish. However, both the yellow and the blue are pure colors straight from the tube.

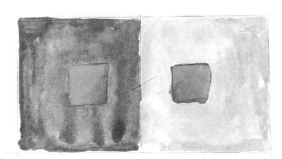

The two greens look different, but they are the same.

The green of the center area remains uniform, but the effect of simultaneous contrast on either side is minimized. The yellow becomes greenish, as does the blue.

The green of the center area remains uniform, but the effect of simultaneous contrast on either side is maximized. The yellow goes toward the orange, and the blue toward the purple.

The effect of simultaneous contrast is emphasized throughout. The center and the surrounding colors shift to heighten the contrast.

The two greens look the same, but they are quite different. They have been adjusted to account for the effect of simultaneous contrast.

As our art is not a divine gift, so neither is it a mechanical trade. Its foundations are laid in solid science; and practice, though essential to perfection, can never attain that to which it aims unless it works under the direction of principle.

— Sir Joshua Reynolds

Color is one of the forms of radiant energy and a portion of the electromagnetic spectrum.

— Maitland Graves

The public prefers its color organized in the following order:
Contrast: Complementary Color
Gradation: Analogous Color
Tone: Monochromatic Color

Red:Blue-Green
1:1

Green:Purple
2:3

Yellow:Blue
1:3

Balance and Organization

Colors are balanced when they are used in the same proportion as when mixed to produce a neutral gray.

According to Johannes Itten's *The Art of Color*, each pair of chemical complements takes up one third of the color wheel's 360 degrees. Balanced or neutral color results from mixing red and green in equal parts. However, you need twice as much blue as orange for balanced color, and three times as much purple as yellow to achieve a neutral.

The point is that some colors, like yellow, may be dominant and yet take up less than half of the painting's area while others, like blue, need much more than 50 percent of the area to dominate a composition.

Organization: The main ways to organize color are the three familiar design principles:

1. Contrast (complementary colors)
2. Gradation (analogous colors)
3. Theme and variations (monochromatic)

Contrasting color, always a complementary color scheme, is the simplest and most basic way to organize color. It is also the most emphatic and potentially the most exciting. Its weakness is that if you use too many contrasting colors, the result is confusion, not organization. However, a strong organizing pattern usually controls many areas of complementary color.

Many simple compositions based on contrast use large areas of intense color. Busier compositions need quieter color schemes featuring closely related colors and neutrals.

Gradation organizes the color along a line in spectrum order. The minimum requirement for any line is three distinct, analogous colors.

The most sophisticated and creative color scheme is also the easiest to master; it's the monochromatic color scheme. Nature is anything but monochromatic, so when you restrict yourself to one color, you are automatically creative. Another advantage of this color organization is that it ensures the painting's color unity.

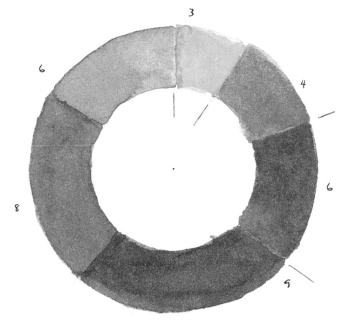

3

6

4

6

8

9

Balanced color

A pair of complementary colors are balanced when they add up to 12 (120°), or one third of the color circle.

A fairly small increase in the proportion of one color beyond the balancing amount will allow that color to dominate.

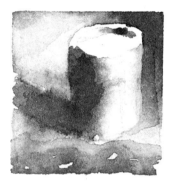

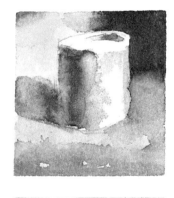

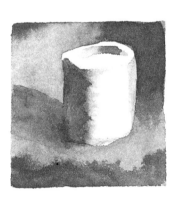

Complementary (Contrast)

Analogous (Gradation)

Monochromatic
(Theme and variations)

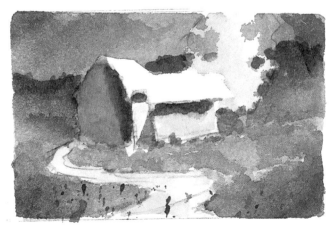

Y:P 1:3
1*:3-=Yellow dominant

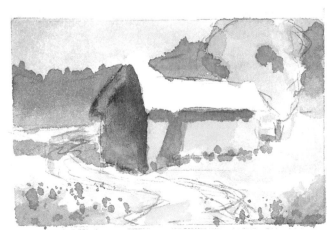

Y:B 3:8
4:8=Yellow dominant

As a spokesman for what the eye perceives, the painter must adopt a single viewpoint within which his pigments function. It comes as something of a surprise just how restricted this limitation is in most masterworks, whether Rembrandt or Matisse, Giotto or Picasso. The painter singles out which manifestation of color is best suited to his statement and then subordinates all others to it. We will accept a very limited color concept as long as it is consistent.

—Rex Brandt

Green trees, blue skies, red barns, and golden fields grow tiresome very quickly.

—Robert E. Wood

All color is no color.

—Kenneth Clark

Color Preferences

Gender: Women prefer red; men, blue. Women's second choice is blue, men's red. Next come purple, green, orange, and yellow.

Age: Children prefer intense primaries; older people, muted colors.

Education: The more educated viewer will prefer muted hues; the less educated viewer usually prefers more intense hues.

Seven Ways to Use Color

No doubt there are more than seven ways, but this list of Rex Brandt's will keep a painter busy for a lifetime.

Color Preferences: Decide who your viewer will be and choose your colors accordingly.

Local Color: The apple is red. The grass is green. Color is used only for identification of objects and areas, and is the least creative way to use color.

Space and Atmosphere: Color helps us read the painting from back to front as space in the picture plane. This is also impressionist color.

Emphasis: One color stands out and calls attention to itself against its background. In interior decorating, it's called an "accent color."

Emotion or Expression: The Fauvist and expressionist use of color is mainly for its emotional or decorative effect. Their color expresses what the subject felt like to the artist.

Rhythm and Motion: Color repeated at rhythmic intervals gives the painting a beat, like the beat in music.

Formal: When an artist chooses to work with a limited palette, his continuing use of that palette becomes the fulfillment of a formal type.

Open and Closed Color

You think of an apple and a lemon as having definite boundaries. They are two separate objects and so you paint the apple red and the lemon yellow. The result, closed color, often looks like a coloring book—it's not true to vision.

When the color spills over the edges of the forms, it is open color. Open color results in the "lost and found" edges that give softness to the forms and variety to the edges, permit a gradational flow of color across the forms, and give a painting its sense of air. Open color is closer to human vision than closed color. Open color reaches its high point, free color, when the color bears *no* relationship to the forms, as in the work of Raoul Dufy.

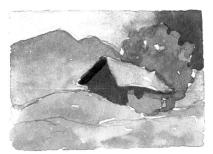

Local Color

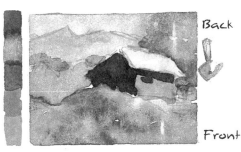

Space and Atmosphere.

Side Side
Back
Front

Light

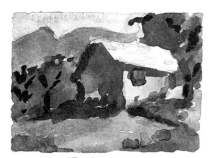

Emphasis

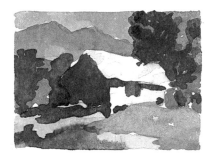

Emotional or Expressionist

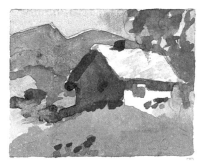

Rhythm and Motion

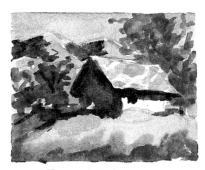

Formal Color

Yellow Ochre/Ivory Black, a favorite palette of West Coast watercolorist, Phil Dike.

Ultramarine Blue/Burnt Sienna

A traditional and very useful two-color palette

Yellow Ochre

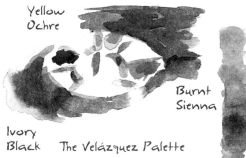

Burnt Sienna

Ivory Black The Velázquez Palette

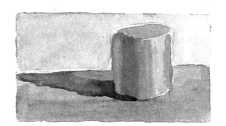

This palette contains five colors. Within it are the two-color palettes and the Velázquez palette cited above. This palette yields at least three other schemes or palettes:

Ultramarine Blue, Yellow Ochre, Burnt Sienna

Ivory Black, Yellow Ochre, Alizarin Crimson

Alizarin Crimson, Yellow Ochre, Ultramarine Blue

Closed Color

Open Color

"Free" Color

103

Scientifically, line is the distance between two points. To the artist, line is the measure of the shapes which are his language.
—Rex Brandt

You can only learn to paint by drawing, for drawing is a way of reserving a place for color in advance.

— André L'Hote

I had two instructors, both of whom loved telephone poles. One painted both the poles and the wires: He used the draftsman's line. The other painted only the poles. He let the crosspieces of his telephone poles create two points with a relatively clear space between them. He knew that when you looked at his painting you'd see the wires as clearly as if he had drawn them with a draftsman's line.

Line

You don't always have to draw a line, but you can't avoid creating a line. The accuracy of your line doesn't matter that much, but how you use it does.

Generating a Line

There are more ways to generate a line than just drawing it:

Closure: Even if we don't see all of it, we insist on seeing a thing as complete. Although we may not be aware that we're doing it, our minds provide the missing parts. It's called closure, and it's the reason a lost line is never really lost; the viewer always finds it. For example, a pair of converging lines always complete themselves in an angle even if the lines don't meet.

Any Break in a Line: The coupon in an advertisement is set off from the rest of the ad by a broken line. The advertiser hopes that you will be compelled to complete the line by cutting it out. It works the same way in painting: A break in a line creates closure.

Relatively Clear Space: Any two interesting points with a relatively clear space between them will generate a line as long as both points lie in the field of vision. "Relatively clear" means the two points are more interesting than anything that's between them.

Center of Gravity: When the forms in a painting have a strong three-dimensional quality, we feel the centers of gravity inside them. Implied lines seem to develop between these centers of gravity.

Boundary: Any time you see the edge of something clearly against something else, it is a boundary line. The difference between the two areas may be anything: value, hue, intensity, texture, etc.

Explicit Lines: The draftsman's line is unique because it is the only line that has width, quality, and intensity.

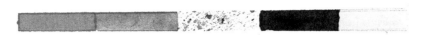

Dots generate a square on the left and a triangle on the right, as well as a base line connecting the two figures.

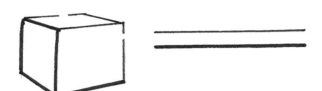

A boundary line results where two clearly different areas meet.

Only the draftsman's line is characterized by width, quality, and intensity.

Any pair of interesting points with a relatively clear space between them generates a line.

Any break in a line may be a terminus, a point of intersection, or a meeting of two lines.

Closure: A pair of converging lines completes an angle even though there is no terminus point.

 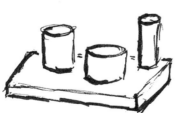

The path between the imagined center of gravity of two forms creates a line. (The forms may be two- or three-dimensional.)

Lines may be conventions, such as the Oriental one of parallel, oblique lines for rain.

A point moving in space, like a shooting star or a rocket, also generates a line.

 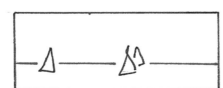 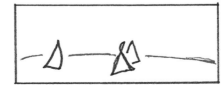

The Planetary Horizontal: Because the earth is curved, the horizon may be represented as a subtle curve. This can be a useful convention when painting the sea, desert, or prairie.

The characteristic movement of a graphic line is progressive.
—Donald Graham

Basic Characteristics of Line

Length

Attitude (degree of variation from the horizontal)

Amount of Curvature

A curve may be horizontal, vertical, or oblique depending on the relationship between its two ends, or termini.

The Language of Line

Some lines and their arrangements seem to communicate the same ideas to everyone regardless of cultural differences. These associations are important to the painter because they determine how the viewer will react to the painting.

Apparent movement along a line is the feeling of following the course of a line: Our eye seems to travel around the outside contour of a form. Movement along a line directs the viewer's attention where the painter wants it.

At times the line itself seems to move. With a drawing of something that's ordinarily in motion, such as waterfalls, clouds, surf, or even growing plants, the eye may move along the line; but it's the line itself that seems to move the way the object does.

The front of any object always leads it in that direction. So while it's easy to draw a car moving forward, it's almost impossible to draw one backing up. The curved lines of such objects as windblown trees, smoke, drifting clouds or sails suggest movement in a specific direction and they lend energy to the painting.

An oblique line seems to move in the direction it leans; a curve seems to move in the direction of its bulge; an angle seems to move toward its apex; and a vertical seems to move up or down, depending on whether you imagine it as being above or below a ground level.

Since Westerners read type from left to right, we tend to study paintings (if there are no other directional cues) from left to right. For us, movement of the lines in a painting from right to left will slow the reading while movement from left to right will speed it.

Linear themes create an underlying grid for the painting and set out the theme on which the painter will play his variations. Several well-known linear themes that have proven successful for painters over the centuries are shown at the bottom of the opposite page.

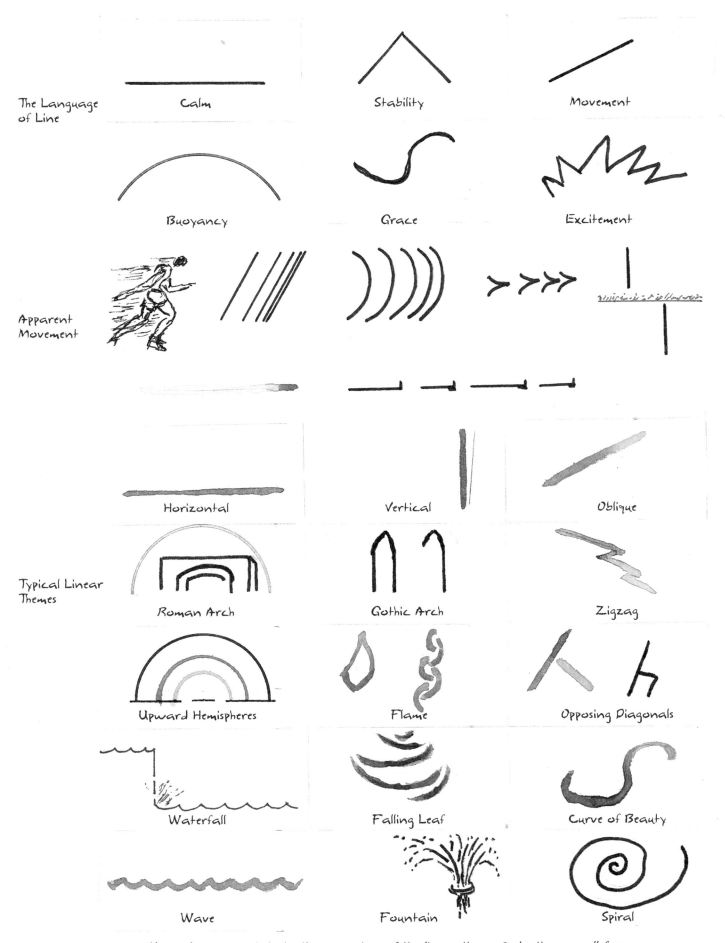

The Language of Line

Calm

Stability

Movement

Buoyancy

Grace

Excitement

Apparent Movement

Horizontal

Vertical

Oblique

Typical Linear Themes

Roman Arch

Gothic Arch

Zigzag

Upward Hemispheres

Flame

Opposing Diagonals

Waterfall

Falling Leaf

Curve of Beauty

Wave

Fountain

Spiral

Use color appropriate to the expression of the linear theme. Calm themes call for calm color; exciting themes for exciting color, and themes of movement for gradation of color. (After Watkins)

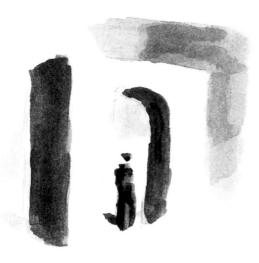

How do you paint something that's invisible? How do you create a lost edge and where does it belong?

The human eye is a marvelous instrument! Just give it the right clues and it will build up the whole form that it knows is there. When you lose and find the edges, the viewer finishes the painting or drawing for you more beautifully and accurately than you or any artist ever could; and he not only feels good about your painting, but he feels good about himself because he is now an active participant in the creative process.

Lost and Found Edges

Perhaps no advice is more frequently heard in painting classes than "lose and find the edge." Perhaps no advice in painting classes is more frequently misunderstood (if, indeed, it is understood at all).

We learned all about found edges with our first coloring books, in which every edge was found for us. But the purpose of our coloring books was not to make us painters or draftsmen, but to teach us to take direction and follow the rules. The result: We became upstanding citizens but our painting grew edgy and stiff.

Found edges are obvious; they describe the "turning edges" of cubic or pyramidal shapes, as in architectural forms. They are sharp edges or corners, areas of high contrast. Found edges are a form of counterchange. Found edges create the contrast that is the design.

An edge may be completely lost and found through closure. Or an edge can be blended so we are not quite sure where it begins or ends. A blended edge describes the turning edge of a curved surface or the boundaries of a cast shadow. Edges may be rough-brushed, hard, blended, or completely unseen. Rough-brushed and hard edges are found edges while blended and unseen edges are lost edges.

We can thank Leonardo da Vinci for inventing the blended edge that blurs the boundaries and merges one form with another. He called it *sfumato*, which is Italian for "smokelike."

Lost edges generate passages; it is the passages that create the unity that is the pattern. When a painting utilizes closure because the edges are lost, no matter how many times the viewer has seen it before, each time he looks at it he must complete it again in his mind. The viewer can never grow tired of it. The painting remains forever new for him because the painter left it for him to finish.

Boundary edge Turning edge

Some of the edge may be lost provided closure takes place.

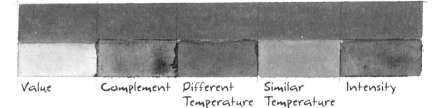

Value Complement Different Temperature Similar Temperature Intensity

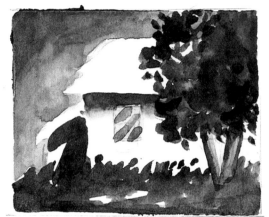

Informal Texture: We see texture where values change. We read the texture of the edge as the texture of the area.

Value contrast dominates. We read the strong light/dark contrast before the close middle-value contrast even though the middle-value contrast is hard-edged and the light/dark contrast is blended.

Found Edges: Hard or Rough-Brushed	Lost Edges: Blended or Unseen	Blended Edges:
1. In the center of interest	In the background	Provide smooth transitions between areas with different values
2. Planes taking direct light	Planes in shade and shadow	Keep darks from becoming too prominent
3. Planes taking focused light (for example, a spotlight)	Planes taking diffused light. (Natural light is always somewhat diffused.)	Unite figure and ground
4. The cast shadow nearest the object that casts it	The cast shadow as it moves farther away from the object that casts it	Generate gradational movement
5. Edges that are closer to the picture plane in the represented volume of the picture box	Edges in recession. (The entire boundary edge of a sphere recedes.)	Affirm the plastic qualities of the materials
6. Turning edges on cubic forms	Turning edges on curved forms	Provide for audience participation and hide drawing errors. The viewer will always complete the painting better than you could possibly paint it.
7. Where local colors change but local values remain the same, or where local values change but local colors remain the same	Where local colors and local values change	
8. To describe thin objects	To describe thick objects	Sfumato— "Smokelike"—refers to edges that dissolve imperceptibly, like smoke, into adjacent areas.
9. Where a flat, decorative effect is desired	Where the three-dimensional effect of mass is desired	

The painter must leave the beholder something to guess.

—E.H. Gombrich

What we seek is a genuine reciprocity, a give-and-take, between object and non-object that makes each (square) inch of the paper important.

—Rex Brandt

When you realize that the contours of objects are not always visible to the human eye and therefore don't have to be recorded, you enter into a period of visual discovery like no other.

—Jack Clifton

Hierarchy of Edge. We read:
1. Rough-brushed edges first
2. Smooth, hard edges next
3. Then blended edges
4. Finally, lost edges

The Hierarchy of Edges

We see some edges before we see others. We see a light edge against a dark sooner than against a midtone; we see a hard edge before we see a blended edge. And, although a lost edge is unseen, it may well be the most interesting of all edges. The most demanding and most interesting edges belong in the center of interest; the less demanding and less interesting ones belong in the background.

Color relationships also control the order in which we read edges. If the color of an edge is analogous to an adjacent color, temperature becomes the determining factor. If the analogous colors have different temperatures, the edge will be more demanding than if the two edges have similar temperatures. In other words, warm against cool is more visually demanding than warm against warm or cool against cool.

The artist uses the hierarchy of edges so that his viewer will look at the things in the painting in the sequence in which the artist wants them seen.

My friend, the flower lady, is never so happy as when she is painting in her garden. In the 20 years that I've known her, she's never painted anything but flowers. Although she holds an advanced academic degree, when she thinks about painting, she thinks in very concrete images of flowers. She has difficulty relating, say, an example from landscape or figure to her beloved flowers. I can empathize because I have a similiar problem. But principles are universal; that's why they're principles, and they apply regardless of subject matter. I hope it's easier to see how the principles apply to subject matter that interests you from nonobjective charts like these rather than trying to make the jump from, say, landscape to still life painting, or vice versa.

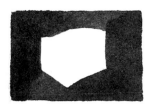

Negative space becomes active.

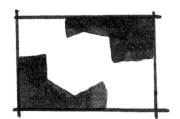

"Tongs" grip the lights. Pattern, the result of passage in the lights, and design, the result of counterchange in the darks, emerge.

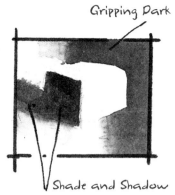

Gripping Dark

Shade and Shadow

We achieve reciprocity when we
- paint the pattern of shade and shadow
- paint a gripping dark against the light side of the positive.

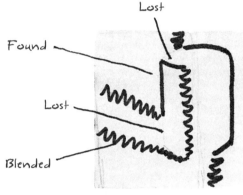

Found

Lost

Lost

Blended

Represent the found edge with a straight, unbroken line:

Represent the blended edge with a wavy line: ∿∿∿∿∿

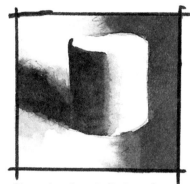

Sfumato—"smokelike"—refers to edges that dissolve as imperceptibly as smoke into adjacent areas.

Always try to have at least one passage of light and one of dark between object and background and between overlapped objects. Passage ensures open shapes.

Hierarchy of Hue: The high contrast of complementary colors is more demanding than the contrast between two analogous colors. If the temperature of the two analogous colors is different, as here, the edge will be more demanding than if the analogous colors had the same temperature.

Hierarchy of Value: Value rules. Nothing is more important than light and dark. Although a rough-brushed edge reads more quickly than a hard edge, a blended light/dark edge seems more demanding than a rough-brushed light/midtone edge.

Hierarchy of Intensity: The high contrast of neutral and intense is seen before the contrast of two intense colors. In fact, the two intense colors may cancel each other out. The contrast between two neutrals will be seen last.

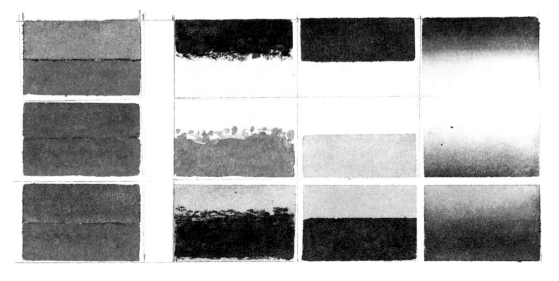

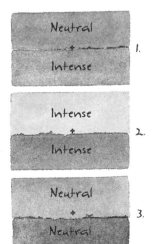

Neutral
+
Intense
1.

Intense
+
Intense
2.

Neutral
+
Neutral
3.

Texture is most evident where dark meets light on the turning edge and at the outer edge. Experience has taught us to assume that the areas in between have similar textures.

— Rex Brandt

Here's a helpful formula based on the Golden Section that you can apply to all sorts of things, such as area, color, and so forth:

> 60% Dominant
> 25% Subordinate
> 15% Accent

Once you get the hang of the Golden Section, try repeating the process gesturally with a pencil in your hand. When you come to point G on your line, mark it with your pencil; it'll be close enough. Gesturing is similar to the golfer's practice swing. It gets the muscles firing and results in a mark right where you want it. I call it "air drawing."

Texture

Informal texture is what we see around us. Most things in nature have two important edges, the outside boundaries and the inside turning edge. We read the texture of these edges—rough, smooth, or blended—as the texture of the area. Therefore a rough-brushed edge explains the texture of a tree, while a smooth, hard edge explains the texture of a ball bearing. The texture of the tree requires a rough edge and the texture of the ball bearing calls for a smooth, hard edge. These are the demands of type. Since such texture results from the demands of type and not the formal demands of pattern and design, it is informal because it informs us as to the character of the object's texture.

Formal texture occurs when texture is used as an element of pattern. We say it is used for form as opposed to content. (Informal texture explains content because it reports the textural quality of the referential image.) Dufy, for example, used texture formally.

The Golden Section

The Golden Section is older than the Bible. It goes back at least 5,000 years and in all that time nobody has ever found a better way to divide a line or area into two parts. The Golden Section is a ratio by which a line is divided into two handsomely related parts. The shorter part of the line has the same relationship to the longer part of the line that the longer part has to the entire line. The longer part is called the extreme and the shorter part, the mean.

There's nothing very difficult about the Golden Section. However, it is one of those things you have to do; you can't just read about it and expect to understand it. So try the instructions on the next page, using pencil and paper, a compass, and a straight edge.

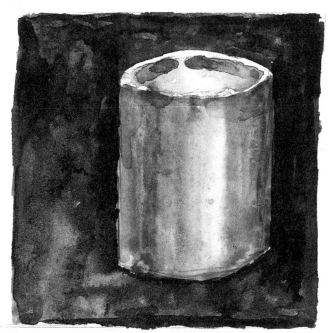

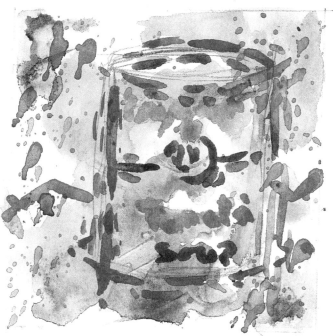

Formal Texture: Texture is used formally; that is, to give the painting form or structure. Such texture exists for its own sake, independent of subject matter, and helps reaffirm the flatness of the picture plane. Formal texture is often a mark of the expressionist painter. Like informal texture, formal texture appeals to the viewer's sense of touch; he wants to touch the picture's surface, not the object represented.

Informal Texture: When the paint looks so real that you feel that if you touched it you would be touching hair, metal, fabric, flesh, etc., that's informal texture. The paint looks like what it represents. We read the texture of an edge, either an outside edge or a turning edge, as the texture of the area. Thus, the edge informs us as to the texture of the object represented. Informal texture is usually found in objective paintings.

A B C D E

The Golden Section

Here are five pairs of lines. The two lines in pair A are equal in length; they have a static relationship that's not very interesting.

–Although the two lines in pair B are not the same length, they are so close that they look like a mistake.

–Pair C presents the Golden Section. The short line has a clear relationship to the long line but both lines are different enough to be interesting.

–In pair D the short line is half the length of the long line. The relationship between the lines is predictable and, as such, not particularly interesting or visually demanding.

–In pair E the short line is so much shorter than the long one that they appear to have no relationship to each other.

1. Draw a straight line AB.
2. Draw a perpendicular line from B.
3. Divide line AB in half. Mark the midpoint.
4. Put the sharp end of a compass on B and the pencil point on M. Swing a radius so it intersects line B at C.
5. Draw line AC.
6. Swing a radius from C that intersects AC at D.
7. Now stick the point of your compass into A and increase the radius to D. Swing the radius down so it intersects AB at point G (for "Golden Section").

Four (physical) sensations yield a feeling of tactile mass: pressure, warmth, cold, prick.
— Stephen C. Pepper

The characteristic movement of an area is that it spreads.
— Donald Graham

A good shape is two different dimensions, oblique and interlocking.
— Ed Whitney

Many things which appear random, complex, or confusing at first, even trees and cumulus clouds, are easy to understand and paint when you see them in terms of the piling-up principle. There's a kind of dynamic appeal to a pile of anything.

Wall

Gothic Arch

Mass

Put an apple in a deep bowl. You can see that the apple takes up space inside the bowl. That perception of filled space is the primary characteristic of mass.

Visual mass consists of areas of color. Whether you paint an apple or just a block of color, the result has visual mass. Every characteristic of color—hue, value, intensity, color quality, temperature, apparent weight, and apparent distance—is a secondary characteristic of mass.

When you think of drawing, you usually think of line. In order to suggest the shapes of forms, line drawing concentrates on the outline of the boundary edges or the contours of the object you're drawing. In contour drawing you always feel as if you're touching the surface. An object drawn with simple contours doesn't carry very much visual weight.

However, there's a different kind of drawing that's more useful to the painter—mass drawing. Mass drawing is more concerned with how shapes fill space than with the contour, or outline, of shapes. You make a mass drawing with the side of your pencil, not the tip. An object in mass drawing always feels as if it has weight.

Because it reports the lights and darks as the eye sees them, a mass drawing usually starts somewhere in the middle of the form and works its way out toward the edge, whereas a line drawing first finds the edge and then works its way in toward the center of the form.

Roman Arch

Pyramid Tower

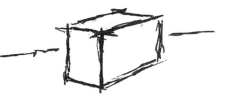

Shape: When the boundary edges of an area are clear, it's considered a shape. Positives are usually read as shapes.

Line is tactile.

Area: When the boundaries of a mass are not clear, it's considered an area. Negative space is usually read as area.

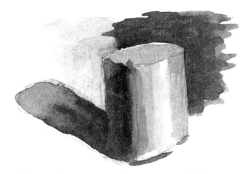

Two-dimensional mass attracts line. Looking at a line drawing or a linear painting, we are aware of the boundaries of the forms.

Three-dimensional mass repels line. In a mass drawing or painterly painting we are aware of the sense of filled space, not this linear quality of boundaries.

Mass is visual.

The Piling-up Principle: Watch a kid play with a set of blocks. Because of gravity, the blocks can stand if they support each other. As he piles his blocks one on top of another they begin to show form and direction. They gradually become a pyramid, an arch, a tower, or a wall. The blocks are unified by an organizing pattern, the piling-up principle. You can see the piling-up principle at work in many of Cézanne's paintings.

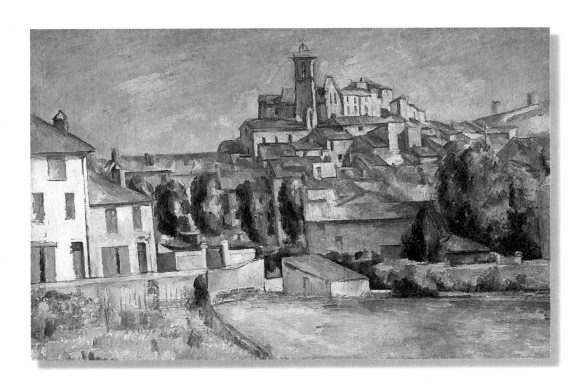

It does seem to be true that most great artists are very sensitive to the effects of three-dimensional mass and that their weaker followers fail to discriminate these effects.

—Stephen C. Pepper

<u>Reilly's Rule</u>: The local value of a dark object in the light is always darker than the local value of a light object in shade or shadow. Conversely, the local value of a light object in shade is always lighter than the local value of a dark object in the light.

Form Description and Surface Texture

Surface texture supplements form description by suggesting, in paint, the tactile feel of a surface. Value relationships and highlights explain surfaces as dull or shiny.

The Effect of Light: Look at a tennis ball in the sunlight. The ball is lighter where the light strikes it and darker on the side away from the sun. The side where an object takes direct light is usually called the "local color" of the object or sometimes the "body tone," and the side away from the light is called either shade or form shadow.

The place where value changes from light to shade is called the core on a curved surface and the plane-change accent on a cube-like surface. The core has a blended edge, while the plane change accent is always hard-edged.

Cast Shadow: Look at the ball again. This time notice how the shade flows into the cast shadow. You see and paint shade and cast shadow as a single dark shape. If you can somehow suspend the tennis ball above the surface, the cast shadow becomes a dark shape separate from the form shadow. The cast shadow is always darkest closer to an object; as it recedes, it becomes lighter.

Reflected Light: Look again. Notice the underside of the tennis ball. Some of the direct light has been reflected onto the underside of the ball. That's called the light bounce. Reflected light is embedded in the shade. (If you don't see the light bounce, try putting the tennis ball on a mirror. Even if you don't see it, you should paint it.)

Reflection/Absorption: Light is either absorbed or reflected. A dull or matte surface, such as cloth, absorbs more light and reflects less light than a shiny surface, such as polished chrome.

Highlights: These are embedded in the body tone where the form is closest to the viewer and in line with the light. A hard-edged highlight explains that the surface is hard to the touch, and vice versa.

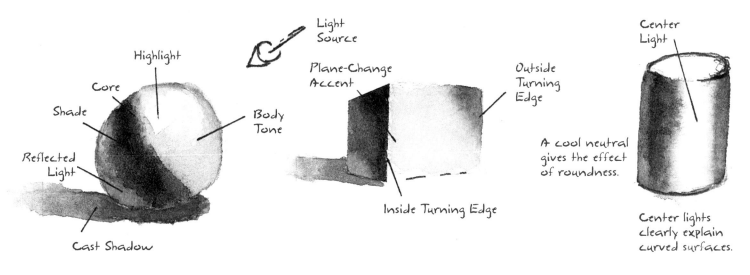

Light Source

Highlight

Core

Shade

Reflected Light

Body Tone

Cast Shadow

Plane-Change Accent

Outside Turning Edge

Inside Turning Edge

Center Light

A cool neutral gives the effect of roundness.

Center lights clearly explain curved surfaces.

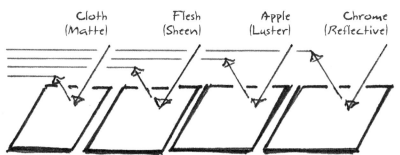

Cloth (Matte) Flesh (Sheen) Apple (Luster) Chrome (Reflective)

Different surfaces reflect the sun's energy (heat) differently.

See (and paint) shade and shadow as one shape.

The shade side of a light object is lighter than the lit side of a dark object and vice versa.

Surface	Reflected	Absorbed
Snow	75%	25%
Water	40% to 5%	60% to 95%
Grass	30% to 20%	70% to 80%
Dry Sand	25%	75%
Plowed Field	25% to 95%	75% to 5%
Dense Forest	5%	95%

Warm Sun

Cool Sky (north light)

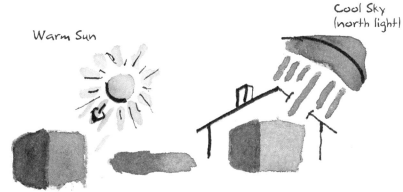

The hue of the body tone is affected by the color of the light. Sunlight is warm; studio light, cool. It is not simply a matter of a darker value of the hue.

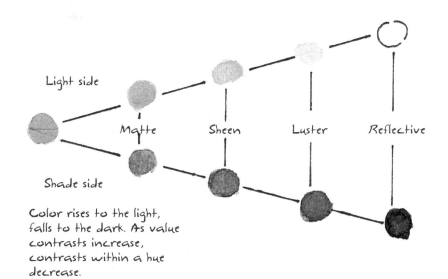

Light side

Matte Sheen Luster Reflective

Shade side

Color rises to the light, falls to the dark. As value contrasts increase, contrasts within a hue decrease.

The highlight on a smooth, hard surface (like an apple or grape) has hard edges.

The highlight on a soft surface (like flesh or fabric) has blended edges.

Location of Highlights

Constantly be a slave to your focal point. That's the heart and guts of your painting. And nothing is more important to your focal point than the background.

 —Helen Van Wyk

Animate the negative space, for the positives take care of themselves. . . .

Swell the positives. I promise you that you won't lose the negative space.

 — Rex Brandt

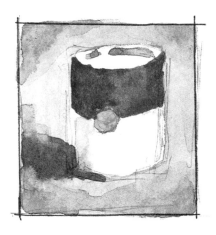

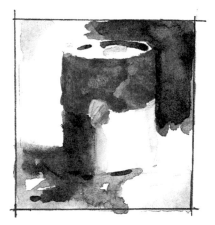

Figure and Ground

A figure is any object that stands out clearly as a unit against the background. A figure can only be a unit of pattern or a type. A type, of course (say, an apple), can also serve as a unit of pattern. Often the figure is called the subject or the positive.

Everybody loves subject matter, so the positives always offer the aesthetic pleasure of recognizing a natural type.

It was probably subject matter that first drew you to painting. You wanted to make a picture of something, or to look at a picture of something. Most viewers usually have considerable interest in subject matter. A gardener may like pictures of flowers, and a sailor, pictures of boats and the sea. (However, even a gardener will usually prefer a good seascape to a poor floral.) Your viewer's conscious interest, unless he is a painter, lies primarily in subject matter.

The ground is a plain or patterned area of color against which a figure appears and takes shape. The ground is always an extended mass of color. Other terms for the ground are the background negatives, or negative space. Interesting negative shapes are always a mark of superior composition.

We all enjoy paintings that depict things with which we're familiar. But because the viewer is familiar with your subject, you don't have to paint in every detail. Through closure the viewer will provide any missing details in the positives and never even know he's doing it. Thus the viewer always takes care of the positives. All you have to take care of is the negatives, which demand more attention from the painter than do the positives.

Plain Patterned Unit of Pattern Type

Ground

Monochrome — Plain — Neutral

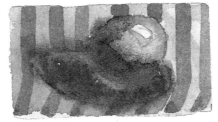

Patterned

Analogous — Gradation

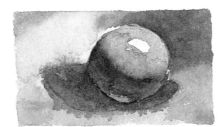

Complementary — Contrast

Your background serves your subject in the same way a black velvet cloth serves the jeweler; it displays your wares to best advantage. A simple positive may look better against a patterned background. However, a patterned object will usually look better against a simple background.

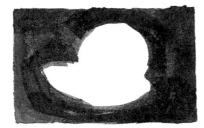 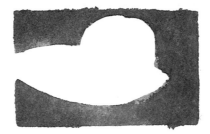

You can't judge anything until you can see it. In negative space studies, you paint only the negative space so you can see and evaluate it, even though in the final painting it may be white or light. Shade and shadow form a single figure against the ground.

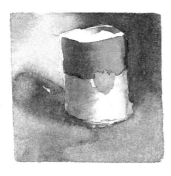 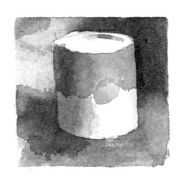

Lateral Extension: Wide shapes always make better positives in a painting than thin ones. Skinny shapes tend to become linear, while fat shapes are painterly. The important shapes in nearly every great picture seem to spread from side to side because the painter deliberately exaggerated their width. Any time a shape spreads laterally beyond the limits imposed by accurate drawing, it becomes more generous and dramatic.

119

The sense of space is worth five times of any other quality.
— John F. Carlson

As soon as we become aware of the tensions that exist between surfaces, we experience space. Observing objects in nature, look at them intently, not as forms, but as surfaces. When we begin to relate one surface to another, we literally, "see" space. Once we see space, we become aware of the tensions between planes and our graphic world becomes more tangible.
— Donald Graham

The inside of a bowl or cup encloses space. We call this space "volume."

Put a ladle or a spoon inside the cup or bowl and the sense of volume is heightened. This little trick which the artist uses to suggest volume is called wedging.

Volume

Since mass fills space, it stands to reason that you can't have mass without space. However, the feeling of space does not depend on mass. Look at the inside of a clear drinking glass; although it is invisible, you are aware of the space enclosed by the glass. We say the glass contains volume.

It's pretty remarkable that we can experience space; after all, it is invisible. We can't see it or touch it, but we sure can feel it—ask any claustrophobe.

Although three-dimensional mass always conveys a feeling of solidity or filled space, volume does not. If you partly fill the empty glass with orange juice, the juice fills the part of the volume the same way furniture fills part of the volume of a room. That's why a room, a courtyard, a city street, an arcade, an arch, or a forest view always conveys the feeling of volume—you are aware of the enclosing surfaces as surfaces rather than as part of a mass.

Here's the problem: In the section on mass we learned how to represent three-dimensional objects on a two-dimensional surface. But they don't quite come off right unless we can somehow represent the volume in which they exist. How can you draw something that's invisible? Perspective is the answer. There are many different perspective systems, and the artist will often use more than one in a picture.

Perspective begins at the picture plane, the surface on which the picture is painted. The viewer never gives it a second thought. He knows that no matter how convincing the illusion of the third dimension, the picture is really just an arrangement of flat shapes on a flat surface.

Usually the sense of space in a picture extends to a specific distance behind the picture plane. Often a vertical plane, known as a shut-off plane, marks the deepest point in this represented depth. The shut-off plane may be be the rear wall of a room, a mountain range, a mass of trees, anything.

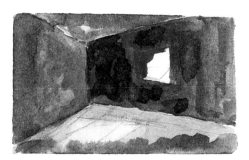

The sense of volume becomes clear when you draw the inside of a room or create a still-life box.

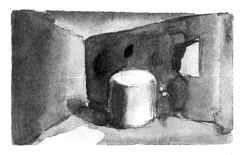

Introduce a mass and the feeling of volume is intensified. When a mass is used this way, it's called a core.

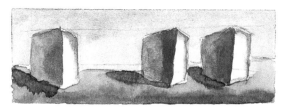

Tension between surfaces increases as the distance between them decreases. The closer together the surfaces, the greater the feeling of volume. You sense the space between the mass in the center and the mass on the right more than you do between the mass on the left and the one in the center. It's a matter of interval.

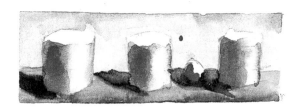

A core between surfaces always intensifies the feeling of volume.

Three-dimensional mass:
Understandable, but not very convincing because volume has not been depicted. The background of the page becomes a null context. It has no feeling of space; it's just paper.

Volume:
The three-dimensional mass appears more convincing because the volume has been depicted.

The picture plane is the surface on which the picture was made.

You read the aesthetic conventions of the various perspectives as naturally as you breathe. They're simple and obvious—until you try to use them!

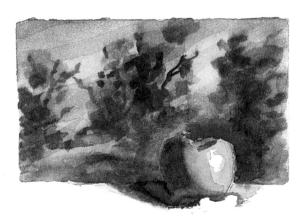

Except for the special case of trompe l'oeil painting (from the French for "fool the eye" and pronounced trom-ploy), which is a sort of visual joke, it's unusual for a three-dimensional mass to appear to protrude in front of the picture plane.

Materials
Volume

Approach your subject as if it were a still life.

—Rex Brandt

Landscape painting is really just a box of air with little marks in it telling you how far back in that air things are.

—Lennart Anderson

It is impossible to exaggerate the diminishing of a measure in recession.

—Ed Whitney

The spectator, likewise, has an obligation to enter into the scene, not just admire the work as a thing.
-We look at the picture.
-We walk in the picture.
-We ramble through the picture.
-We live in the picture.
All are desirable, but the last two are held in greatest respect.

—Kuo Hsi

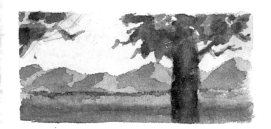

The Picture Box

Foreshortening is just drawing what you see. Look at a tennis match on television. You'll see that the sidelines and the center line recede to a vanishing point somewhere above the top of your screen. The net looks much farther away from the near baseline than the far baseline.

So, in painting, as a plane recedes in foreshortening, the closer half of the plane looks longer than the far half, and you paint it that way, representing depth beyond the picture plane in an area called the picture box.

The floor of the picture box is usually divided into three zones: a foreground, a middle ground, and a background. The relationship of these zones is very precise.

Let's say you're standing on a goal line of a football field. Your foreground starts at the ten-yard line closest to you. (Usually when you look at something, you are looking out toward it, not down at your feet.)

Your foreground extends back ten yards to the 20-yard line. Your middle ground extends another 20 yards to the 40-yard line. Your background stretches 30 yards to the 30-yard line on the far side of the field. If you write it down as a series of numbers, it looks like this: 10, 10, 20, 30.

The total depth represented in your painting is 60 yards and the viewer feels as if he were 70 yards away from the shut-off plane that marks the rear wall of the picture box.

These numbers comprise a Fibonacci series, in which the next number in the series is always the sum of the last two numbers. Although this is art and not math, the Fibonacci series shows up all the time in both painting and nature. The most basic series is 1, 1, 2, 3, and so forth.

Because a painting is a vertical surface, not horizontal, you must reverse the Fibonacci series to convincingly represent volume on the picture plane. If you do this the vertical relationships of your three zones will be correct and the sense of depth in your painting will be absolutely convincing. The series now reads: 3, 2, 1, 1.

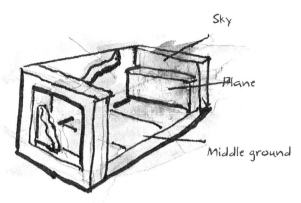

Sky

Plane

Middle ground

The Picture Box: The painting is like a little stage or shadow box, and the mat or frame serves as the proscenium. The back of the box looks smaller but suggests more space.

To understand the imaginary volume of the picture box, think of a fish tank.

5 mi.

30 ft.

The three areas are the same depth because we see them as a vertical plane.

As a horizontal plane (the floor of the picture box) they will foreshorten.

The farther away a zone is, even though it represents greater depth, the smaller it is depicted.

Reversed convergence in the landscape: The lower edge of a picture may represent only about 30 feet in width while the horizon seems to be about five miles wide.

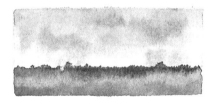

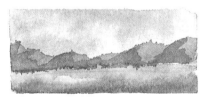

A shut-off plane increases the sense of volume.

Markers: At the end of each plane something always sticks up to mark the end of one zone and the start of the next. These verticals are your subject matter and they work like the dividers in a file drawer.

Reversed convergence in the picture box: There's more space outside the court at the top of the TV screen than at the bottom. Although the perspective lines converge to a vanishing point above the picture, the volume converges to a vanishing point below the picture.

Controlling Deep Space: A painting representing deep space may have five or more zones. If it has five zones, the Fibonacci series would read: 80, 50, 30, 20, 10, 10

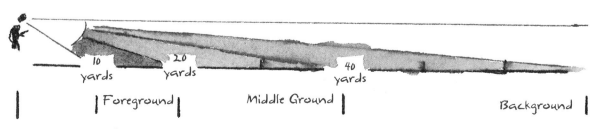

10 yards 20 yards 40 yards

| Foreground | Middle Ground | Background |

Materials
Volume

People think one-point and two-point perspective is how the world actually looks, but of course, it isn't. It's a convention.
— Roy Lichtenstein

My friend Paul photographs furniture. (Next to cars, Paul tells me, furniture is the most commercially photographed category.) Before a photo shoot, Paul creates glamorous room settings that look nothing like any place I've ever seen. Paul created a room for a client, and took hundreds of test shots. The client kept rejecting them, saying, as clients do, "I don't know what it is, but there's something wrong." Finally, somebody noticed that the client was about as tall as Toulouse-Lautrec. Paul lowered the camera lens to the client's eye level and the problem was solved; the shoot went off without a hitch.

Perspective Defined

It's got a lot of names: Italian perspective, Renaissance perspective, vanishing-point perspective, Western perspective, diagonal-in-depth perspective, to name a few.

These days vanishing-point perspective is out of fashion in some circles. One of my first instructors introduced vanishing-point perspective as "something you ought to know about but won't use much." He was wrong—at least for anybody who wants to paint with some degree of realism or any sense of three-dimensional mass. The most frequent drawing error in realistic paintings is not understanding where the vanishing points belong.

Mercifully, vanishing-point perspective is neither as dull nor as difficult as most people think. In fact, it's pretty simple once you understand a few terms. However, you can't just read about it, you've got to do it. So get paper and pencil and follow along.

Vanishing-point perspective is an aesthetic convention that pretends the human eye is a single–lens camera firmly fixed on a tripod. The eye is presumed to have a fixed focus of about 30 degrees—the cone of vision. (By the way, it's not your nose that's in the middle of your head, it's your eyes.)

Often, vanishing points live on the horizon. The horizon is an imaginary horizontal line that changes depending on where you're looking. If you roll your eyes back in your head to look up at the ceiling, the horizon shifts up. When you use vanishing-point perspective, you have to locate a horizon and stick with it. The horizon is always drawn parallel to the horizontal edges of the picture.

You can't see forever on a clear day, but you sure can see far if you're high enough or if what you're looking at is tall enough. I remember going down to the beach on a clear summer evening and seeing Manhattan's skyscrapers shimmering on the horizon. Imagine how Turner felt when he first saw Venice rising out of the sea!

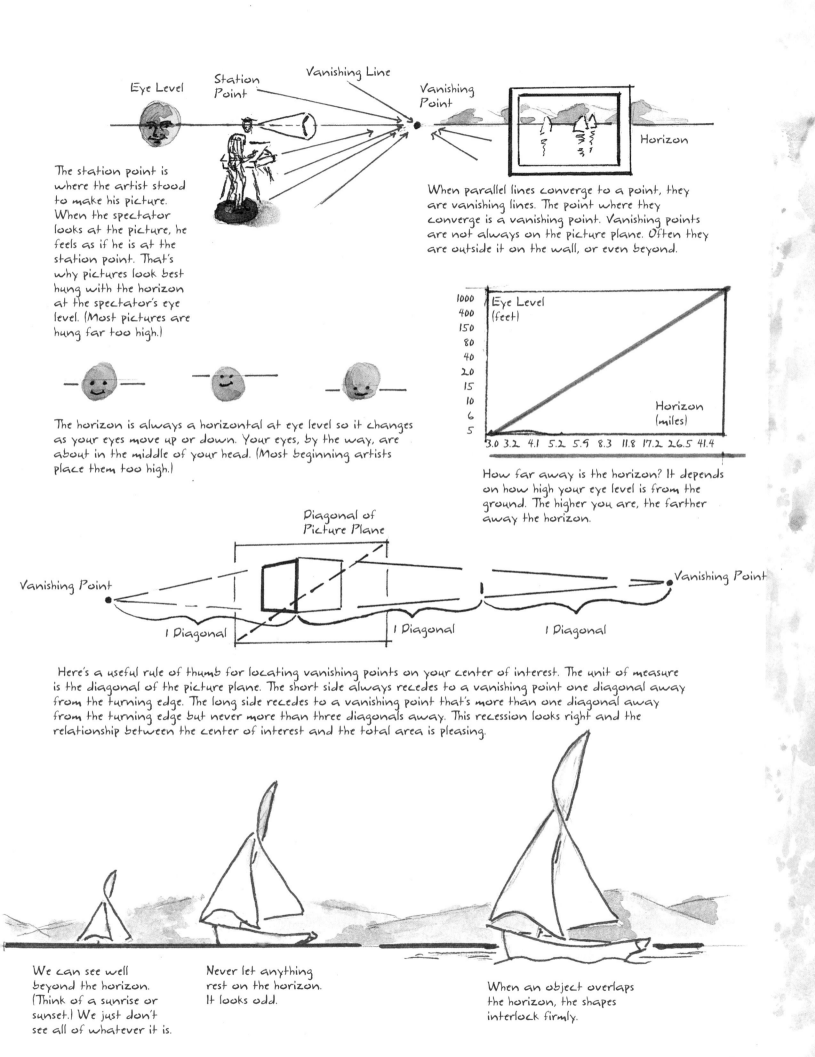

Eye Level

Station Point

Vanishing Line

Vanishing Point

Horizon

The station point is where the artist stood to make his picture. When the spectator looks at the picture, he feels as if he is at the station point. That's why pictures look best hung with the horizon at the spectator's eye level. (Most pictures are hung far too high.)

When parallel lines converge to a point, they are vanishing lines. The point where they converge is a vanishing point. Vanishing points are not always on the picture plane. Often they are outside it on the wall, or even beyond.

The horizon is always a horizontal at eye level so it changes as your eyes move up or down. Your eyes, by the way, are about in the middle of your head. (Most beginning artists place them too high.)

Eye Level (feet)

1000
400
150
80
40
20
15
10
6
5

Horizon (miles)

3.0 3.2 4.1 5.2 5.9 8.3 11.8 17.2 26.5 41.4

How far away is the horizon? It depends on how high your eye level is from the ground. The higher you are, the farther away the horizon.

Diagonal of Picture Plane

Vanishing Point

Vanishing Point

1 Diagonal 1 Diagonal 1 Diagonal

Here's a useful rule of thumb for locating vanishing points on your center of interest. The unit of measure is the diagonal of the picture plane. The short side always recedes to a vanishing point one diagonal away from the turning edge. The long side recedes to a vanishing point that's more than one diagonal away from the turning edge but never more than three diagonals away. This recession looks right and the relationship between the center of interest and the total area is pleasing.

We can see well beyond the horizon. (Think of a sunrise or sunset.) We just don't see all of whatever it is.

Never let anything rest on the horizon. It looks odd.

When an object overlaps the horizon, the shapes interlock firmly.

Plane is an element of line, the diagonal an element of volume. Recession makes its appearance only when foreshortening and spatial illusions are mastered,

—Heinrich Wölfflin

If arithmetic, mensuration, and weighing be taken out of any art, that which remains will not be much.

—Plato

Of all the bridges between spectator and picture, none is as powerful as the horizon. If the horizon is the same for both spectator and graphic characters, there is a common bond.

—Donald Graham

One-Point Perspective

Let's begin with simple one-point perspective, where everything recedes to a single vanishing point.

Just follow the instructions on the opposite page. When you get through, you may want to color in your results or otherwise fancy them up so you can amaze your family and friends with your remarkable talent. You could make a career out of one-point perspective.

A diagonal always suggests depth while verticals and horizontals, because they echo the edges of the picture and affirm the flatness of the picture plane. If you keep one edge of an important recession parallel to one of the picture's vertical edges, you can have your cake and eat it, too. You create a sense of depth from the perspective drive into space, at the same time reaffirming the flatness of the picture plane.

One problem with perspective lines that lead the viewer into the painting is that they can as easily lead him out. They may also create a drive into the deep space of the picture and prevent the eye from moving around in the picture. Perspective lines can punch a visual hole through the rear of the picture box, unless you stop them with a shut-off plane.

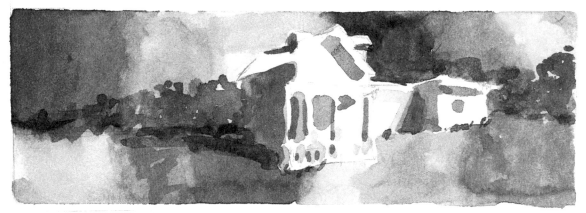

This sketch incorporates five different perspectives. Unlike color, the more perspectives you use the more convincing your picture will be.

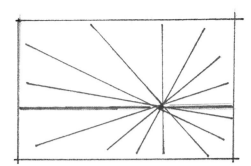

1. Draw a line representing the horizon that is parallel to the horizontal edges of the picture. Do yourself a favor and put it somewhere above or below the center of the picture.

2. Locate a vanishing point somewhere on the horizon. Often the artist will use something specific, such as a light sail against a dark sky or headland, a building or a figure, to make it easy to find the vanishing point. If you don't want it later, you can always paint it out.

3. Draw some lines lightly with a ruler through the vanishing point. These are vanishing lines.

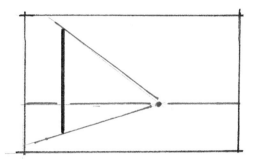

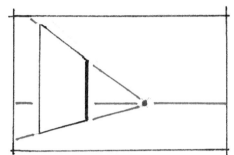

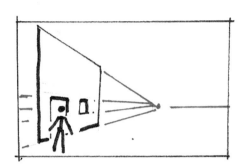

4. Somewhere close to an edge drop a vertical line from a vanishing line above the horizon to a vanishing line below the horizon.

5. Closer to the vanishing point drop a second vertical that connects the same two vanishing lines. The resulting shape could represent the side of a building, or anything else you want.

6. Draw a stick figure that overlaps the shape and make sure that the head intersects the horizon drawn in step 1. Relate windows and doors to your figure.

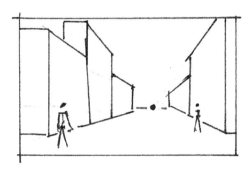

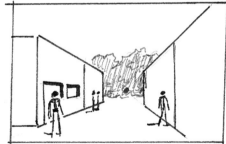

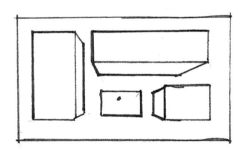

7. Draw in other buildings, putting some on the other side of the road. Add windows and stick figures to taste. For now, if you see a second side to a building, show it as a horizontal.

8. Add a shut-off plane to keep the perspective drive into space from punching a hole in the picture box.

Looking down (or up) in one-point perspective can be dramatic.

We tend to follow the figures. If you separate the head from the torso a little bit, the figure appears to be coming toward us. If you show only about half the head and merge it into the body, the figure appears to be moving into the pictorial space of the picture box.

Bird's-Eye View

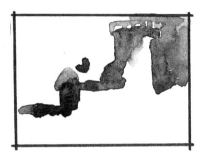

Normal

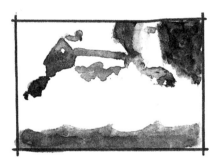

Worm's-Eye View

Two- and Three-Point Perspectives

Obviously, there are limitations to one-point perspective. You usually need more than one technique to create a sense of space. But once you understand one-point perspective, two- and three-point perspectives become simple.

In two-point perspective, you see two sides of an object instead of one. Each side recedes to its own vanishing point. In two-point perspective, everything recedes diagonally; only the verticals and the horizontals are parallel to the edges of the picture.

Three-point perspective adds a third vanishing point, above the horizon in a worm's-eye view and below the horizon in a bird's-eye view. In other words, all the verticals recede to a third vanishing point, and usually create a dramatic effect.

Vanishing points don't have to be perfect, just convincing. With a little practice, you'll soon throw away your ruler or straight-edge.

Once you've mastered perspective you don't have to be mastered by your station point. Try various station points or points of view.

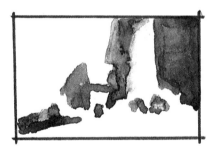

From Left

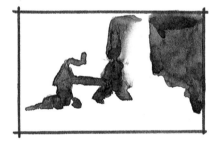

Center

From Right

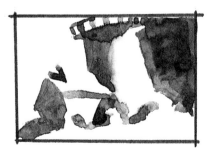

Tilt Left

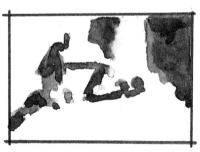

No Tilt

Tilt Right

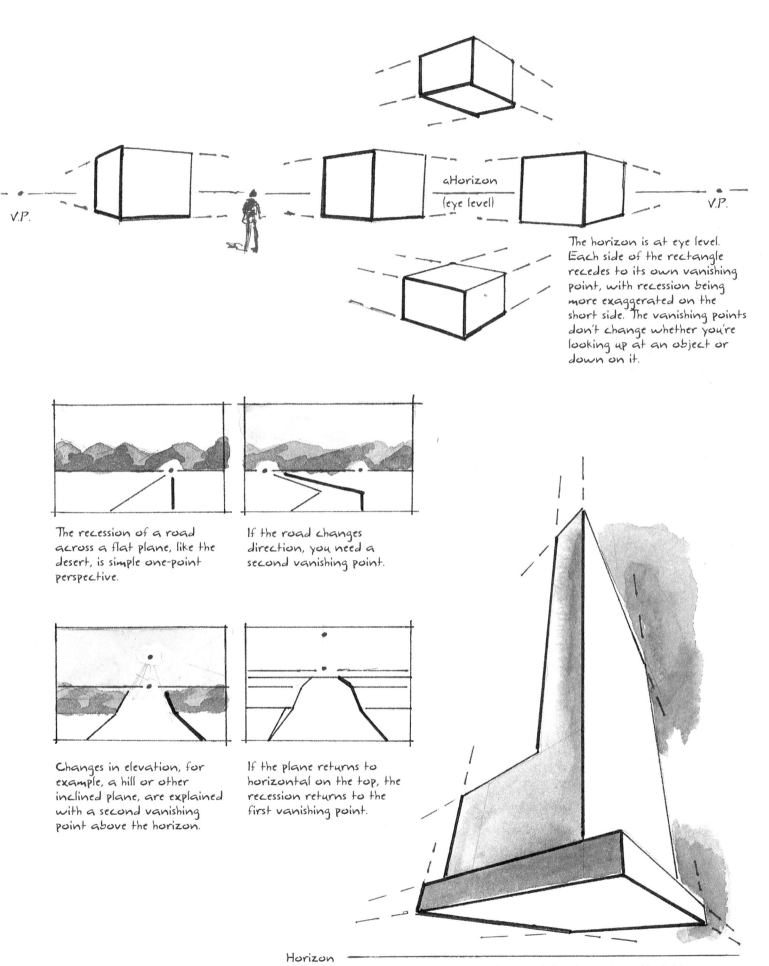

V.P.

aHorizon (eye level)

V.P.

The horizon is at eye level. Each side of the rectangle recedes to its own vanishing point, with recession being more exaggerated on the short side. The vanishing points don't change whether you're looking up at an object or down on it.

The recession of a road across a flat plane, like the desert, is simple one-point perspective.

If the road changes direction, you need a second vanishing point.

Changes in elevation, for example, a hill or other inclined plane, are explained with a second vanishing point above the horizon.

If the plane returns to horizontal on the top, the recession returns to the first vanishing point.

Horizon

Three-point perspective is often used for dramatic effect. You should be able to locate the vanishing points in this drawing.

Tools find uses.

—R. Buckminster Fuller

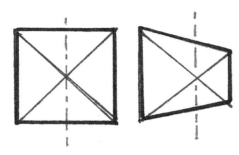

You find the center of a plane in recession the same way you find the center of a square—by drawing two intersecting diagonals. The point of intersection is the center. Foreshortening makes the near half of a plane in recession larger than the rear half.

Intersecting Planes: There are no perfectly flat horizontal planes in nature. Even a manicured suburban lawn has little bumps and hollows. Waves disturb the surface of the sea; sand dunes, the desert.

If you depict the foreground in a landscape as if it were as flat as a billiard table, it won't ring true. Intersecting planes more accurately express any terrain, including foreground.

Proportional Division

Proportional division is one of those subtle things that makes a big difference in the way viewers react to a painting. If you get it right, nobody notices; but if you get it wrong, viewers know something is wrong, though they may not know quite what.

Proportional division convincingly locates things that are the same size in the depth of the picture box. It's particularly useful for the recession of things that are about the same size or height and evenly spaced, such as street lights, telephone poles, windows, or tile floors.

Get a pencil and paper and try it out, following the diagrams on the next page.

Locating figures in the picture box: There's an aesthetic convention at work here: All standing men are the same height, all standing female figures come to about shoulder height on the men, and children are shorter than adults. It's a traditional method for viewpoints.

If you take the viewpoint of a standing man, the eye level of every standing male figure will intersect the horizon. The position of the men's feet will vary depending on how far back they are in the picture box. When the feet of two or more standing male figures are on the same horizontal, both figures read as being the same distance back in the picture box.

Now, say a woman is standing next to a man; her head will be at the height of the man's shoulder, but her feet will be on the same horizontal as her male companion's feet. If you draw the scene from a woman's viewpoint, the heads of all standing women will intersect the horizon, while the men's shoulders will all be on the horizon.

The same principle applies in drawing the world from a child's-eye view, or the viewpoint of someone sitting in a chair or lying on his stomach on the beach. If you depict the scene as if you were at the top of a maple tree, the tops of all the trees will intersect the horizon. It's that simple and the creative possibilities are limitless.

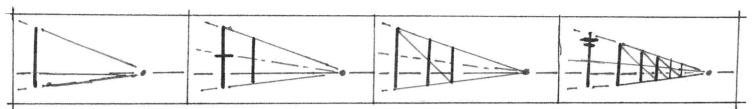

1. Establish a horizon and locate a vanishing point on it. Drop a vertical to represent your first telephone pole and draw the vanishing lines from both ends of the vertical to the vanishing point.

2. Find the midpoint of your vertical and draw its vanishing line. Decide where you want your second telephone pole and drop that vertical from the upper vanishing line to the lower vanishing line.

3. Draw a diagonal from the top of the first telephone pole through the midpoint of the second telephone pole to the lower vanishing line. Where the diagonal intersects the lower vanishing line, raise the vertical of your third telephone pole to the upper vanishing line.

4. Repeat step 3, only this time from the top of the second pole through the midpoint of the third pole to find where the fourth pole belongs. Repeat the process until you run out of room.

1. Establish a horizontal base line. Divide it into equal sections according to the number of squares you want. Draw the vanishing line from each mark to a single vanishing point. Then draw in the back line as a horizontal wherever you want it.

2. Draw a diagonal from corner to corner in the foreshortened square. Where the diagonal intersects the first vanishing line draw a horizontal. That's your first row of squares.

3. Draw a horizontal where the diagonal intersects the second vanishing line. That's your second row. Repeat the process until all the rows are in.

4. This type of proportional division can be used for all kinds of recession; for instance, to establish the relative depth of foreground, middle ground, and background.

There are two exceptions to the head-horizon rule. The man in the hole and the man in the box are at the same distance from the viewer as figure A.

Materials
Volume

There are three aspects to perspective. The first has to do with how the size of objects seems to diminish according to distance; the second, the manner in which colors change the farther they are from the eye; the third defines how objects ought to be finished less carefully the farther they are away.

—Leonardo da Vinci

Vanishing points are illusive. They're all over the place

—Jerry McClish

In recession the first five inches represent 600 yards, the next half-inch represents 30 miles.

—Ed Whitney

The foreground is just an access or entry. The less you do to a foreground, the better.

—George Post

Uphill and Downhill Illusions

Paintings that show changes in elevation, the uphill and downhill illusions, are much more interesting than simple recession across a flat plane. The secret of these illusions is the same as that of the inclined plane—two vanishing points, one above the other.

The Downhill Illusion: Look at the cross-section on the opposite page. In the typical downhill illusion, your station point is high on a hill that descends to a flat plane below your feet. That flat plane extends for some distance, and then a second vertical plane, often higher than the plane on which you're standing, rises to act as a shut-off plane.

The Uphill Illusion: As the cross-section shows, the typical uphill illusion starts with a flat plane that turns into an inclined plane. Since the station point is low, the horizon is low on the picture plane. The secondary vanishing point will often be somewhere up in the sky.

Depth Notation: It's helpful to include notes on depth as well as color and value, in your location sketches and pattern schemes. Depth is recorded in a square to distinguish it from color notes, which are recorded in circles. Use a scale of 0 to 100, with 0 representing your station point. (The picture always starts somewhere past 0.) The end point of 100 represents the most distant object or the horizon, since it is possible to see tall things beyond the horizon.

Then it's just a matter of percentages. Something that's about halfway between you and the farthest object is notated as 50. If it's 70 percent of the way back, mark it 70. You are simply indicating the relationship of things to each other in the depth of the picture box. The back wall of a still life may be only a few inches away, but it's recorded as 100, the same as the distant shut-off plane in a landscape that's 50 miles away.

Horizon

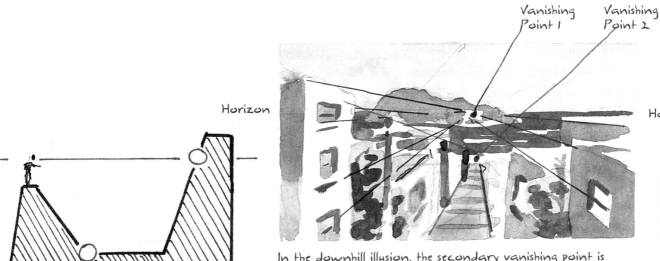

Horizon

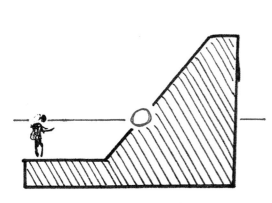

Cross-section of typical
downhill illusion

In the downhill illusion, the secondary vanishing point is
below eye level. Most volumes are drawn below eye level and
recede to the vanishing point on the high horizon.

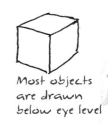

Most objects
are drawn
below eye level

Vanishing Point 2 Vanishing Point 1

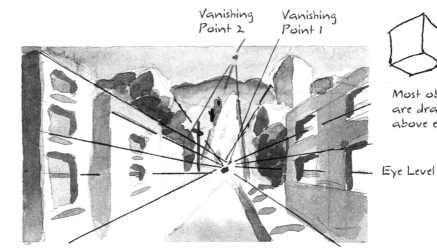

Cross-section of typical
uphill illusion

Most objects
are drawn
above eye level

Eye Level

In the uphill illusion, the secondary vanishing point is above
eye level. Most volumes are drawn above eye level and recede
to the vanishing point on the low horizon.

If you indicate the figure from the side, you should center the
head on the front of the torso or even put it slightly in front
of the torso.

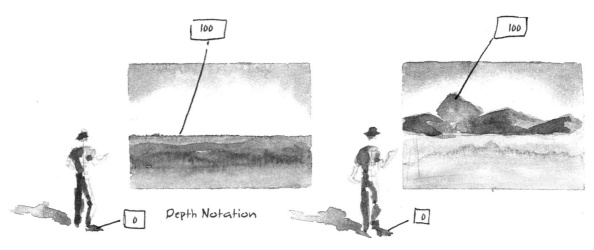

Depth Notation

Materials
Volume

For God's sake, remember that things are smaller in recession, whether they are the same things or different things, and do this whether the depth of the painting is three feet or a hundred miles. Make the close thing in recession larger than the big things farther away. Otherwise, it worries us. We get nervous if anything gets large in recession.

—Ed Whitney

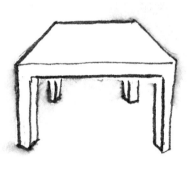

Compromise Perspectives

Height on the Picture Plane: When the lower edge of one shape is closer to the top of a painting than the lower edge of a similar shape, the shape that is higher on the picture plane reads as farther away. This is the aesthetic convention for distance, as often found in Persian miniatures.

The Diminished Repeat: When the only difference between two shapes is their size (and the smaller shape is higher on the picture plane), the smaller shape reads as farther away than the larger one. If both shapes rest on the same horizontal baseline, the smaller shape usually reads as a smaller version of the larger one. When a smaller shape is lower on the picture plane than a larger one, the larger shape reads as an oversize version of the smaller one.

Any Convergence: Any oblique line is a depth clue. Converging lines are the aesthetic convention that says "volume." They suggest foreshortening and depth in the picture box. Any foreshortening suggests space, even if the foreshortening of one object is inconsistent with the linear perspective of other objects in the picture.

Inverted or Reverse Perspective: Inverted or reverse perspective occurs when parallel lines converge forward toward the picture's lower border instead of upward as in traditional, Western, linear perspective. Any convergence is a depth clue; as long as there is convergence, the viewer accepts the space. In certain art traditions, the spectator may not even notice a reverse perspective at first. A lot of non-Western art uses reversed convergence, and I suppose those artists probably think of the Western perspective as reverse perspective.

Multiple Station Points: Another compromise perspective based on linear perspective. Multiple eye levels and horizon lines are a hallmark of Cézanne's work and became one of the bases of cubism.

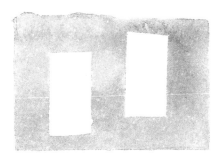

The lower something is on the picture plane, the closer it reads to the viewer.

If a shape is higher on the picture plane and is smaller than a similar, lower shape, the feeling of depth is more intense.

When the smaller shape is lower on the picture plane, the size of one of the shapes usually seems exaggerated.

When two similar shapes are drawn as different sizes, the smaller shape usually reads as farther away in the picture box.

However, if the two shapes share the same horizontal baseline, the small shape seems to be a smaller version of the large one.

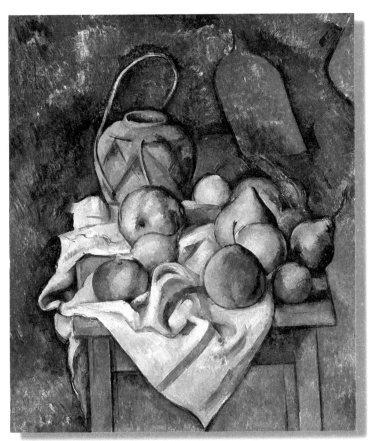

Cézanne often used multiple station points which allowed him to explore more than one point of view in the same picture. You can't read multiple viewpoints simultaneously, so it takes longer to decode the picture. In fact, multiple viewpoints give a painting's fixed imagery a sense of change over time—even in a still life.

The world seems to be made up of a never-ending series of overlapping forms. There always seems to be something in back of something else.

—Donald Graham

Overlapping shapes are a safer indication of depth than is linear perspective.

—Rex Brandt

A good shape is two different dimensions, oblique and interlocking.

—Ed Whitney

You mustn't kiss on canvas.

—Helen Van Wyk

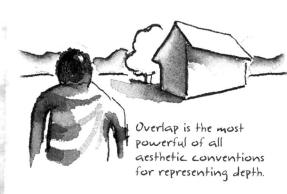

Overlap is the most powerful of all aesthetic conventions for representing depth.

Overlap Perspective

Overlap is the painter's most powerful tool for showing depth. It is also a singular aid to good composition.

When you overlap smaller forms in front and larger forms behind, you preserve the picture plane while, at the same time, you generate pictorial space. You see it all the time in Oriental art: The scholar is smaller than the pagoda he overlaps, the pagoda is smaller than the tree it overlaps, and the tree is smaller than the mountain it overlaps.

Overlap frequently makes use of sectional perspective, in which a three-dimensional mass is seen as if it were as flat as a playing card. Think of the form as a microscopic cross-section, a slice, as one card out of the deck. (A lot of Cézanne's forms are based on sectional perspective.) Where Italian perspective dramatizes the obliques, sectional perspective downplays them.

Complex forms in nature may be easier to understand when you use sectional perspective and analyze them as if they were overlapping playing-cards. Such playing-card analysis can help you to understand the subtle changes in direction of complex planes like the curves of a boat's hull.

The only problem you're likely to encounter when you use overlap is the graphic star, a junction of two lines that destroys the sense of space.

When any two lines—including boundary lines—meet, the resulting depth is ambiguous and flat. You don't know which line is in front of the other, or whether the lines are on the same plane. Even the slightest break in the two lines will make their relative positions clear so that you know what's in front and what's behind.

Halation, that slight aura that seems to surround an edge when you stare at it long enough, also reduces the graphic star effect and is true to vision.

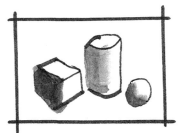 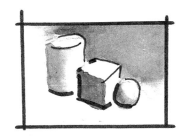

Graphic Star

Using overlap, be careful to avoid the graphic star. The viewer is uncertain as to which shape goes behind the other or whether the two shapes are adjacent to each other. Halation avoids the graphic star, and since halation is true to vision, using it does not seem arbitrary.

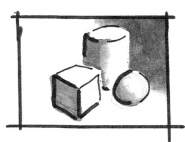

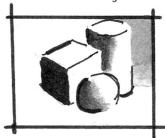

When you compose using overlap, you avoid the look of a mail-order catalog.

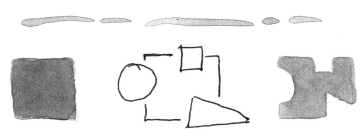

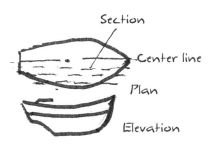

Section

Center line

Plan

Elevation

Simplifying spatial analysis into overlapping geometric shapes can help you understand the structure of complex shapes like trees or the curve of a ship's hull.

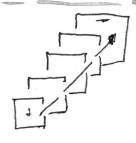

Overlap makes it easy to transform a dull, static shape into an exciting one.

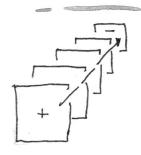

You find inverted perspective used repeatedly in Oriental painting. The convention is to maintain the actual scale. The house is bigger than the man; the mountain is bigger than the tree.

Even if the pattern expands to the left in size, the eye's movement is drawn to the right, perhaps due to our Western tradition of reading left to right.

The movement of overlapping forms somehow seems more satisfactory when the movement into depth of the overlapped shapes is from smaller in the foreground to larger in the background.

Aerial Perspective

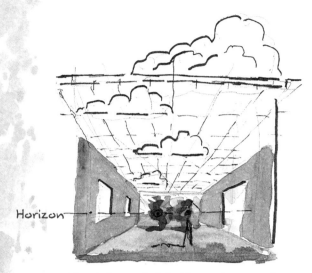

Clouds have flat bottoms, like a ceiling.

Things in recession become paler, bluer, and less intense.

—Ed Whitney

Since pictures are flat, not deep, laymen are usually more intrigued by the illusion of depth than they are by the arrangement of zones on a surface.

—Stephen C. Pepper

There is a kind of perspective called aerial perspective which depends on the thickness of the air.

—Leonardo da Vinci

Nature, for us men, is more depth than surface. Hence the need to introduce into our light vibrations, represented by the reds and yellows, a sufficient amount of blue to give the impression of air.

—Paul Cézanne

*E*ven on a crystal-clear day, distant mountains appear a pale blue. That's because the earth's atmosphere is filled with dust, water, and other particles that act like a series of thin, gauzy veils to alter the appearance of local value, hue, and intensity in recession.

Dark colors get bluer and lighter in recession while white and near-white become a little darker and slightly warmer as they recede. Warm colors—yellow, orange, red—drop out first. Intense colors become more neutral as they recede.

You can use any hue, value, or intensity in the foreground because the effect of aerial perspective on the local colors is minimal, but the background—even in still life or portraiture—must always be paler, bluer, and more neutral.

Strong contrasts in value suggest that objects are near while close values suggest distance. A distant building or a building seen through the mist appears distinct only where it receives direct light.

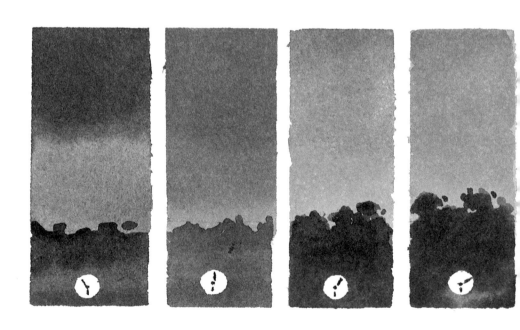

The luminosity which makes a Claude Lorrain painting so attractive results from his lightening the darks in recession more than he darkened the receding lights.

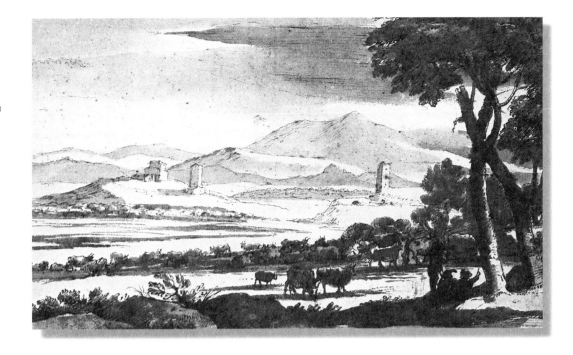

Whites and near-whites become slightly darker and warmer in recession. Darks and midtones become lighter and cooler.

Warm colors drop out before cool ones. Yellow is the first color to drop out and blue, the last.

Intense colors drop out before neutrals.

Sunrise, sunset: The color of the low sky changes in strict spectrum order about every five minutes. Sunrise begins with violet on the horizon, followed by red violet. Sunset reverses the sequence. The undersides of any clouds reflect the color of the horizon or the color just below the horizon.

Veils of Atmosphere: Looking at something in the distance is like looking through a series of filmy, light blue curtains of gauze. Glazing is one way to achieve this effect.

139

The five tone values:
 Mass Tone
 Shadow Tone
 Reflected Light
 Cast Shadow
 Highlight
 —Helen Van Wyk

If it's a bright sunny day, the colors will be weak on surfaces where the light is striking and rich in the shadows. If it's an overcast day, the lighting is even and colorful throughout. In the early morning or late afternoon, a warm glow often bathes the environment and the shadows become opaque.
 —Milford Zornes

Warm light of morning or evening:
 Extra layers of moisture and dust make light warm while shade and shadow move to the cool sky quality.
Cool light of noon:
 Shade becomes warmer, shadows become cooler.
Cool north light of the studio:
 Shade and shadow become warm.
 —Rex Brandt

The cast shadow is the darkest thing in nature.
 —Ed Whitney

Light and Shade

Light unifies the picture. The effects of light and shade are depth cues as much as linear or aerial perspective. The painter often exaggerates the effects of light and shade by painting the relationship of the shade to the light darker than he sees it.

Reflected Light: Since you can see the side of an object in shade, there must be some reflected light illuminating that surface. Reflected light causes a light bounce effect on the far side of objects in the shade and warms the underplanes. At first, you may find it difficult to see the light bounce. Look carefully under an eave on a bright, sunny day and you'll see it's much warmer and lighter than the cast shadow.

If form description is to be convincing, no part of the shade can ever be as light as the lit side. No part of the lit side, except the underplanes, can ever be as dark as the dark side. A surface with a dark local value will be darker in the light than a light local value in the shade.

The Cast Shadow: The cast shadow is any area which receives no direct light because something opaque has blocked the light. The cast shadow lets the artist link the darks for better, more generous shapes. In fact, the cast shadow is one of the realistic artist's most useful tools. For example, it explains: the form of the object that casts it; the form of the object on which it falls; three-dimensional volume by showing how far behind one plane an object is; and even the time of day, in the manner of a sundial.

The Plane-Change Accent: The turning edge occurs where two planes meet or where a curved plane turns from light to dark. Because the shade side and the light side come together at the turning edge, simultaneous contrast makes the shade appear darker and the light lighter. If you exaggerate value differences at the plane-change accent, you will describe form convincingly.

The Highlight: The highlight reports the precise location of the light source. It is always at a right angle to the painter's station point and the light source.

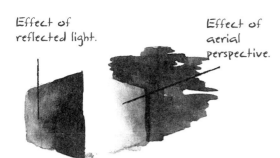

Effect of
reflected light.

Effect of
aerial
perspective.

Reflected light is the same value as the shade
and a combination of the surrounding
color plus the color of the light.

You don't always need a third color to
get the effect of one. Closure defines the
roof plane as different from the sky. We
read the flat blue wash as two colors.

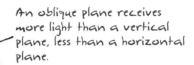

An oblique plane receives
more light than a vertical
plane, less than a horizontal
plane.

A vertical plane receives the least light.

A horizontal
plane receives
the most light.

The value of a cast shadow never changes: It's the value of
the surface on which the shadow is cast that changes.

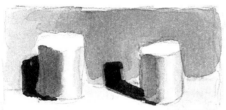

Reflected light
makes a surface in
shade lighter and warmer as
it recedes. Aerial perspective makes
a surface in light a little darker and a
little cooler as it recedes.

The cast shadow
explains the form on
which it is cast, and
may establish how far
the object is from the
background.

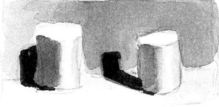

The edge of a cast shadow
is always a blended edge.

Shadows are always
transparent. A small dark
in the cast shadow explains
that it is transparent by
showing that you can see
into it.

Unless the cast
shadow is
connected to its
object, it will appear
to float in space.

The cast shadow
explains where its
object is in relation
to the planes on
which it falls.

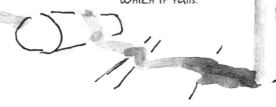

If you put a light in a cast
shadow, it explains that the
cast shadow lies on a plane
facing up. This keeps the
cast shadow from reading
as a vertical plane.

Exactly right is all wrong!
—Ed Whitney

The dots to the model's right are evenly spaced, one head apart. Count the number of head-spaces from top to bottom—the high heels and reflection seem to elongate the figure.

Scale

Although the normal human figure is about six-and-a-half heads high, we usually draw it as eight heads high because it looks more graceful that way. It's also easier to draw it that way. In the normal figure the groin is the midpoint of the body, the nipples are the midpoint of the upper body, and the navel is halfway between the groin and the nipples. In fashion drawing it is not unusual for the figure to be as much as ten heads high, with the additional length in the legs.

Scale through the association of sizes: The normal-size human figure is the yardstick by which we judge the size of various objects in nature. The viewer automatically assumes the scale of the figure in a painting is correct. If a building seems small in relation to a figure, it looks like a doll house; too big and the figure seems to be in some sort of twilight zone where giants dwell.

Scale through emphasis of the parts (detail): When a shape is explained—or identified as a thing—by many small details, it usually seems smaller than an identical shape which has fewer details. If you want strong shape impact, reduce the size and importance of the details or omit them entirely. Enlarging significant details and reducing their number also lessens the impact of the shapes and forces the viewer to see the picture in a more intimate way; that is, his psychic distance from the picture will be less than the psychic distance depicted by the artist.

Details are not always necessary for at least two reasons: Ordinarily the viewer is not very close to the picture; it hangs on a wall ten or twenty feet away from him. He never sees all those tiny details the artist labored on so long and lovingly. Further, each time he looks at the painting, the viewer provides the missing details in his mind.

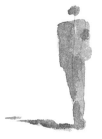

We use the human figure as a measuring stick.

 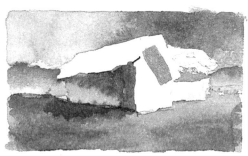

Both buildings are the same height from the lower edge of the picture plane; because the one on the right is larger, it appears closer than the one on the left.

A shape interrupted by many small details loses its impact. The details trivialize the subject and force the viewer to see the trees, not the forest.

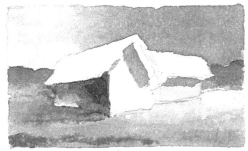 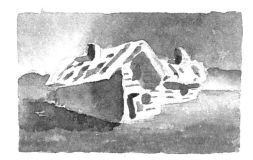

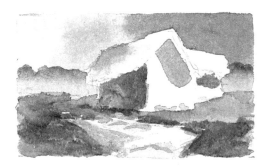 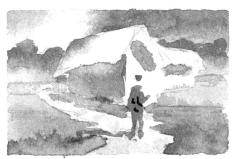

When you introduce an interesting core in front of something, especially if it overlaps the center of interest, you force us to view the center of interest in a more intimate way.

Always leave more negative space at the bottom of the picture than at the top

Yes No

I believe an artist's duty is to make a painting so complete that when it's framed and put on the wall it seems to say, "I'm all there is. There is no more."
—Robert E. Wood.

Perspective is to painting what the bridle is to the horse, the rudder to the ship.
—Leonardo da Vinci

Edges in recession:
Far—blended
Middle—hard
Near—rough brushed

Color in recession:
Far—cool, neutral
Near—warm, intense

Volume Control

Any time you put a mark on a surface, it lies somewhere in relation to the represented volume of the picture box. When the mark seems to exist somewhere behind the picture box's rear wall, we say it "punches a hole in the picture box." If the mark appears to come forward of the picture box, that's disturbing; it feels like somebody just threw a ball through your living room window. Keeping the marks within the represented volume of the picture box, whether that depth is an eighth of an inch or 80 miles, is usually called, "preserving the integrity of the picture plane."

Aerial perspective of the sky is one way to preserve the picture plane. The value sequence is the same as aerial perspective on land. The near, high sky is dark, the distant low sky is light, so the gradation is from dark at the top edge of the painting to light nearer the horizon. Intensity follows the same sequence: the near, high sky is more intense and cooler, the distant, low sky is warmer and more neutral.

The normal color sequence is reversed in aerial perspective. The cools drop out first from the near, high sky; the warms drop out last in the distant, low sky. The high sky is violet-blue; the middle sky, a green-blue; and the low sky takes on a yellowish or reddish cast. The combined effect of aerial perspective in the sky and on the earth creates a feeling of looking inside a hollow cylinder which has been split lengthwise.

If the painter is true to the cone of vision, he will often paint the sky yellow, since only the low sky appears in the painting. The viewer accepts the yellow sky as blue.

Three techniques help control volume in the picture:

Wedging: Introducing a shape between two surfaces increases the sense of volume.

Wrapping: Draping a piece of cloth around an object generates a sense of three-dimensional mass.

Cupping: The umbrella-like effect of a niche or telephone booth also helps to generate a sense of both mass and volume because we are aware of the space within the surfaces.

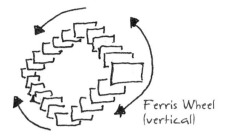

Ferris Wheel
(vertical)

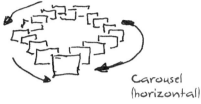

Carousel
(horizontal)

Containment

Any time you have movement into depth you need a way for the eye to return to the picture plane, not only to preserve the picture plane, but also for the sake of unity. Overlapping shapes, as seen on the left, is one way you can accomplish this.

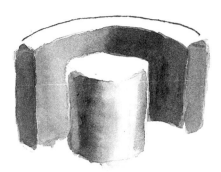

Warping the background so it returns to the picture plane results in a bas-relief effect that preserves the integrity of the picture plane.

A blue sky causes the sheet to "fall over backward." The picture seems to fall away from the viewer.

Cone of Vision

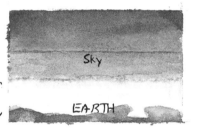

Aerial perspective in the sky returns the upper edge of the picture to the picture plane. A dark cast shadow will anchor the foreground.

A drive into depth by overlapping shapes must be balanced with a return to the picture plane.

Wrapping Cupping

Introducing an axial shape, a central core, increases the sense of space and generates movement and countermovement at the same time. The core forms a stable shape around which the composition revolves the way the tires of your car revolve around the axle.

Wedging

Wrapping and cupping, variations on wedging and overlap, generate a sense of both three-dimensional mass and pictorial space. (Remember, all these circles are flat.)

(After Donald Graham)

When things are partially hidden, they are more interesting.
—George Post

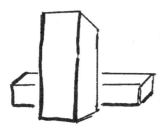

Some space is generated by the two forms.

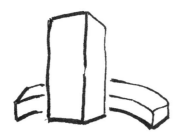

When one form is distorted to accomodate the other form, more space is generated.

When both forms are distorted, maximum space is generated. The distortion may be as exaggerated or as subtle as the artist desires.

(After Donald Graham)

Look Into, Look Through, Look Over

To make a still-life box, cut off the top and two sides of a box. (Drape it if you wish.) Set up a still life within this little corner and see how the interval between the still life and the surfaces that enclose it generates a tangible sense of space. Your still life looks more volumetric than if it were set up against a flat wall. Call it a look-into because you are looking into the still life.

The landscape painter often paints just the enclosing surfaces of, say, buildings. There's a composition you've seen many times in French restaurants of a street corner or plaza, in which the space is defined by the facades of the buildings. Additional space is sometimes generated by overlap or cores and clusters.

The picture box is based on the theatrical convention of the proscenium arch. We look through the enclosing arch into the stage's enclosed space, sort of like peeking through a keyhole. It's a look-through. And a look-through not only creates a sense of space because of the enclosing surfaces but also a certain sense of intimacy because we feel as if we are peeking. (There's a little of the voyeur in all of us.)

Turn the proscenium arch upside down and you have a sense of looking over something into an enclosed space. Call it a look-over.

In most portraits, including still lifes, usually the overlap shingles back and thrusts the center of interest forward. In most landscapes, usually the overlap shingles forward and, at the same time, encloses the center of interest. Even if the center of interest is identical in both paintings, it seems closer in the portrait and farther away in the landscape. Thus the landscape painter and the portrait painter use space very differently when they compose, and the landscape painter may have as much difficulty with portraiture as the portrait artist does with landscape. Their skill is not the issue here; it's how they think that makes the difference.

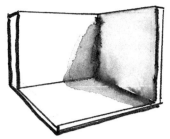

Because the corner encloses the space and the still life, more graphic space is generated than if the still life were simply shown against a wall. It's a look-into.

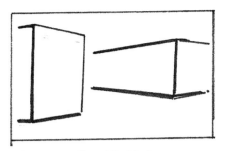

One way the still-life box translates to landscape is by showing a street corner.

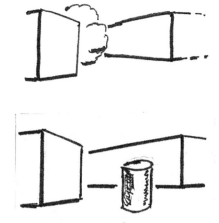

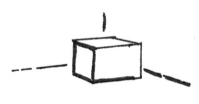

Overlap can add to the sense of space as can a core, which might be a statue, a figure, or a tree.

The picture box is thought of as the enclosing proscenium arch of the theater. It's a look-through and it's based on overlap. (We peek through the keyhole of the proscenium arch.)

Wrapping helps generate the sense of mass. Sometimes figure painters ignore the third dimension of the drapery to the detriment of their painting.

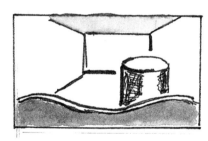
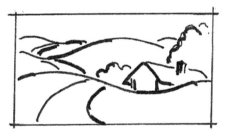

Turn the proscenium arch upside down and it's a look-over. We look over something into the space of the picture box.

Don Graham made his students draw a box within a box every day for 30 days so they would develop a sense of graphic space.

Overlap shingles back, bringing the center of interest forward—the usual still life or figure composition.

Here the overlap shingles forward, pushing the center of interest back, but also creating graphic space. It's an easy way to generate graphic space in a composition, especially in a landscape.

Overlap creates a sort of graphic sandwich, in which the center of interest is the filling.

The easiest composition for the beginner is the panoramic landscape.

—Ed Whitney

Nothing is more difficult to paint than the panoramic landscape.

—Rex Brandt

I don't know why you'd want to say your work comes from nature, because art relates to perception, not nature. But all abstract artists try to tell you that what they do comes from nature, and I'm always trying to tell you that what I do is completely abstract. We're both saying something we want to be true.

—Roy Lichtenstein

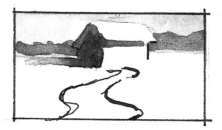

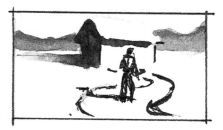

Adding the figure generates space within the picture box.

The Sense of Space

Any time a picture is about a thing or things it's a portrait. A portrait doesn't have to be a person; it can be a lighthouse, a tree, an apple, or a soup can.

Good portrait painters usually are very good at still life, too. However, their work often falls apart when the subject is landscape. The problem is clearly not their drawing skills or their ability to show three dimensions. It's simply that they don't understand how to generate graphic space convincingly.

The portrait artist composes with masses; that is, things. What's left over after the things are painted is the negative space. Unfortunately, negative space does not always generate graphic space convincingly.

Anybody who has ever taken a photograph from one of those scenic outlooks has been disappointed when he got the prints back. The photo was flat and uninteresting because a two-dimensional photograph just can't capture that sense of volume the photographer found so visually exciting.

Take a pencil and move it around inside a bowl or a glass. Try not to touch the sides or bottom. You quickly become very conscious of the space enclosed by the surfaces. The space inside the surfaces becomes more important than the surfaces themselves. Now hold out your hands with the palms facing each other. As you slowly bring your hands closer together, you will experience the space between your palms more vividly. In the same way, the artist uses the surfaces of his positives to generate graphic space in a picture.

Obviously you need both mass and volume; it is simply a question of emphasis. When you draw or paint three-dimensional mass as in a portrait, still life, or a landscape, the negative space serves as volume even though it is not emphasized. When you place the emphasis on surfaces and the relationship between them, the volume becomes almost tangible. You feel almost as if you could put your hand into the space or even walk in it. Mass plays second fiddle to volume.

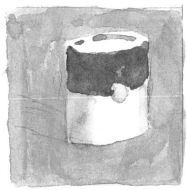

We learn to paint in the studio from objects; but when we go out to paint landscape, volume becomes our subject: we get into trouble because nobody taught us how to paint nothing.

Negative space is always a consideration for the painter, even if the spectator is unaware of it. However, negative space alone does not insure graphic space.

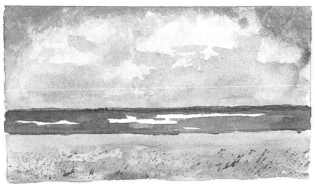

Sand, sea, and sky: There's plenty of negative space here, but not much feeling of real space. We don't feel as though we can walk down the beach to the water's edge. The picture seems surprisingly flat.

Strangely enough, as the amount of negative space diminishes, the sense of graphic space increases. We feel the represented space to be more tangible.

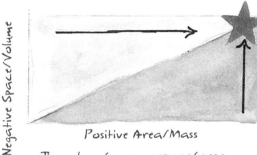

Positive Area/Mass

Negative Space/Volume

The volume/mass or space/area matrix: As the amount of negative space decreases and the area devoted to the positives increases, the sense of volume or graphic space increases.

The punch bowl encloses space. If we think of the punch bowl's interior surfaces, we can literally see the space in much the same way we see a parking space between two parked cars in the parking lot. We don't see the cars; we see their surfaces as the boundaries of the parking space.

An aspic mold or an angel-food cake pan defines space even more clearly because of the center core.

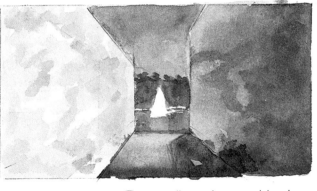

Two walls and a road lead down to the water. As we walk down the path toward the water and the walls seem to come closer together, the sense of space becomes more vivid.

The sense of enclosed space feels almost like peeking through a keyhole.

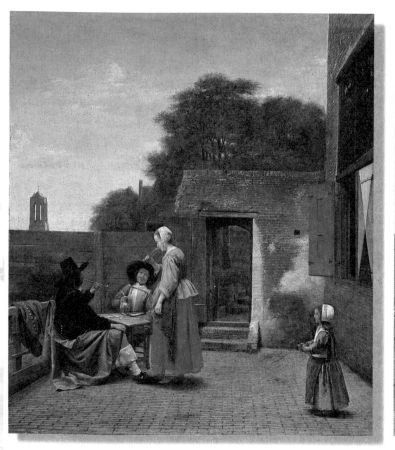

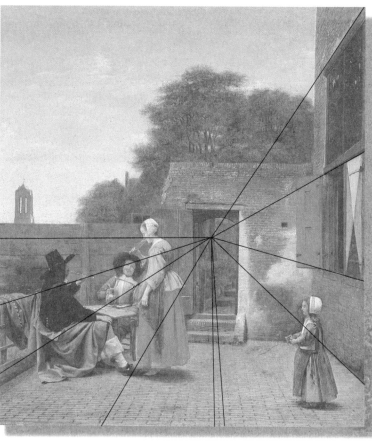

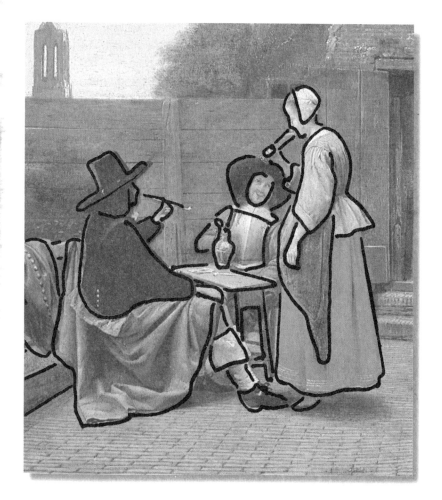

Pieter de Hooch painted a virtual textbook on how to represent volume. He used linear perspective, aerial perspective, overlap, enclosed surfaces, look-throughs, look-intos, look-overs, diminished repeats, proportional spacing, cores, clusters, and more in this marvelously instructive painting. You may want to use tracing paper to explore exactly how De Hooch used overlap and linear perspective.

In fact, De Hooch's painting is a remarkable summary of aesthetic principles and materials. It's a painting that will repay your study many times over.

The Bridge

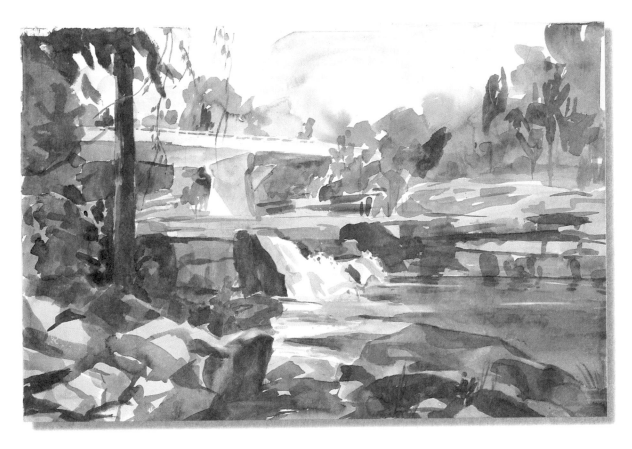

Painting is only a bridge linking the painter's mind with that of
the viewer.

—Eugène Delacroix

> Art is the desire of man to express himself, to record the reactions of his personality to the world he lives in.
>
> —Amy Lowell

> Intellect is to emotion as our clothes are to our bodies: We could not very well have civilized life without clothes, but we would be in a very poor way without bodies.
>
> —Alfred North Whitehead

> Life being all inclusion and confusion, and art being all discrimination and selection, the later in search of the hard latent value with which it alone is concerned, sniffs around the mass as instinctively as a dog suspicious of some buried bone.
>
> —Henry James

> Painting is founded on the heart controlled by the head.
>
> —Cézanne

> Give the paint a chance, give the brush a chance.
>
> —John Marin

> Take nothing for granted as beautiful or ugly.
>
> —Frank Lloyd Wright

Style, the Bridge From Theory to Practice

Some things you can do something about and others you can't. For example, you can't change when and where you were born. Whether he wants to or not, every artist reflects his time. All of us carry the accumulated baggage of our time and culture, and there's not a thing we can do about it.

Still, art is always about making choices. The sum of the choices that the artist makes equals his personal visual idiom or style. As long as those choices are reasonably consistent, his style will be recognizable and personal. This doesn't mean the artist is locked into those choices forever; skills can always be improved and taste and interest are always subject to change.

You don't have to draw well to produce pretty good art. The invention of the camera did away with the need for traditional academic drawing. Looking at the mature work of Klee, Miró, Pollack, and Chagall, I don't see much in the way of traditional academic drawing skills. Like many artists with the skills to work anywhere on the concept-related/image-related continuum, these artists deliberately chose to work at the simpler, concept-related end. If you don't have much confidence in your drawing skills, work closer to the concept-related end of the scale.

We've now explored many of the choices the artist makes in creating pictures and developing a personal style. If you want to make pictures, the search for a personal style can take years of trial and error. Or you can be more efficient, and make some choices based on what you can do and on what you think looks good on the wall. You can base your decisions on the framework of possibilities in the preceding sections. Start anywhere you want, but start with something definite. That will give you a solid foundation upon which your style can grow, develop, and change organically.

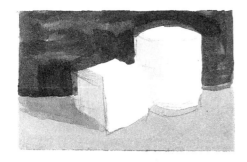
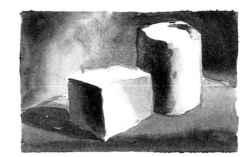

Represented mass and volume result in a mood of strength.

Different value relationships carry different emotional meanings.

Different color relationships carry different emotional meanings.

The effect of passage:
Lights merge into lights,
darks merge into darks,
darks grip lights like tongs.

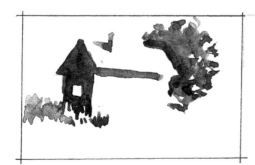
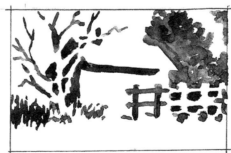

The graphic sandwich.

Overlap and counterchange.

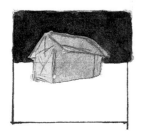
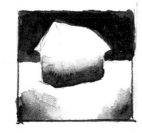
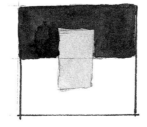
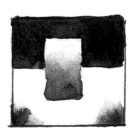

Simultaneous contrast of value.

The Bridge

1. <u>Vision</u>: Which mode best represents how you want to paint?
 a. Through-the-Window
 b. Selective
 c. Light-and-Shade
 d. Focus-and-Fringe
 e. Fringe Realism/ Impressionism
 f. Dynamic
 g. Dream-World

2. <u>Image-Related/Concept-Related</u>: Where do you fall on the scale?

3. <u>Linear or Painterly</u>: Which do you prefer?

4. <u>Objective or Expressionist</u>: Which best describes your painting?

5. <u>Value or Color</u>: Which do you consider more important?

6. <u>Key</u>: Which do you prefer?

7. <u>Temperature</u>: Do you prefer warm or cool paintings?

8. <u>Volume</u>: Do you prefer paintings that suggest volume, or flat, decorative paintings?

9. <u>Color Organization</u>: Do you usually use:
 a. Contrast
 b. Gradation
 c. Theme and Variations

10. <u>Use of Color</u>: Do you ordinarily use color as:
 a. Local Color
 b. Space and Atmosphere
 c. Light and Shade
 d. Emphasis
 e. Rhythm and Motion
 f. Emotionally Expressive

Personal Profile

You've seen many scales on which to locate your own work or the work of other artists. The composite of all these scales draws a profile of an artist's style. If you profile your own work and also the work you want to emulate, you will see where you are and where you'd like to be. For example, a friend of mine is unhappy about her color, although she loves color. Her profile showed her where she needed to change: She genuinely admires the expressionist use of color, but continues to use local color.

This chart is hardly the last word on style, but it can be a starting place to spark your thinking. (You may wish to use different criteria to develop your own chart or profile.)

1 a._____ b._____ c._____ d._____ e._____ f._____ g._____

2 Image-Related Concept-Related

3 Linear Painterly

4 Objective Expressionist

5 Value Color

6 High-Key Low-Key

7 Warm Cool

8 Volume Decorative

9 a._____ b._____ c._____

10 a._____ b._____ c._____ d._____ e._____ f._____

Using a pencil, mark on each scale the qualities that appeal to you in a painting. Connect the marks to draw a profile. Then, using a different color pencil, mark on each scale the qualities you ordinarily find in your current work. You may see areas where you'll want to make some changes.

- Planning
- Painting
- Editing

Procedure

A recipe for bread has a sequence of steps we must follow in the proper order. Change the order and we do not get bread.

—Donald J. Lofland

To be without method is deplorable, but to depend entirely on method is worse. You must first learn to observe the rules faithfully; afterward, to modify them according to your intelligence and capacity.

—Lu Ch'ai

I hate it when I put the cart before the horse.

—Helen Van Wyk

Planning

In one way, painting a picture is no different from flying an airplane, performing brain surgery, hitting a golf ball, or giving a dinner party; follow professional procedure, and your results will be more professional.

What's one difference between the professional and the amateur? Consistent results. If you go to a favorite restaurant and order the same meal you ordered six months or even a year ago, it tastes the same as it did then; that's professionalism. The secret of its consistency is materials and procedure: similar ingredients, prepared and served the same way every time. Change the ingredients and you change the taste. Change the steps and you change not only the taste, but the product. A procedure is just an orderly progression of steps, repeated every time to insure consistent results.

Following a strict procedure doesn't make you less creative or limit your growth; on the contrary, it provides a platform for experiment and growth because it frees you from the minutia of technique and allows you to concentrate on what you want to express.

Three-Step Procedure: Most productions, whether making a movie or giving a dinner party, are done in three separate stages: Pre-Production, the planning stage; Production, the painting stage; Post-Production, the editing stage.

Nobody ever has enough time. Of course, the more time you have, the more polished your work may look. If you had nothing else to do for a year but work on one painting, it could look like a Van Eyck. If you have only an hour or two, the result will necessarily look less "finished," but it won't necessarily be less good.

The painter's deadlines are usually self-imposed; nowhere is it written that you must complete the entire painting in an hour, or even a day. You gain time when you plan before you paint and by refusing to hurry during the final stage.

Painting is a three-step process: planning, painting, and editing. The ideal is to spend a third of the time available on each step.

Caution: Don't overfinish the painting in the early stages. Usually the better it looks in the early stages the worse it looks when it is finished.

On location or in a workshop, feeling the pressure of time, the painter ignores the planning stage and jumps right into the painting stage. He's absorbed in what he's doing, time runs out, and, to have a finished painting for the critique, he hastily finishes the painting with ill-considered darks. The painting looked better before he "finished" it. He finished it all right; he killed it.

Location time is precious. Try to spend at least half your time there gathering information, making notated sketches, color notes, etc. Don't try to finish on the spot; instead, finish it in your studio or, like Monet, go back to the location a second or third time.

Anticipate by planning ahead. Life always has surprises, but there are a lot of non-surprises, too; and you can at least prepare for some of them. Sometimes it seems we try to plan everything in our lives except our paintings —and it shows in our paintings.

Allot your time so that you spend half of your stay at the location in planning and the rest in painting. Then complete the painting back in the studio.

Even if you spend only 20 minutes of an hour on location making a notated sketch to keep as a permanent record, you still have 40 minutes to get down the broad outlines of your painting.

Save the finishing touches for later. Give yourself a little distance from your work and maybe get some advice before finishing it. Look at it hanging on the wall to confirm that at least it looks better than the wall and thus fulfills functional type.

Canvas: 16 x 20
Paper: ½ sheet
Time: 20 minutes

Canvas: 12 x 16
Paper: ¼ sheet
Time: 10 minutes

Quickies:

Canvas: 9 x 12
Paper: ⅛ sheet
Time: 5 minutes

Quickies loosen you up in a hurry after you've finished the planning process and before you jump into the painting process. They're a great way to warm up and also a good way to end a session on a high. Take less than a minute for each inch of the long dimension. Use a kitchen timer and drop the brush when you hear the bell. Don't say, "One more stroke won't make a difference." It will. Don't even think about it! (Quickies build character because the temptation to add just one more stroke is nearly irresistible.) Don't be in too much of a hurry to judge them. Put your quickies away for a week or so and then look at them. They may surprise you by their color and freshness.

I shall not pass this way again.
—Stephen Grellet

The Beaufort Scale (from 1 to 5) is accepted shorthand for wind, speed, and direction.

1. Light air, 1-3 mph, smoke drifts slowly.

2. Slight or light breeze, 4-7 mph, leaves rustle, wind felt on face.

3. Gentle breeze, 8-12 mph, light flags extended, small branches move.

4. Moderate breeze, 13-18mph, raises dust, papers, and leaves; all flags extended.

5. Fresh breeze, 19-24 mph, flags snap briskly.

Symbolize the effect of an invisible force like wind or gravity to give energy to your painting. The color of smoke is warmer nearer its source.

The Notated Sketch

The notated sketch is the cornerstone upon which professional quality painting rests. It offers three advantages over direct painting in the field:

Portability: A sketchbook, or even a sheet of paper, and a pencil that yields two values are all you need.

Time: Once you have some experience in making notated sketches, it takes no more than 20 minutes to make even the most detailed one.

Emotional Intensity: No one can sustain a high level of emotional intensity for very long before concentration lapses. The short time it takes to make a notated sketch ensures concentrated seeing and deep involvement with the subject.

Once you sell a painting, it's gone forever; but you'll keep your notated sketch forever. It will help you recall everything about a particular subject and day; not just how it looked, but even how it felt. I profoundly regret having spent my time in workshops in Maine and California making paintings for the crit and not making notated sketches. Some of those locations still haunt me. I think I could resolve them now, but I have nothing to go on. Even if I were to return to those locations today, they have changed greatly since I was last there. It would've been better if I had not had paintings for crit, but instead had notated sketches for the rest of my life.

Studio or Plein Air: Everyone enjoys painting directly from their subject, whether it's landscape, still life, or figure. The evidence, however, is overwhelmingly in favor of gathering information and inspiration in the field and then painting in the studio. Modern scholarship shows that much of the work on many Impressionist masterpieces was done in the studio, not *sur le motif.* Even a top portrait painter works on commissions between sittings so that he is not intimidated by the need to capture a likeness as he develops his design. When the sitter returns, the painter works on getting a likeness without losing his design.

A simple cone precisely reports the direction of the light.

A simple compass orients you to the direction.

Wind speed and direction can be reported in relation to the compass. Here it is southeasterly about 15 miles an hour.

Make the pattern scheme with a brush, not a pencil or felt-tipped pen. It's not only good practice, it's faster.

Use a pie chart to explain cloud cover.

$^{1}/_{4}$ $^{5}/_{8}$

Cumulus

Stratus

Cirrus

The notated sketch has three essential components:
- A postcard-sized, three-value pattern scheme proportionate to the finished painting with color notations and three-dimensional notations;
- Diagrams of structure for anything that seems too complicated to remember. If anything in the diagram is too small to explain the detail, make an enlarged diagram of the detail.
<u>Diagrams, not drawings;</u>
- Written or visual notes covering all five senses.

Humidity affects aerial perspective. (Fog is humidity, too.)

Make note of anything that will help you remember:
 Place:
 Time:
 Temperature:
 Humidity:
 Sound:
 Taste:
 Touch:
 Smell:
 News Events:
 Date:

Temp.	Relative Humidity					
86°F.	16%	24%	31%	45%	57%	100%
68°F.	28%	42%	54%	79%	100%	
61°F.	36%	53%	69%	100%		
50°F.	52%	77%	100%			
43°F.	67%	100%				
32°F.	100%					
	4.35	7.27	9.41	13.65	17.31	30.4

Grams of water vapor per cubic meter at 100%

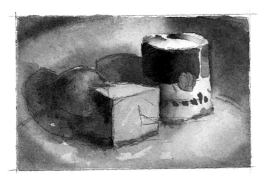

Deconstruction begins here.

Sometimes you try to make it happen instead of just letting it happen.

—Ken Venturi

Most people are more comfortable drawing first, then developing pattern.

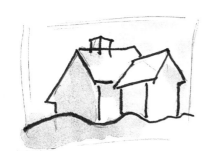

It's more creative and results in a better picture if you make a pattern first, then draw.

The Plan View

Think of every painting—not just a landscape—as having three planes: background, middle ground, and foreground.

We paint what we see, and what we usually see is an elevation or a series of overlapping elevations. An elevation is a side view of something, while a plan view is a bird's-eye view. The plan view explains the spatial relationships of the positives as if they were seen from above in the same way a floor plan explains the spatial relationships of your furniture. Often something seems wrong with a painting but you can't quite put your finger on what the problem is. Usually the problem is a hole, an empty area or areas not always readily apparent in the elevation but immediately apparent in the plan.

The Graphic Hole: When the painting or pattern scheme seems sparse, it's usually because all the interest is in the foreground and background, and the middle ground is empty. The picture is like a cheap chocolate rabbit; when you bite into it, there's nothing there. The empty middle ground is called a graphic hole.

A graphic hole becomes particularly evident when the painting uses a strong horizontal—like a floor line or the horizon—to suggest a large area. An easy way to avoid this is by thinking of the plan view as a chessboard that has three rows (foreground, middle ground, and background) and as many columns as you need to fill the space. Then, just make sure there are objects in every row.

When you raise the plan to an elevation, the negative areas often seem too large. Negative space is easily filled with inventions based on the artist's knowledge of natural phenomena. One shrub more or less, in the right place, can make a big difference to your finished painting.

The notated sketch serves as a first pattern scheme. A second scheme based on a plan view further refines the pattern.

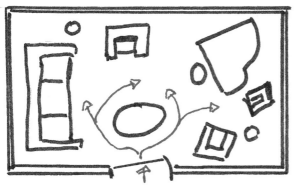

Circulation studies: With a floor plan you can explore different arrangements of furniture and create different traffic patterns.

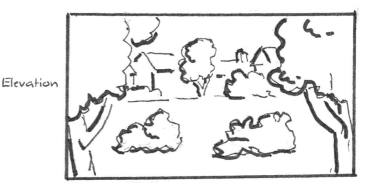

Elevation

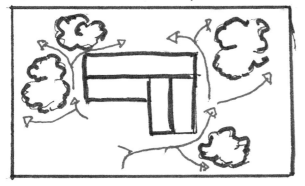

The plan view in a landscape reveals the paths the viewer's eye will follow as he looks at the painting. The technical term is "circulation." The plan view reveals what needs to be moved around to achieve a satisfactory pictorial arrangement.

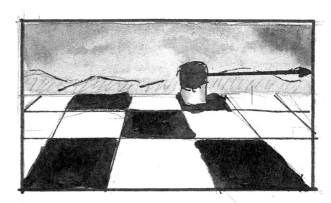

Plan

A plan view with three zones immediately reveals empty areas that may otherwise go unnoticed, to the final picture's detriment.

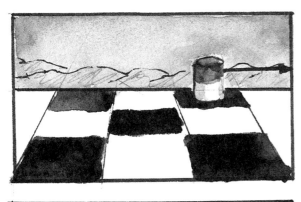

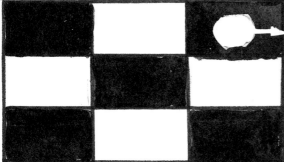

A conventional projection doesn't work in deep space pictures because the shapes in the elevation are not the same distance from the sides of the picture as the shapes in the plan.

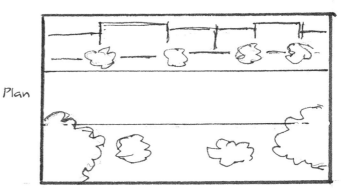

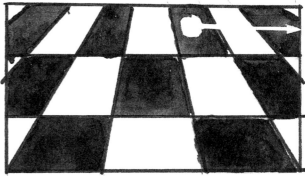

In a non-conventional projection, the plan view also recedes to a vanishing point, but the horizontals that mark the zones are not foreshortened. This way, when the elevation is raised, the shapes are directly above their locations in the plan.

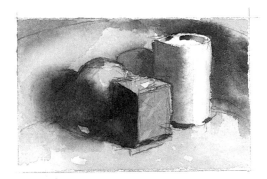

If you wind up with a successful pattern, you've got a successful painting. To wind up with a successful pattern, you've got to make pattern schemes.

—Ed Whitney

The more wise and powerful a master, the more directly his work is created and the simpler it is.

—Meister Eckhart

Making just one is a waste of time.

—Robert E. Wood

Never let yourself forget—you always build your drawing, starting with a loose sketch and then fleshing it out. It's the professional way, the best way.

—Stan Lee and John Buscema

All human error is impatience, a premature renunciation of method.

—Franz Kafka

Pattern Schemes

*E*very reputable painting instructor and every instruction book says the same thing: "Make pattern schemes before you paint."

The pattern scheme should be limited to the span of the attention, with somewhere from five to nine areas. If it has five areas, at least three will be positives and two, negatives. If it has nine areas, at least five will be positives and four may be negatives. Always have more positive areas than negative areas.

The postcard-sized pattern scheme provides a surprisingly accurate preview of how the finished painting will look on the wall. When I look at a half-sheet painting from about 14 feet away, the width of the painting appears to be about three and a half inches. My pattern scheme for that painting was standard postcard size, six inches wide. My pattern scheme was actually larger than the finished painting appeared to be on the wall.

The sketchbooks and studios of every great artist, from Leonardo and Raphael to Cézanne, Matisse, and Picasso, or Andrew Wyeth and Norman Rockwell, attest to the importance of the planning stage and pattern schemes. Every commercial artist or art director does dozens of quick roughs, or thumbnails, before he develops a finished layout. Even after a lifetime of experience, the great illustrator, Dean Cornwell, said that he made 50 pattern schemes as a matter of course before he ever made an illustration. If professional artists with international reputations find it important to spend time on this stage, why do so many artists think they can ignore it?

Painter Emile Gruppé recommends dividing a three-by-five card into four small rectangles and developing a thumbnail scheme within each rectangle. When you develop patterns this small, you'll be selective. There's no way you're going to get much detail in them, so your patterns become broad, powerful statements, each with a single dominant area or element.

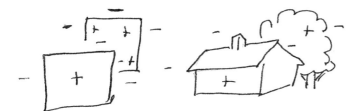

An area may represent a positive and, at the same time, serve as a negative for a positive that overlaps it.

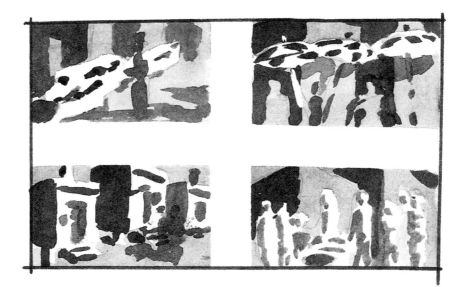

Four quick thumbnails on a standard 3 x 5 index card force the painter to be selective.

Step 1: A simple layout with five to nine circles indicating areas. More areas are positive than negative.

Step 2: A rough indication of subject matter. Always draw from back to front. In figure work it's called "drawing through the form."

Step 3: Paint the pattern of form, shadow, and dark local values.

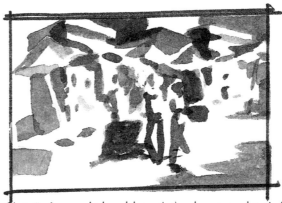

Step 4: As needed, add cast shadows and paint negative areas as holding darks to meet the demands of the design. Create passages of linked darks and save other passages of linked lights.

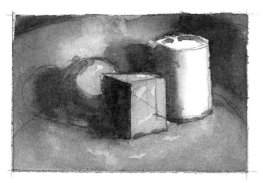

More painters have labored more long hours trying to fit square ideas into long shapes, and vice versa, than can possibly be imagined. I rank poor choice of format with bad color as the most common oversights in painting.

— Rex Brandt

Fit natural phenomena into the pattern scheme. Anything else, and you're doing the job ass backwards.

— Ed Whitney

Format and Horizon

Every subject forces the artist to choose from among a variety of options. Quick thumbnail roughs—pattern schemes and color plans—allow him to explore these options and avoid dead ends when he actually begins painting his picture.

Format: The first and most important shape in any painting is its format—the shape of the canvas, paper, or panel. Most paintings are either horizontal, vertical, or square. The edges of the picture are the longest lines in the picture, and so the format is expressive in the same way that line is. For example, a vertical format signals dignity in the same way as a vertical line; while a horizontal format, like a horizontal line, suggests calm.

The square's decorative potential is often overlooked. Because it is an innate standard shape, the square offers an attractive choice; and it's not difficult to design the square dynamically when you use the Golden Section to divide the space. The reason most painters use rectangles is that standard sheets, canvases, and frames come that way.

Scale: Several factors come into play here: time (if you have only a limited amount of time, it makes sense to choose a smaller format); skill level (the smaller the format the easier it is to design and execute); and cost (smaller is cheaper).

The difficulty of the large format stems from this optical problem: You can't enlarge more than about an inch and a half in any direction without some sort of change and that increases the difficulty geometrically, not arithmetically. You'd think it would be twice as hard to paint a full sheet (22"x 30") as a half-sheet (15"x 22"), but it's ten times as hard!

Most spectators (including many judges) think that big paintings are somehow more important than small paintings. That's not true, of course. I am always surprised by Van Gogh's paintings. In reproduction they look big because they have big shapes and big ideas. But the canvases themselves are small because Van Gogh couldn't afford anything larger.

Format:

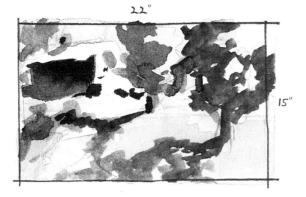

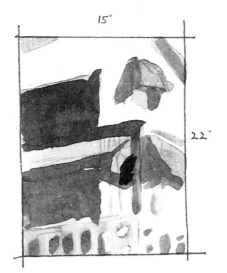

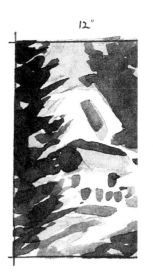

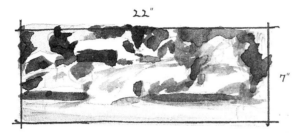

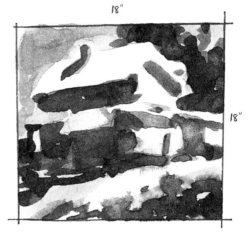

Too often the painter permits the materials manufacturer to dictate the most important creative decision in painting, the format. The painter uses the standard half sheet, quarter sheet, or eighth sheet because it's easy. But cutting a 15-inch-square format from one of the half sheets yields different, expressive formats. This way you always have a variety of formats from which to choose in selecting one that complements your painting idea.

Different formats suggest different emotional ideas. Go beyond the obvious. Never be satisfied with your first idea until you've tried alternatives.

Horizon:

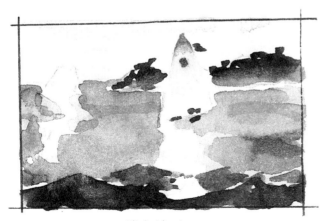

High Horizon

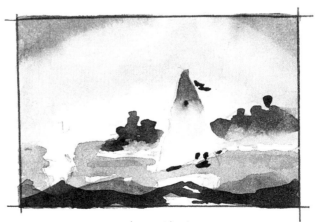

Low Horizon

The high horizon yields a flat, topographical pattern that looks like an aerial photograph. It flattens the shapes in the same way as a plan view does, and the result is usually a flat, decorative, Cézanne-ish treatment of the picture plane. The low horizon is always dramatic and simpler to paint than the high horizon picture because it favors overlap relationships. The problem with the low horizon is that there's usually too much negative space.

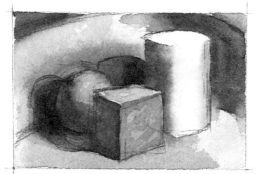

Think pattern first, then drawing, then color. The character of your painting is resolved in the pattern scheme.
—Ed Whitney

Half the time when I paint, I'm twenty feet back.
—Barse Miller

Low-key paintings outsell high-key paintings two to one.
—Dalzell Hatfield

If one special plan occurs out of ten, I consider the time well spent.
—Robert E. Wood

Point of View and Key

Like the still photographer or movie director, the artist must choose a point of view which, in turn, determines the degree of his viewer's involvement in his picture. The closer the artist's viewpoint, the closer and more intimate the viewer feels he is to the subject. Georgia O'Keefe's large-scale flower paintings invite intimacy with their extremely close point of view.

Far Point of View: The long shot or panorama suggests vastness and open spaces. Some teachers think this is the easiest point of view for the beginner while others claim it is the most difficult of all viewpoints. Both are correct; the panoramic view eliminates most drawing problems. All the beginner has to do is divide the space into two unequal areas and paint the upper portion in light sky colors and the lower portion in darker earth tones to have a credible painting. However, the sky often lacks any feeling of volume, and the painting fails to express the sense of space that is the very essence of the panorama.

Middle Distance Point of View: Moving closer eliminates a lot of negative space and, because it reduces the depth of the picture box, it is easier to control volume. Since the sense of space sets painting apart from photography, this becomes a workhorse viewpoint for many realistic painters.

Close-up Point of View: Because of the limited psychological distance between the viewer and the painting, the spectator feels an intimate relationship to the painting and its subject matter. The near point of view can be dramatic to the point of appearing melodramatic.

High and Low Keys: In a high-key painting, the darkest value in the painting is a midtone. High-key paintings have a feeling of delicacy, but because they don't have the strong light/dark contrasts which usually describe a finished picture, they sometimes seem tentative and unfinished. In a low-key painting, the lightest value is a midtone. Low-key paintings have a feeling of strength to them and always look finished.

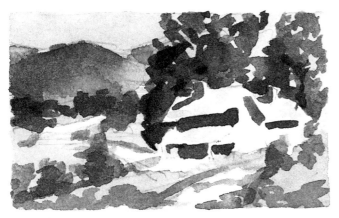

Far point of view: gives a sense of volume, which is the essence of this viewpoint. However, too much negative space may result in a flat, decorative feeling.

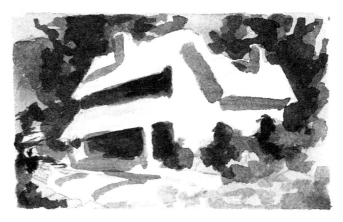

Middle distance point of view: probably the most serviceable for the landscape painter. Its drawback is that it's used so often that it may look commonplace, unless it's treated as a bird's-eye or worm's-eye view.

Close-up point of view: usually more dramatic than either the panoramic or middle distance points of view.

Extreme close-up: most dramatic, sometimes melodramatic. Use carefully.

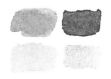 High key: has a feeling of lightness and delicacy. The darkest value in the painting is a midtone (here yellow ochre). A high-key painting looks the way a harp sounds.

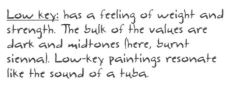 Low key: has a feeling of weight and strength. The bulk of the values are dark and midtones (here, burnt sienna). Low-key paintings resonate like the sound of a tuba.

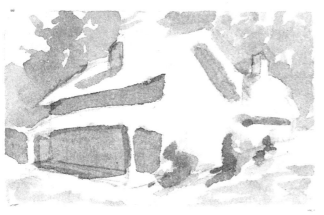

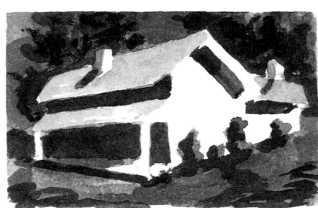

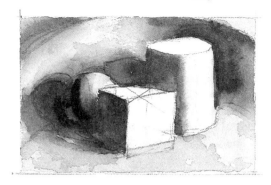

Ways to Use Color:
Local color
Color for space and atmosphere
Color as light
Rhythm and motion
Emphasis
Expression (emotion)
Formal

Variations on a Single Color:

Intense only

Neutral only

Intense dominant

Neutral dominant

Intense only/
warm dominant

Neutral only/
warm dominant

Intense dominant/
warm dominant

Neutral dominant/
warm dominant

Intense only/
cool dominant

Neutral only/
cool dominant

Intense dominant/
cool dominant

Color Plans

Color plans carry pattern schemes one step further to include hue and intensity. Because value is more important than hue, the dark/light pattern should be resolved before jumping into color plans.

There are only three basic color schemes and each is based on a design principle:

1. Monochromatic, based on theme and variations.
2. Analogous, based on gradation.
3. Complementary, based on contrast.

The design principle of restraint states that one color is better than two and two colors are better than three. Two colors, a warm and a cool, are all you need to express sunlight and shadow. (A neutral and a warm—or a neutral and a cool—are also sufficient to express sunlight and shadow because of simultaneous contrast; the warm makes the neutral look cool and vice versa.) Three pigment primaries are all anyone needs to express a full range of color.

The possibilities for color are endless. Before you even consider high, low, and middle key, take the choices inherent in a monochromatic palette, for example, as shown at left.

Just as with pattern schemes, the more color plans you explore, the better your finished painting will be. Thinking of them as little paintings and using them for birthday cards, postcards, or Christmas cards may make doing them seem less tedious. Anyone familiar with the affective sequence knows that the thing mildly disliked becomes, in time, the thing most liked. Keep at it and you'll soon enjoy making color plans.

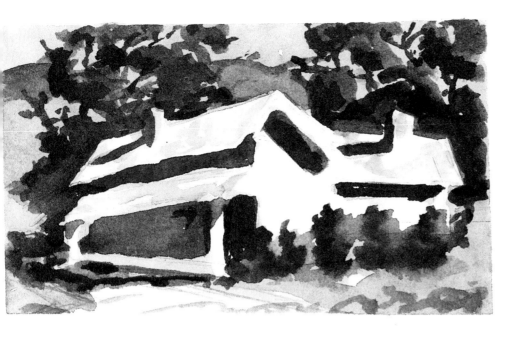

Monochromatic
(Theme and Variations)

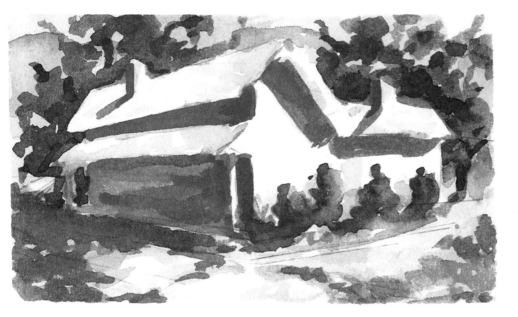

Analogous
(Gradation)

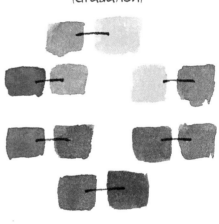

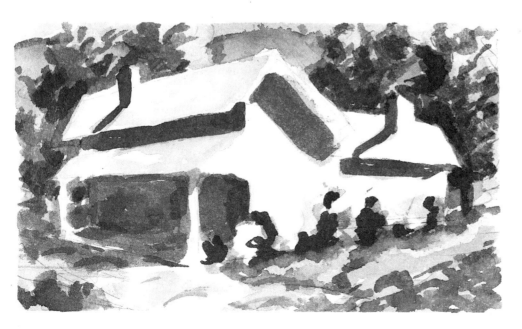

Complementary
(Contrast)

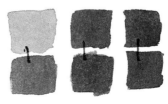

169

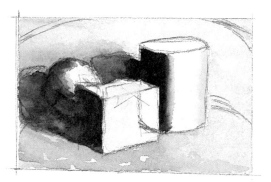

Nature contains the elements, in color and form, of all pictures as the keyboard contains the notes of all music. But the artist is born to pick and choose and group, with science, those elements, that the result may be beautiful....to say to the painter that nature is to be taken as she is, is to say to the player that he may sit on the piano.

—James McNeill Whistler

Subject matter is not nearly as important as the arrangement of the elements into a pattern.

—Ted Kautsky

If life were organized, there would be no need for art.

—André Gide

Don't paint something that is so subtle that no one understands it.

—Helen Van Wyk

The standards of quality are those that tell us how to put the right mark in the right place.

—Edward R. Tufte

Composition

Composition is what's left over after you've eliminated everything it's not. Composition is not how; the hows of painting are technique, the different ways pigments are applied to achieve different effects. Composition is not subject matter; the identical composition can be equally effective as still life, figure, or landscape. Composition is not drawing; otherwise, nonobjective art would not qualify as art. Composition is not color; if it were, Rembrandt's etchings wouldn't be art. What's left?

Composition is *where*—simply putting the right mark and the right color in the right place.

You'll find the secret to good composition in your kitchen drawer with your everyday silverware. That drawer is partitioned off into a grid that illustrates the principle of alignment. Knives, forks, and spoons each have their own compartment (the principle of proximity). The drawer may hold dinner forks and salad forks; regular knives and butter knives; teaspoons, tablespoons, and soup spoons (the principle of theme and variations).

Next to the silverware drawer there's probably a junk drawer containing all those odds and ends that don't seem to fit anywhere else. Compared to your silverware drawer, it's a mess. The junk drawer is comparable to the order found in nature. There may be some kind of organization to it, but it's not apparent to rational man.

Every organization is a hierarchy in which some things are more important than others. Similarly, a well-composed painting is an organization chart of its elements. The viewer knows right away what's important and what's not.

Yes, a painting may look as if it were uncomposed in the same way a dance may appear spontaneous. Watch the title dance number *Singing in the Rain*. We recognize (at least on an intuitive level) that Gene Kelly's dancing is composed. A work of art is always composed, and it requires considerable artifice to make it look spontaneous.

The theme is blue triangles (they could be sailboats). The order is random and appears random.

The theme is still blue triangles. But because here they are clearly organized by a gradational line, we recognize that the picture is composed.

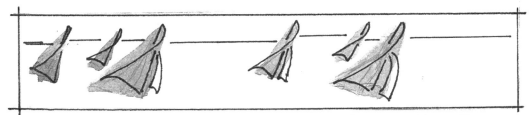

Here the random sequence is repeated, but it could just be a coincidence. The spectator cannot be sure of the artist's intention.

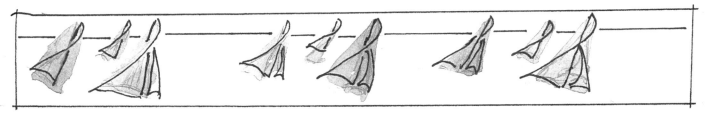

Repeating the random sequence a third time shows that it's no accident.

Alignment: Every element should bear a clear visual relationship to at least one other element, forming the painting's underlying grid. The grid may be oblique as well as horizontal and vertical.

Proximity: Similar shapes are grouped together, thus unifying the composition. There's a row of circles, a row of rectangles, and a row of triangles. (I've suggested one way the shapes can be translated into subject matter.)

The point is, something must be organized. If you don't want to organize the shapes, you must organize the color. Here the groups of shapes are different but similar colors unify each group.

The whole business is largely a confidence trick. Half the battle in learning to draw is believing and knowing that you can.
—Rowland Hilder

If you don't know how to pronounce a word, say it loud.
—Will Strunk, Jr.

If you know you can't do it, don't do it. Disguise it somehow.
—Helen Van Wyk

You only learn to paint by drawing, for drawing is a way of reserving a place for color in advance.
—André L'Hote

Draw it carefully in your mind, then write it down quickly.
—John Marin

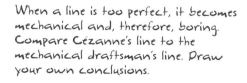

When a line is too perfect, it becomes mechanical and, therefore, boring. Compare Cézanne's line to the mechanical draftsman's line. Draw your own conclusions.

Drawing

If you can print your name, you can draw. Drawing is not some mysterious gift reserved for the chosen few. It is an acquired skill no different from the acquired skill of writing. Simply being interested enough to work at developing the skill is the mysterious gift. You don't have to be able to draw in order to paint. Although Jackson Pollack drew very well, there's no drawing in his drip paintings. Still, the realistic painter needs some knowledge of drawing.

Drawing is 80 percent seeing and 20 percent knowledge of structure. "Seeing" means seeing objects in their simplest geometric equivalents before you see them as flowers, faces, or trees. Seeing in this way results in simplified, geometric ways to report structure, called schemata. It's easier to base your drawing on the innate, standard forms and volumes and then develop an accurate representation of your subject by refining these simple shapes than doing it the other way around.

There are three basic elements in drawing: anatomy, proportion, and perspective.

Anatomy: You have to learn a little about anatomy, the structure of things, but once you know some anatomy, it's easy to use innate, standard forms to represent your subject. Always look for the backbone, which is your subject's center line or axis; it's the crucial design line on which your drawing hangs.

Proportion: How big things are in relation to each other and where they are in relation to each other and distances between things.

Perspective: The most important perspectives for the realistic artist are Italian and light-and-shade.

Don't feel bad if you don't think you draw very well. Toward the end of his life even Leonardo da Vinci regretted that he had never learned to draw better. Besides, every good drawing is always "flawed" in some way.

Think of it this way: Drawing, like painting, is a matter of corrections. The draftsman gropes until he finds the line.

Anatomy of a Boat

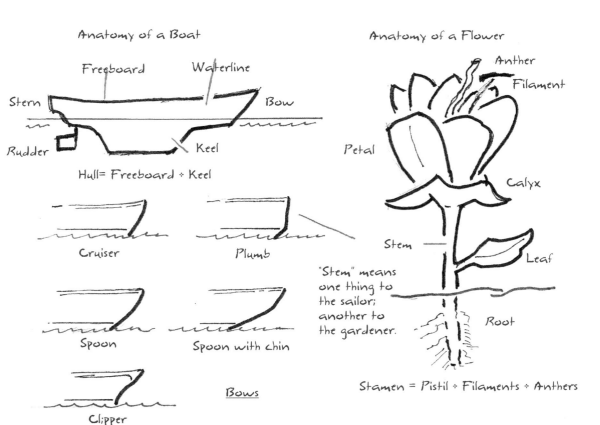

Freeboard

Waterline

Stern

Bow

Rudder

Keel

Hull = Freeboard + Keel

Cruiser

Plumb

Spoon

Spoon with chin

Clipper

Bows

Anatomy of a Flower

Anther

Filament

Petal

Calyx

Stem

Leaf

Root

"Stem" means one thing to the sailor; another to the gardener.

Stamen = Pistil + Filaments + Anthers

Contour Drawing: Put pencil to paper and don't take your eyes off the subject. When you feel the pencil touch the subject—and you will—slowly feel your way around the form.

Gesture Drawing: The hand dances as it tries to capture what the subject is doing with rapid, broad movements.

Schema: Here I saw the apple first as a cylinder and then developed the referential image a little.

Anatomy is largely a matter of vocabulary; if you can name it, you own it. Vocabulary is the first step to expertise. Everything has an anatomy, even ideas. Anatomy tells you what you're looking at or what to look for. The spectator may not be expert enough to tell you what's wrong with the anatomy, but he's seen what you're drawing thousands of times and he'll sense it when something's not quite right.

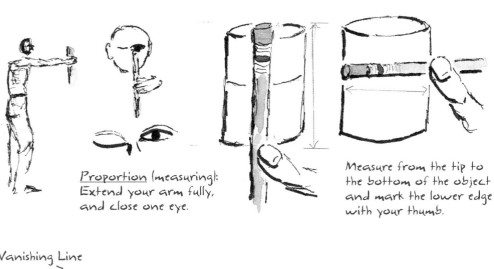

Proportion (measuring): Extend your arm fully, and close one eye.

Measure from the tip to the bottom of the object and mark the lower edge with your thumb.

Drawing knots so clearly that someone could tie them from your drawing teaches you to explain complex, intertwined structures, like muscle and bone.

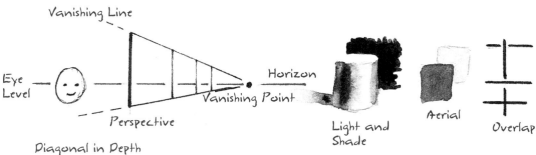

Vanishing Line

Eye Level

Horizon

Vanishing Point

Perspective

Diagonal in Depth

Light and Shade

Aerial

Overlap

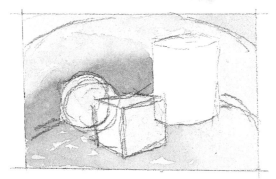

You don't get hung up on the scalpel if you're a surgeon. You get hung up on what the scalpel will do.

—Artie Shaw

What makes a great artist? In the end, it is temperament, personality, and character that count the most. Some musicians are not great technicians, but they give you a rich point of view. In an increasingly mechanized, regulated, and computerized world, there is a need for the handcrafted thing, a reminder of man's ability to feel and communicate emotion, including his love of tools and materials.

—Nathan Milstein

Art is just like golf: a series of natural gestures.

—John Marin

Painting

With the preliminaries out of the way, we can now begin the second stage of the painting process—applying paint to a surface. This second stage involves technique, which is the way you apply your pigments to your canvas or paper. Good technique alone does not necessarily result in good painting any more than good typing results in good writing. However, good technique does make it easier for you to express yourself.

I once watched Julia Child demonstrate how to dice an onion on television, and it changed the way I dice onions. But, although my technique improved, my cooking didn't necessarily improve. My dinner guests didn't care how skillfully I diced the onion; they were interested only in an edible meal. Similarly, your viewer doesn't care how you achieved an effect. All he cares about is enjoying the visual feast that is your painting.

The best way to learn good technique is to watch someone who has it and imitate him as best as you can. These days, if you can't find personal instruction, there's plenty of good technique on television and videotape for you to imitate.

Each medium has its own unique properties and technical tricks. On the next page I've shown the results of a few basic watercolor applications. Explore the technical possibilities of your favorite medium but don't let technique rule your paintings.

Even experienced painters often confuse the way something is said (technique) with what's said (content or expression). An awkward golf swing can produce good results (as Arnold Palmer knows), and there are plenty of good paintings that display plenty of awkward technique. Remember, what makes a painting good is what it says to us, not how the artist painted it.

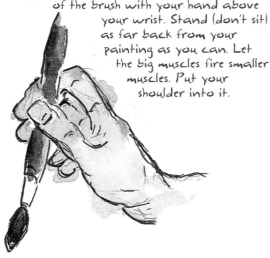

The grip is as important to painting as it is to golf. Lock your fingers high in the handle of the brush with your hand above your wrist. Stand (don't sit) as far back from your painting as you can. Let the big muscles fire smaller muscles. Put your shoulder into it.

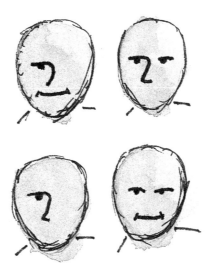

There's no rule that says you must finish a painting in one session. You can stop at the end of any layer. However, each time you stop, leave yourself a clear starting point for the next session. That way, when you return to the painting, even if it's weeks or months later, you know exactly where to pick it up again.

Wet-in-wet: Wet paint is applied. Without waiting for the first layer to dry, somewhat drier paint is applied to the wet surface. The drier the paint, the less the pigment will run or bleed.

Wash Techniques: Flat wash; fundamental, but not particularly interesting. Graded wash; the flat wash is lightened by adding water. The flat wash is given color quality by varying the mother color.

Drybrush: Brush is held at a right angle to the sheet, or almost parallel to it, and pulled rapidly. The mixture on the brush uses as little water and as much paint as possible.

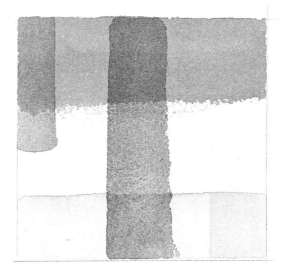

Glaze: the first light application is allowed to dry thoroughly before a second light application is applied. Glazing results in rich, transparent color and optically mixed colors.

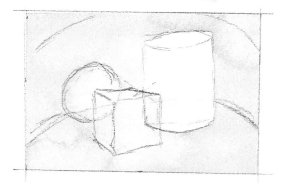

Always leave a starting point for the next phase. Always start with the most fragile (lightest, most delicate) color.
 —Helen Van Wyk

Well begun is half done.
 — Aristotle

Of a good beginning cometh a good end.
 —John Heywood

To know when one's self is interested is the first step in interesting other people.
 —Walter Pater

How to paint the landscape: First you make your bow to the landscape. Then you wait, and if the landscape bows to you, then, and only then, can you paint the landscape.
 —John Marin

You're going to be disappointed by how light this is.
 —Rex Brandt (as he lays in his first wash)

The Underpainting

You build a painting layer by layer. You put down a layer and then the second layer modifies the first coat, and so on, layer by layer, until the painting is complete. The success of each layer depends on the success of the previous layer.

Fat over lean is the rule; that is, apply the paint thinly at first and thicker in succeeding layers. The specifics of applying the layers depends on the medium. In opaque mediums like oil, the darks are thin and transparent and the lights are thick, juicy, and crusty. So the thin darks are applied first and the white highlights are slapped on at the last. In transparent mediums like watercolor, the lights are thin and transparent and the darks are opaque; white paper must be reserved from the start for the highlights.

Before you apply the first wash or underpainting, your painting must have a firm foundation. You must have resolved every major area as to location, size, and shape, as well as any drawing problems. Be sure to set out more than enough fresh paint. Use a brush that you think is too big for the job to ensure boldness and breadth of effect.

You can introduce suggestions of local color into this first light gray wash (no darker than a yellow ochre) and complete any light, soft-edged shapes like clouds. Add a few strong, rich, dark accents where the center of interest will be in the final painting. Putting them in now ensures that they will be there when you need them. What they're going to represent doesn't matter now. (Trust me, when the time comes for them to represent objects, you'll think of something.)

Where you can, explain the form by your rhythm of application. Paint around it as if you were touching it. When in doubt, use short, vertical strokes.

Broken wash, not flat wash—any ineffective or arbitrary whites can be painted out later.

The value of the underpainting should be no darker than yellow ochre, preferably a tint of that color.

Close off the entire sheet. If you have whites at the edges, let them leak out at top and bottom; never at the sides. Whites should expand into the painting, not out of it.

This

Not This

Rhythm of Application: Use vertical strokes applied left to right, not horizontal strokes applied top to bottom.

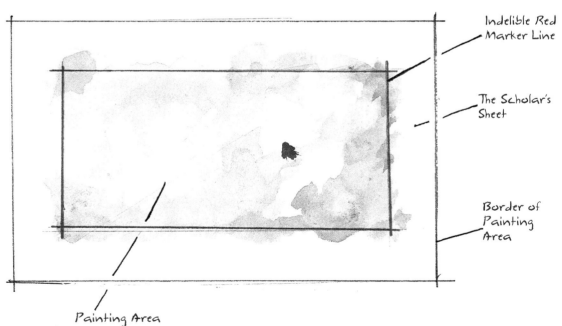

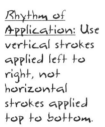

Indelible Red Marker Line

The Scholar's Sheet

Border of Painting Area

Painting Area

The area between the red line and the edge of the sheet or canvas serves as a sketchbook. You can safely test your paints there for diffusion, resolve drawing problems, and make notes that will help you finish the painting in the studio.

<u>The scholar's sheet:</u> Before you start to paint, especially if you're in the field, draw a two-and-a-half to three-inch margin around the painting area with an indelible red marker. Later, this line will serve as a guide to the framer, who will cut his mat to cover it. By painting over the red line to the edge of the sheet, you avoid the natural tendency to lift (or feather) the brush before reaching the end of the sheet. There are no awkward, demanding whites at the outside edges of your painting, and it's easier to locate objects in relation to the red line than to the edge of the sheet or canvas.

Notan: The Second Layer

For all practical purposes, the painting is finished with the application of the second layer. Think of a house under construction. The underpainting is like the foundation and framing. The second layer of shade and shadow and gripping darks is comparable to the walls and roof. Once the walls and roof are complete, the house is habitable; once the pattern of shadow and holding darks is complete, the painting is serviceable, maybe even finished.

Notan is the basis of the selective realism of Oriental painting. In that context, as I understand it, notan simply means the pattern of shade; lights and negatives are left untouched and cast shadows are ignored. I've expanded the term "notan" to include the cast shadows and holding darks. A notan painting has one layer. There may be no underpainting; the painting has only light and dark, no midtones. In notan the midtones become either lights or darks, and each shape, whether it is light or dark, encompasses both positive and negative areas. If you paint only the notan, the result will be contrasty and poster-like. Notan not only creates the painting's dark pattern but, at the same time, it dramatizes the lights through simultaneous contrast.

Usually the contrasts of light and dark that you see in nature are not as clear as they must be in a painting. So, for clarity of statement, keep the side of a light-value or middle-value object that's in the shade about 40 percent darker than the side that's taking light in the painting. When you follow the 40 Percent Rule, the contrasts are clear and convincing.

The notan resonates against the underpainting, if any, and creates the framework on which the details and accents will be hung in much the same way that shutters and other decorative details are hung on the side of a house.

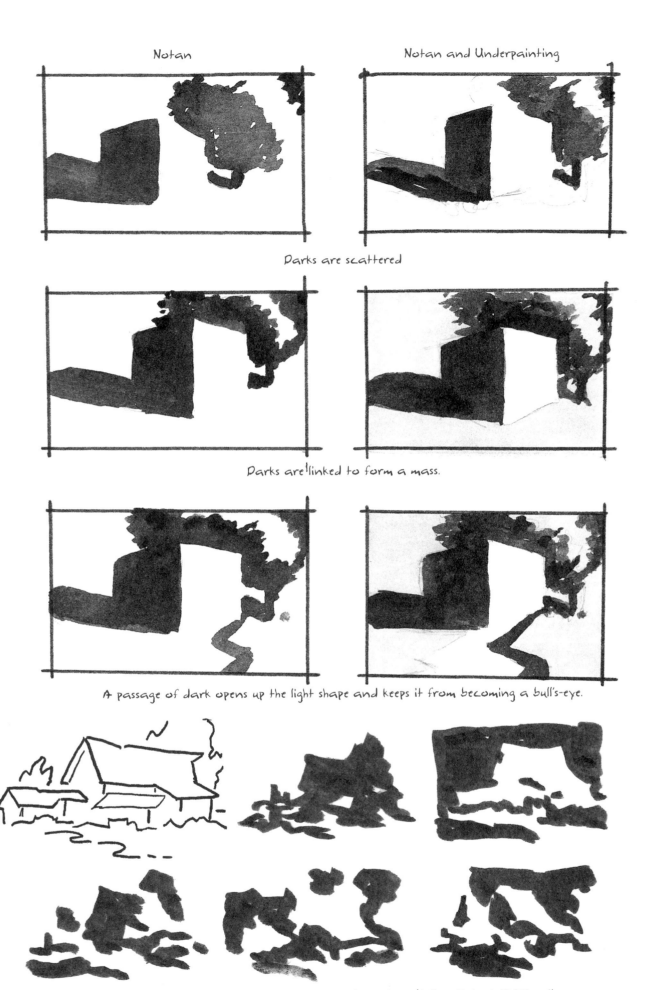

Notan

Notan and Underpainting

Darks are scattered

Darks are linked to form a mass.

A passage of dark opens up the light shape and keeps it from becoming a bull's-eye.

Five different ways to treat the notan. (After Robert E. Wood)

179

Procedure
Painting

1. Select a format and size that reflect your subject and are appropriate to the size of your idea.

2. Find the center and divide the space.

3. Four marks, each a different distance from the edge, establish the area for center of interest. Connect the dots to define the area.

Layering

Painting a picture is a little like painting a house. Two thin coats are better than one thick one, and you don't put the second coat on until the first coat is absolutely dry. In a painting, however, each succeeding coat covers or alters part of the previous layer or layers.

To explain this layering clearly, I've separated each successive layer and shown it by itself; and then I've shown how it affects the previous stages in the next sketch.

This sequence is one of many possible procedures, which are usually dictated by the medium. Oil painters follow a different sequence of application than watercolorists. The oil painter often starts by covering his canvas with a midtone, then adds darks, and finishes by adding his lights; whereas the watercolorist must save his lights from the start.

What's important here is to find a method of doing business that you're comfortable with and then do things that way every time. You're free then to concentrate on what you're saying instead of how you're saying it. Having a consistent procedure ensures consistent quality.

There are plenty of rules in painting but none that says you must finish a painting in one session. You can stop at the end of any layer. However, each time you stop, leave yourself a clear starting point for the next session.

Finishing a painting is usually not a good idea anyway. Always leave something for the spectator to do. More good paintings are ruined by overfinishing than by underfinishing. Eliot O'Hara used to say, "It's the last stroke that spoils the picture." By withholding that last stroke, you may just save your painting.

7. Glaze the second wash over all negatives.

11. Add the pattern of cast shadow. Blend edges to avoid the pasted-on look.

15. Modify the lights to clarify and explain the planes.

19. Add local color and details to the center of interest.

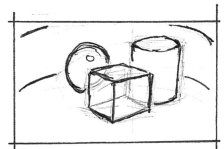

4. Draw the subject as loosely as you wish.

5. The first wash covers everything but the center of interest.

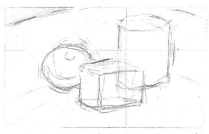

6. Drawing and first wash combined.

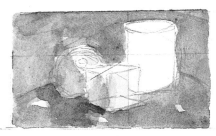

8. First and second washes combined.

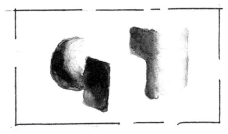

9. The pattern of shade is developed on the positives. Note the cools on the cylinder which set up the center light.

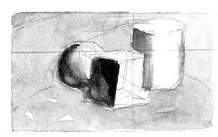

10. Adding shade modifies the preceding layers. Only now are the whites of the center of interest modified.

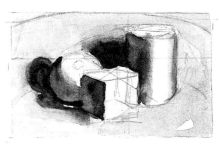

12. Some artists combine shade and shadow into one step.

13. Gripping darks modify the previous layers.

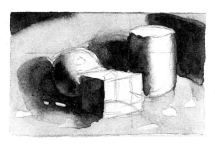

14. Gripping darks set up and explain the lights.

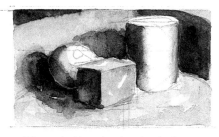

16. The painting begins to take on a finished look.

17. Warm darks are added beneath the forms.

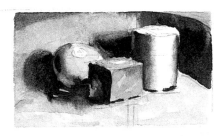

18. Any time you can see into or under something, that dark is warm.

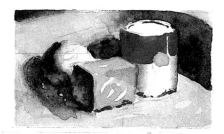

20. Many painters would reasonably consider the painting finished at this point.

21. But because I like the look of focus-and-fringe, I apply the fringe as a last step.

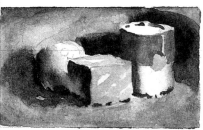

22. The completed painting is more than the sum of its layers. It's a gestalt.

More detail doesn't necessarily mean a better painting, it just means more detail.

—Tom Lynch

God is in the details.

—Le Corbusier

The devil is in the details.

—Flamur Tonuzi

MARVELous advice from Marvel Comics' Stan Lee and John Buscema:
The darks may be used realistically or decoratively. Always have a reason for adding a dark:

- To enhance the design
- To help clarify a complicated layout
- To emphasize a mood

It takes two people to paint a watercolor. One to paint it and the other to hit him on the head with a hammer when he's finished.

—Eliot O'Hara

Ask yourself, "What's it too?"

—Ed Whitney

Editing

Editing is the final step in the picture–making process. The artist may put his picture in a trial frame or mat and hang it on his studio wall while he determines which areas need simplifying and where those all-important final accents belong.

Restraint is the determining principle: Think before you paint. A simple slip can ruin all the work that has gone into the painting.

Spotting: The Final Darks

The final dark accents are just a superimposed element pattern composed of dark spots and, as such, they obey the laws of pattern: Attention span (7±2); interval (proximity); alignment; and center of interest, especially lightest light/darkest dark.

These final dark accents usually serve one or more of three functions: They enhance the design by providing interest; they emphasize the mood; they clarify certain areas. (A line explains the direction of a plane faster than anything else.)

Three technical tips for watercolorists:

1. You won't get rich, juicy darks unless you use rich, juicy paint—that means *fresh* paint.

2. Paint the accents on scrap paper or water media acetate and overlay them on the painting to make sure they work before painting them in.

3. If a large area needs to be repainted, submerge the entire sheet in the bathtub for an hour or so. You could leave it there for a month and absolutely nothing would happen to the painting. Remove the sheet from the tub, place it on a flat, clean surface, and gently lift out the color with a natural sponge. If you're careful, you'll get back to almost pure white paper without damaging the fibers. Of course, stain colors won't lift as completely, but you can lighten them significantly.

High-key pictures may seem bland or unfinished although they do project a mood of delicacy because they lack strong darks.

Lights and darks, by themselves, are sufficient to create the feeling of a finished painting although it may look somewhat posterish.

Darks and midtones also have a finished look, but the picture lacks the sparkle that the lights give it.

If you're going to have darks, make them dark enough.

Isolate the darks to evaluate the dark pattern. Make small dark pattern schemes, sort of like the spots on playing cards, to evaluate the placement and size of the dark spots before you add them. You've put in too much effort to screw up now. Take the time to make these quick little studies. It will pay off.

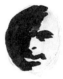

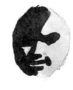

When a light is surrounded by a dark, it becomes a bull's-eye (a trap for the eye) and the shape-impact of the dark is lost. When a dark is surrounded by a light, it becomes a stepping-stone for the eye.

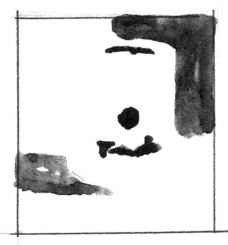

The placement of the dark areas (and spots) creates a definite secondary pattern in every picture. If your isolated dark pattern is unsatisfactory, then the finished painting is likely to be unsatisfactory.

Let the wash begin inland of the line.

—George Post

Use calligraphic shapes for impact

Varied pressure on brush

Stampings

Rolling the brush

Calligraphy

Some painters use colorful, dark areas to accent their paintings; others prefer calligraphy; and still others use a combination of both.

Calligraphy means "beautiful writing" and is an art form in itself. Although we speak of the calligraphic *line*, the essence of painting is shape, not line. For our purposes, a calligraphic mark is any mark that reads as a mark.

The calligraphic mark or line should be confident and definite. Avoid picky, tentative marks; let big muscles fire small muscles. Work from your shoulder; using your arm and your wrist, keep your hand higher than your wrist and your fingers locked when you make a calligraphic mark or stroke.

Explore the use of other tools—a knife, the edge of a credit card, a piece of mat board—to make calligraphic marks. You'll be surprised by how effective the results can be.

Calligraphy enlivens and enriches the surface and reaffirms the picture plane. Those painters who use calligraphy like it because it's decorative, expressive, creative, and as personal as handwriting.

The Line-and-Wash Job

Line-and-wash jobs are so easy that almost nobody does them, and that's a pity because they almost always work out well. They have a sort of syncopated, casual, jazzy feel to them and decorative qualities that many viewers love. It's an ideal approach for the beginning painter because it consists of two partial statements—he doesn't have to finish either the line or the wash, just keep one or the other dominant.

The line never outlines the edge of the wash but is always offset from it, thus the line may echo the edge from the outside, or the inside. Or it may start inside and move outside or vice versa. The line becomes more demanding when its color is complementary to an underlying or nearby wash; less demanding when it is analogous.

Western calligraphy is based on keeping a chisel edge, like that of a flat brush, pointed in one direction so that, because the hand doesn't twist or turn, the stroke becomes thicker or thinner depending on the direction in which the tool moves.

Oriental Arabic calligraphy is based on the round brush, and is a little like skiing. You start somewhere definite and push off, then accelerate, and end your run definitively, with a little flourish.

Like seasoning, a little calligraphy goes a long way. It's awfully easy to overdo calligraphy because it's so much fun. Keep the design principle of restraint in mind as you apply those delightful final calligraphic accents.

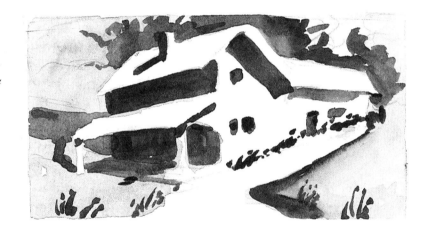

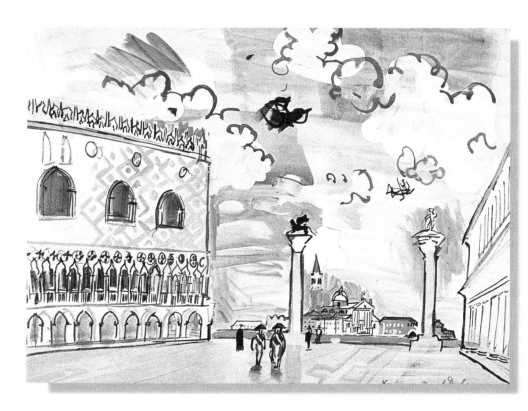

Raoul Dufy, the master of the line-and-wash job.

The mat and the frame are as important to the design as the elements inside the picture.
—Rex Brandt

In planning your mat and frame, you are still designing.
—Ed Whitney

Any picture looks twice as important if it is framed with taste and imagination. Just as an appropriate frame enhances the beauty of a painting, a poorly chosen one greatly detracts from it.
—Frederic Taubes

At least 10% and maybe as many as 20% of all the entries to every show I've ever judged have been rejected because they were badly framed. The frames killed the paintings and called the artists' taste into question. As war is too important to be left to the generals, framing is too important to be left to the framers.

Framing

The frame serves as the transition from the actual space of the room to the virtual space of the painting. Since the frame is a piece of furniture, just like a chair or table, it must be as appropriate to the room as it is to the painting. And, since the basis of interior decoration is wood and fabric, we reach the inescapable conclusion that wood frames and fabric mats are appropriate to most homes.

But the framing must also display the painting to its best advantage. No matter how good your painting is, unless you isolate it from the visual clamor of its surroundings by framing or matting, it doesn't stand a chance. Even if they live in a portfolio rack, paintings should be matted.

Button-back Frames: Because of the high cost of framing, many watercolorists use wooden frames that are not sealed but hold the picture and mat in place. Your framer can do it, but he won't suggest it because the initial cost is higher than normal framing. In the long run, though, it's cheaper.

Matting: If you calculate the area of the mat and subtract the area of the painting, you will be astonished to discover that the mat is by far the largest single area of the painting; therefore, select it with care. Keep light, midtone, and dark trial mats in the studio to test alternatives.

Avoid skimpy matting. Most should be no smaller than two and a half inches on top and sides and three inches on the bottom. They may be larger, but the ratios should not vary.

The center of interest should be as close as possible to the optical center of the frame. A painting in which the center of interest is above the center line looks best if the lower margin of the mat is about a half inch wider than the top margin. When the center of interest is below the center line, the painting looks better if the lower margin of the mat is an inch or more wider than the upper margin.

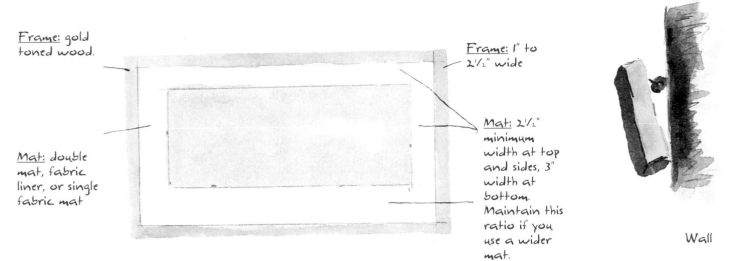

Frame: gold toned wood.

Mat: double mat, fabric liner, or single fabric mat

Frame: 1" to 2½" wide

Mat: 2½" minimum width at top and sides, 3" width at bottom. Maintain this ratio if you use a wider mat.

Wall

Strainer is flush with frame.

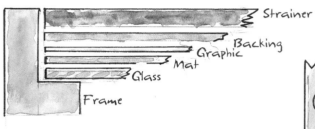

Strainer

Backing

Graphic

Mat

Glass

Frame

Cross-section

The bottom of the mat is always wider than the top and sides because the frame does not hang flat on the wall, which foreshortens the picture.

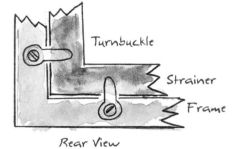

Turnbuckle

Strainer

Frame

Rear View

A high-key painting usually looks best in a dark mat, or double matted with a light outer and a dark inner mat.

A low-key painting usually looks best in a light mat, or double matted with a dark outer and a light inner mat.

Low Optical Center

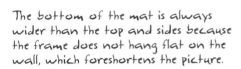

High Optical Center

The honest work of any honest man is not to be sneered at.

—Ed Whitney

A work of art is made primarily to be appreciated, not criticized.

—Stephen C. Pepper

One looks at one's picture and thinks of all sorts of ways to make that picture better. The critic comes along and knows nothing of these ways.

—John Marin

Don't listen. Consider who is speaking.

—Marilyn Horne

Address your picture to your own curiosity, not to someone else's judgment.

—Helen Van Wyk

Our hopes are so far ahead of our abilities. When we are satisfied, perhaps we haven't aimed high enough.

—Rex Brandt

If you don't like it, it will be for one of three reasons:
- bad shapes;
- not enough entertainment;
- beaten to death.

—Ed Whitney

The Crit

If you're not satisfied with your work, you're in good company. Turner and Matisse used to sneak into museums and exhibitions with their paints to touch up their paintings (and gave the guards fits).

Maybe they're masochists, but many painters willingly submit their work to (often harsh) criticism in classes and workshops. Most painters probably don't get as much out of the crit as they could. They pay too much attention to the instructor's comments about their paintings and then turn a deaf ear to his comments about everybody else's work.

Think of the crit as an opportunity to visit a museum or exhibition with your instructor as a knowledgeable tour guide. The crit is your opportunity to study and learn from many different paintings.

Painters usually do not submit unfinished work to the crit, and that's a mistake. Not only is your ego less fragile when the work is unfinished, but also you're more likely to consider the instructor's comments in finishing the piece. Never make the changes an instructor suggests unless you agree with him. It is, after all, your painting.

Some things are better the first time, but painting is not among them. Your next painting will be better than your previous painting—guaranteed!

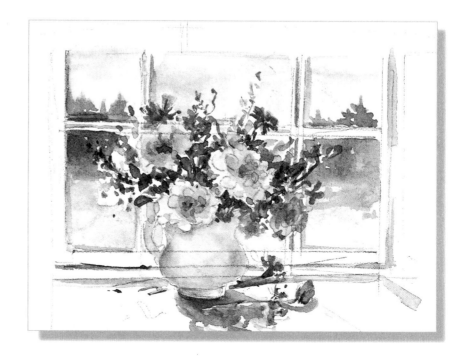

Five Common Mistakes

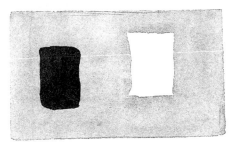 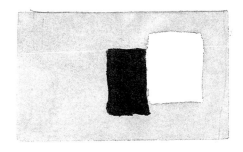

No clear center of interest

Poor placement

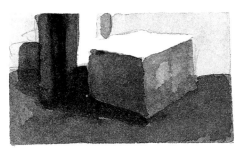 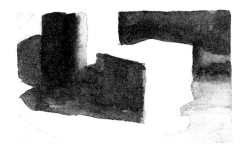

Lack of pattern or weak pattern

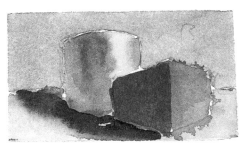 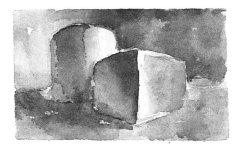

Poor color

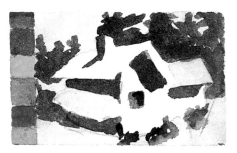 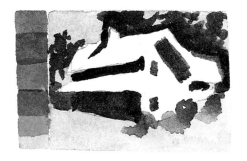

Errors in perspective

Procedure
Editing

All subjects have their fine points, and letting the careless ride roughshod over them is doing a poor favor to subject and student. As the master grows away from his own learning period, he finds that mankind repeats itself. Students make the same mistakes at the same place.

<div align="right">

—Jacques Barzun

</div>

Those people who do not know these truths will not know that you do not know them. Those people who do know these truths will know that you do not know them.

<div align="right">

—Ed Whitney

</div>

Whatever you do, kid, always serve it with a little dressing.

<div align="right">

—George M. Cohan
to Spencer Tracy

</div>

Fine Points

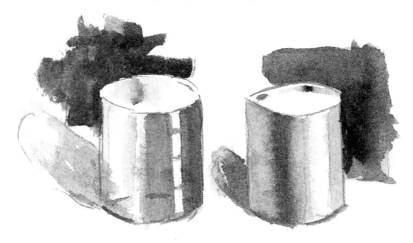

Transparent surfaces, such as glass or the human eye, reverse normal form description. They are darkest near the light, and that dark contains a brilliant highlight. Local color is seen where you find the reflected light on an opaque surface.

Drapery either falls from a single point of suspension in swags or from two points, like bunting in festoons. Drapery folds are symbols of force. They say "action."

Highlights describe the finish of surfaces and add sparkle. The highlight is the equivalent, in the light, of reflected light in the shade. It describes precisely the location of the light source. On a colorless object, it is the color of the light; on an object with color, the highlight is the complement of the local color. An exception is brass, which has a bright yellow highlight.

Form within form: Never pass up the opportunity to show the third dimension. When one form lies inside another, both forms must be shown as having three dimensions even if one form, such as cloth, is very thin.

Any opening you can see into is warm, an open window or door, a nostril or an open mouth. If you report it as cool, even a dark cool, it reads as a reflective surface.

Always draw a curve as a parabola, like the flight of a golf ball. Convex curves are strong; a crouching figure ready to spring. Concave curves are weak; someone relaxing in a hammock.

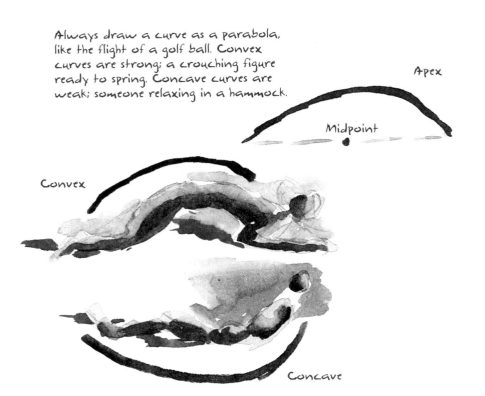

Apex

Midpoint

Convex

Concave

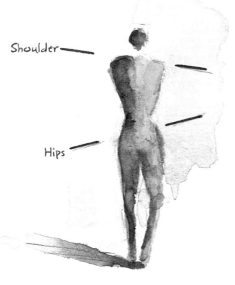

Shoulder

Hips

Contra posta makes figures more dynamic. As long as the base of the neck—the seventh cervical—is over one heel, the figure will be balanced.

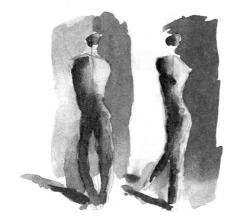

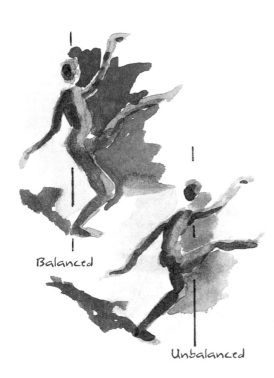

Balanced

Unbalanced

191

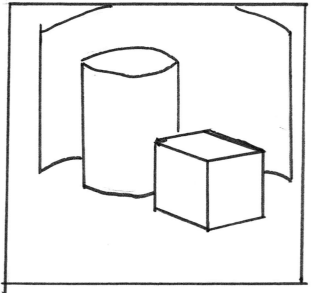

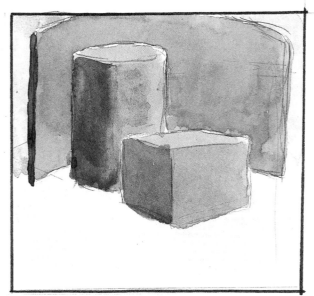

In a drawing like this, lines have an even weight. Every contour is completely found. The picture is filled with graphic stars.

The coloring-book attitude results in a stiff, redundant picture in which line, hue, and value all say exactly the same thing.

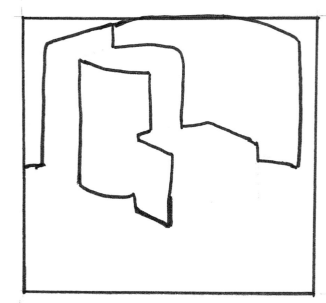

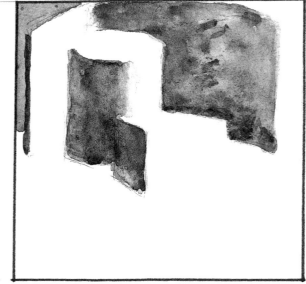

Here the drawing can reach whatever degree of closure or finish the artist desires (indicated by the pencil lines). The result is good, interlocking, abstract shapes.

When the positives are broken up into light and dark, shade and shadow, and holding darks, the shapes will read, through closure, as positives.

Learning

If you want to change yourself, you must change how you think.
—Harvey Penick

Nobody can teach you as well as you can teach yourself.
—Adam Robinson

No great thing is created suddenly any more than a bunch of grapes or a fig. If you tell me that you desire a fig, I answer you that there must be time. Let it first blossom, then bear fruit, then ripen.
—Epictetus

Learning

There was a time when Mr. Einstein was not quite sure what eight times nine came to. He had to learn and he had to be taught.

—Jacques Barzun

No one can draw more out of things, books included, than he already knows. A man has no ears for that to which experience has given him no access.

—Nietzsche

If I learned anything in coaching, it's that you can't repeat things too often. You can't repeat things too often.

—Chuck Daly

I am going on with my researches...I am continually making observations from nature, and I feel I am making some slight progress.

—Paul Cézanne (at age 67, a month before his death)

If I wanted to learn golf, I'd seek out Jack Grout, not Jack Nicklaus. Grout was the pro who taught Nicklaus as a child and to whom he returned for instruction throughout his career. The best painters are not always the best teachers, and vice versa.

The Purpose of Learning

The purpose of learning is to allow us to change—change for the better. Despite workshops, classes, videotapes, and instruction books, you know your paintings are not as good as they should be. It's not entirely your fault. One failure of adult art instruction is that both sides fail to understand and employ even the most basic principles of learning. Most painting instructors are painters who teach, not teachers who paint. They are not familiar with the best ways to teach and you are not familiar with the best ways to learn. When you don't know *how* to learn, the task is harder than it should be and takes longer than it needs to, no matter what you're learning.

Apperceptive Mass

Your apperceptive mass is the sum total of your experiences to date. You're not quite the same person who got out of bed this morning because during the day, things happened to you. Read this book again five years, or even a year, from now and it will seem different because your apperceptive mass has changed.

Not until your apperceptive mass reaches a critical point, where you are truly open to change, will you or your paintings change very much. Until that turning point occurs, no matter how good the instruction, you're not going to get very much out of it. Be patient; it will all fall into place one day.

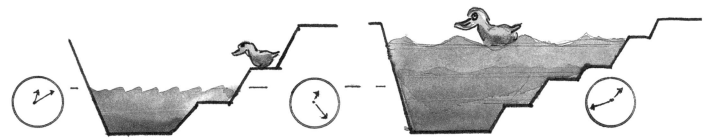

There will always be some things we don't understand or can't do—yet. We're like partially filled reservoirs; however, the rains, meltwaters, and underground springs of our life continually add to our experience. Given a little time, our apperceptive mass changes and our understanding and abilities improve. What once seemed difficult suddenly becomes easy.

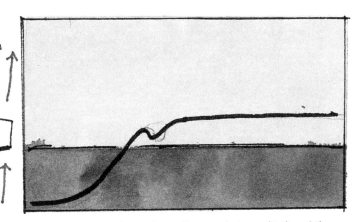

Set reasonable goals, goals you know you can achieve or even surpass. Mastery is an illusive, moving goal that everyone thinks is beyond his grasp. It's like compound interest; if you can improve your painting by 5% each week for a year, the result will astonish you. If you can't draw a house, draw a cube; if you can't draw a cube, draw a square. Your audience will applaud your square, but they might boo your house.

Competence, not mastery. It may take a little while just to achieve competence, but you will. And when it happens, it happens fast and you're on another level. The other day when I went down the hill to the store, I saw a kid fooling around awkwardly with his new skateboard. When I came back about 20 minutes later, he was doing all sorts of remarkable things, as if he'd been doing it for years.

The *Rule of Five:* Any normal human being can remember up to five separate things without much difficulty. When you organize information according to the *Rule of Five,* by putting together, say, five main ideas, each with five sub-ideas and so on, it's called "chunking," and there's virtually no limit to how much information you can remember. It's organized like an outline or a menu. Another useful way to organize information is as a matrix or a calendar.

			October			
SUN	MON	TUE	WED	THU	FRI	SAT
1						
8						
15			★			
22						
29						

Learning

The Gateway to Learning

The first step in the learning process is that awkward stage when you still have to think about what you're doing. For example, once upon a time you had to think about tying your shoes; now you just do it. When you first do anything, even a physical thing like tying your shoes, it's your mental skills, not your motor skills, that are important. You can speed this process with various proven techniques.

Analogy: Unless new material is related to something you already know, it might as well be in a foreign language for all the good it does you. Analogy, "what it's like," is the key that unlocks the door to new ideas or skills. If I tell you, "Hold your brush like a teacup," you may get the idea. Opposites, too, are a form of analogy. Thinking about what it's *not* often makes an idea clearer.

The Rule of Five: Short-term memory is the memory of first-stage learning. The limitation to short-term memory is the familiar span of our human attention, 7±2. Use the Rule of Five and you'll have less difficulty with short-term memory.

Graduated Interval Recall: In 30 minutes a day for 30 days, 9 out of 10 people can learn to speak a foreign language at what the State Department considers an "intermediate high" conversational level. The trick is graduated interval recall. You review the material at increasingly longer intervals. The sooner you review the material after you first encounter it, the better. The gradually longer intervals provide a smooth transition from short-term to long-term memory.

The Hub-and-Spoke Outline: Humans don't think or talk in strictly logical order; machines do. We jump all over the lot and get sidetracked easily. The computer experts call it "fuzzy logic." Lecture material is rarely presented in a clear, logical manner, so even the best notes usually have a disjointed quality. Hub-and-spoke outlining, which resembles a schematic airline map, gives you a visual overview of the material. The hub-and-spoke outline is sometimes called mind mapping.

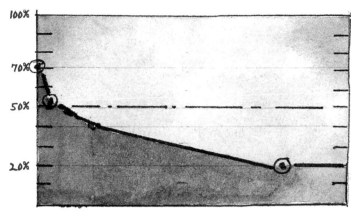

The Curve of Forgetting: When you first hear something, you retain only about 70% of it—even if you're paying close attention. After only ten minutes you remember somewhere between 50% and 60% of what you heard. Nine hours later, it's down to 40% and a week later, you remember about 20% of what you heard if you were paying attention (but at least that much will stay with you).

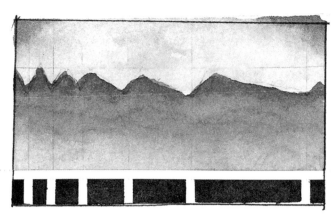

Graduated Interval Recall (represented by the sawtooth edge) helps overcome the curve of forgetting. New material is repeated at increasingly longer intervals. Each time the material is repeated, retention spikes upward and the curve of forgetting flattens out a little more.

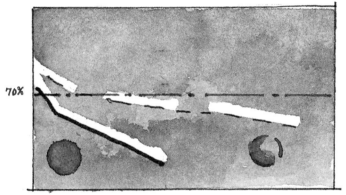

The Cliff-Hanger Effect: Unfinished tasks tend to be remembered twice as well and twice as long as finished ones. Start a new project before you finish an old one and then return to the old one. Soap opera and mystery writers understand this principle very well. ("Tune in again tomorrow.") Put the cliff-hanger effect to good use—never end a painting session without a clear starting point for your next session.

Mind Mapping: In any lecture, discussion, or conversation there's usually a central idea; but one thing leads to another because human discourse simply refuses to follow the logical flow of, say, an outline. Write this idea down in the center of the sheet and then follow the different routes the instruction takes, like creating a map instead of trying to force ideas into some sort of logical sequence. Use color, sketches, diagrams—anything that might help.

Learning

The Pathway to Memory

The great thing about our long-term memory is that as far as anybody knows it's unlimited. We seem to have three distinct long-term memories.

Procedural Memory: Once you master a skill or procedure, it becomes habitual and it's almost impossible to erase it.

Knowledge Memory: It's true, experience is the great teacher. Therefore, our knowledge just keeps growing each day.

Fact Memory: Although our memory of specifics seems to erode somewhat with age, it's okay because while "facts" may change, principles don't.

Here are some ways to help reinforce long-term memory.

Feedback: Cybernetic theory views the mind as a computer. To achieve a desired result, you do something; that's the output. You view the result; that's the input or feedback. As a result of the feedback, your brain asks for the next action. Your attitude should be nonjudgmental, almost Zen-like.

The Learning Curve: Learning may start slowly, but progress soon becomes rapid. There's a sudden, temporary dip in skill just before you reach the next plateau, which is called the asymptote; it quickly passes. The asymptote signals that you are about to reach a new level. Learning proceeds by fits and starts. Once you reach a plateau, turn your attention elsewhere. When you return to the skill, the first plateau becomes the baseline from which you can easily reach the next level.

The Reference Pattern: It's a standard (often an ideal) against which you measure your accomplishments. A golf scorecard is a reference pattern; you set your own par. At Pebble Beach I broke par! (My par, 252, wasn't even printed on the scorecard.)

Skills Components: Speed and accuracy can always be improved. Levels of difficulty can be manipulated. To understand, try pitching pennies into a plastic bowl, or onto the label of an old LP record. It's a great way to observe the asymptote in action, practice visualization, and explore different levels of difficulty.

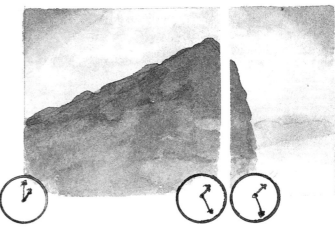

The Asymptote: The thing to notice about the learning curve is that funny little dip just before you hit the plateau. There may also be such a thing as the "good" asymptote—an upward spike that suggests greater improvement than is really there. This has the advantage of being a positive reinforcement and the disadvantage of possibly creating unrealistic expectations.

Feedback: Listen to your painting. When it starts to go bad and your attempts to fix it can't make it better, move on. Remember the first law (of everything): At least do no harm.

The Reference Pattern: The par on the scorecard is the goal for the scratch golfer; it's not the same for every golfer or even for most golfers. The average club golfer probably carries an 18 handicap. In other words, it's realistic for him to expect to shoot 4 on the par 3s; 5 on the par 4s, and 6 on the par 5s, and if his scorecard were printed that way, he'd feel better about his accomplishments. Unfortunately, most golfers take the pattern of the scorecard as their reference pattern.

	PLAYER											
10	400	371	12	4						4	10	364
11	520	485	10	5						5	4	421
12	180	148	16	3						3	18	102
13	440	418	4	4						4	8	390
14	555	514	6	5						5	2	483
15	130	104	18	3						3	16	79
16	465	434	2	4						5	6	406
17	320	308	14	4						4	14	301
18	405	383	8	4						4	12	362
IN	3415	3165		36						37		2908
TOT	6810	6277		72						74		5695
HANDICAP												
NET SCORE												
DATE		SCORER				ATTEST						

Skills Components: There's a level of difficulty that's just too easy for you and, because it holds no challenge, the game becomes boring. For example, you could just walk over and put all the pennies on the target. There's also a level of difficulty that's too hard for you. You could try to pitch the pennies into a shot glass from twelve feet away while blindfolded. But you won't play that game very long because it's too difficult and, therefore, frustrating. Choose a reasonable level of difficulty. Remember, all the spectator knows is what he sees, and what he sees at the end is not you pitching coins blindfolded, but a shot glass filled with pennies.

Learning

Our delight in any particular study, art or science, rises and improves in proportion to the application which we bestow upon it. Thus what was first an exercise becomes, at length, an entertainment.

—Joseph Addison

You have to learn everything at once. You can't say that you must understand plot before dialogue, description before point-of-view, or even beginnings before endings. There's no (one) rational order or sequence in which those elements must be learned. They're all necessary.

—Jerome Stern

There is nothing so pure as practice and discovery.

—Jim Nance

Making mistakes and occasionally appearing foolish is the price you pay for learning and improving.

—Adam Robinson

Whatever you would make habitual, practice it; and if you would not make a thing habitual, do not practice it, but accustom yourself to something else.

—Epictetus

The Pleasures of Practice

The figure skater's graceful, polished performance is the result of a lot of nasty spills. In a manner of speaking, so is the musician's, dancer's, or painter's performance. Hidden behind every great performance lie countless hours of rehearsal. Many of us are like children with their first tennis rackets; we want to play *now*. We want instant gratification without much effort. If results are too long in coming or seem unsatisfactory, we're quick to give up. That's not the road to Wimbledon, kids.

Adults find two excuses for not practicing: They don't have enough time or they think practice is boring and, in the little free time they have, they don't want to be bored. Neither excuse is valid.

The Means-to-End Mutation: Activities undertaken as steps to other goals to come are eventually valued for themselves. The beginner always has a goal in mind; call it "the end." His goal might be reputation and ego satisfaction, acceptance in juried shows or professional societies, awards, or selling his work. He sees the painting as a product that will help him attain his goal.

Along the way he realizes that if he is ever to achieve his goal he must submit to some sort of discipline. He puts up with the drudgery of sketch class, the monotony of playing his scales, or those seemingly endless rehearsals. Call it "the means" that will take him to the end or goal. Then one day, he realizes he simply enjoys the practice for its own sake. The painting or the round of golf have become less important than the pleasure he derives from the activity. The product becomes a byproduct; the activity becomes its own purpose.

Visualization can be practice. You can use it to improve your painting skills while standing in line at the bank or the supermarket. Studies show that you'll improve even if your only practice is visualization. Of course, actual physical practice is still better. Visualization combined with physical practice yield the best results, especially where planning and decision-making are more important than automatic responses.

The army is the largest and most efficient educational institution in any country. It uses 10% of the time available for explanation, 25% for demonstration, and 65% for practice. Practice follows right after the demonstration, not right after lunch.

The Dale Carnegie Way: 35 minutes is about as long as anyone can sit still. The Dale Carnegie people say, "The mind can absorb no more than the seat can endure."

Here, the cavalry meets Dale Carnegie. Who says time must be measured in 60-minute "hours"? Create your own instructional "hour" out of 35 minutes, or whatever time you have.

Massed vs. Spaced Practice

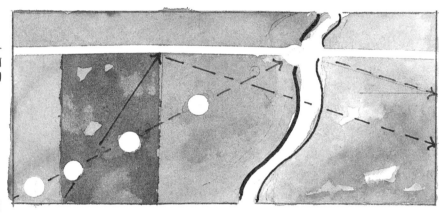

Highest skill level achieved

Level of improvement retained

Spaced

Mass

When you set aside a chunk of time to work on something, that's massed practice. Improvement is rapid, and the short-term results are positive. But even if you can't find as much time as you'd like, you can still work on something at odd moments. That's spaced practice. Results take a little longer with spaced practice, but the level of permanent improvement is twice that of massed practice.

The means becomes the end. Over time, instead of drudgery, practice becomes a joy. Exercise a little patience and the means-to-end mutation destroys the boredom excuse.

It is a profoundly erroneous truism, repeated by all copy books and by all eminent people when they are making speeches, that we should cultivate the habit of thinking about what we are doing. The precise opposite is the case. Civilization advances by increasing the number of important operations we can perform without thinking.

—Alfred North Whitehead

Time and rest are needed for absorption. Psychologists confirm that it is really in the summer that our muscles learn to skate and in the winter, how to swim.

—Jacques Barzun

Nothing lasts forever, unless it is hope.

—Ira Berkow

Confidence is when you have hit this particular shot many times in the past with success, and you know you are capable of doing it again. Optimism would be if you had never hit this shot successfully in your life, and are hoping this will be the first time.

—Harvey Penick

Success is doing what you set out to do. Art is not a foot race or a pole vault. You can't measure it.

—Artie Shaw

The Autonomous Stage

All learning duplicates that original triumph—learning to walk. One day you can do it and it's as if you always knew how. The skill is yours and you don't think about it anymore. Soon after you learn how to walk, running seems almost effortless. This is the autonomous stage. Once you're there, only two things can hurt your performance; fear of failure and fear of looking foolish, and both stem from status-seeking.

We're afraid people won't like or respect us if we do something poorly or awkwardly. We confuse our work with ourselves. When we worry about what others will think, our work suffers.

Everyone agrees tension is a killer. Tension is a synonym for psychological fear, and it can paralyze anyone. Once you're paralyzed, everything you know, everything you've worked for, goes out the window; you regress.

The Antidote to Tension

Confidence is knowing you can do what you set out to do. You can gain it and avoid tension by:

Taking care of only the business at hand: Don't get too far ahead of yourself by worrying about the result or what someone may think of it.

Staying within yourself: Break the job down to a level where you know you can't fail. Athletes call it "the zone." Zen masters know it as "satori." It's that mystical state where you just do it. The occasional asymptote doesn't bother you and success doesn't matter. You're at another level and the results are great. For most, the zone arrives suddenly, lasts for a while, and slips away as mysteriously as it came. The zone lies somewhere between boredom, which is too little arousal, and anxiety, which is too much arousal. Err on the side of boredom. It is easier to ratchet yourself up from boredom than to escape the clutches of tension.

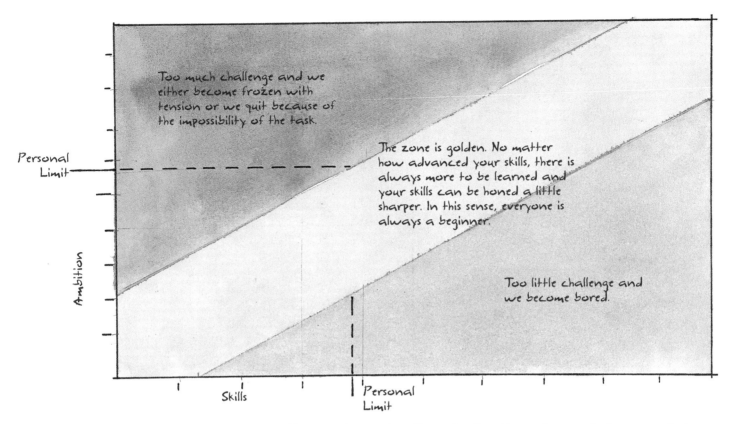

Too much challenge and we either become frozen with tension or we quit because of the impossibility of the task.

The zone is golden. No matter how advanced your skills, there is always more to be learned and your skills can be honed a little sharper. In this sense, everyone is always a beginner.

Too little challenge and we become bored.

Personal Limit

Ambition

Skills

Personal Limit

The goal is to express yourself in paint as naturally, easily, fluently, and persuasively as you do in conversation or writing. You can get there—or at least close enough so that no one but you will know the difference.

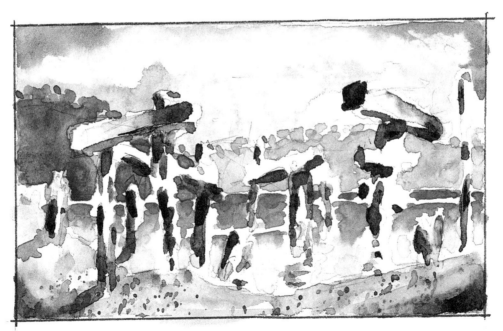

Every journey always ends back where you started. The goal turns out to be exactly what you did so awkwardly in your very first painting—to honestly say something that only you could express, and only in a picture. Getting there is a wonderful journey that just gets better as you go along.

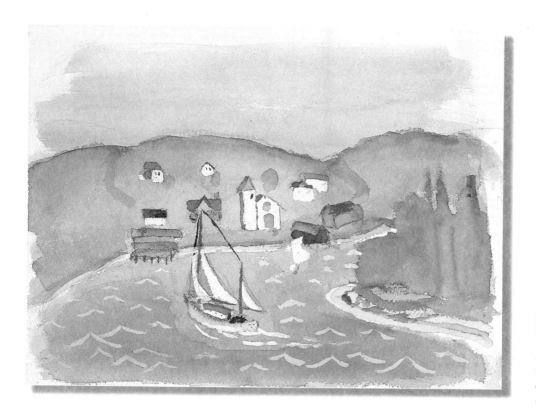

Here's the first painting I ever made on location. It's clearly the work of a novice; even so I can find some nice things to say about it. I was so nervous about painting outdoors that I waited until I was on a lonely promontory of rock 300 miles away from home before trying. Even out there in the middle of nowhere, somebody came up behind me while I was painting and said, "I've always wanted to paint, but I don't have any talent." At the time I didn't think this picture was very good and I told him so. Still, I kept the painting for sentimental reasons. A couple of years ago, I matted and framed it, and hung it on the wall. Now when I get discouraged I look at it to remind myself that I've improved a little since then and maybe I can improve more if I keep at it.

Here's a more recent version. I'm a little closer, but it's a long way from what I had hoped for. Well, maybe next time.

When you paint, people always show up from somewhere and feel compelled to comment on your work. Now when someone says to me, "I've always wanted to paint," my answer is, "What's stopping you?"

Picture Credits

The art collector Albert C. Barnes insisted that there be no explanatory captions on any of the paintings in his collection, not even a plaque identifying the artist. Paintings, said Dr. Barnes, are meant to stand on their own, and when you add words to a painting, you change not only the look but the meaning of the painting.

Every effort has been made to identify copyright holders; we apologize in advance for any unintentional omissions.

13—Walter DuBois Richards, *Community Dock.*

15—Photo by Tim Daly.

18—TOP: Jan van Eyck, *The Arnolfini Marriage,* 1434. The National Gallery, London (Bridgeman/Art Resource, New York). BOTTOM: Hanabusa Itcho (1652-1724), *Bull and Rider.* Seattle Art Museum, Eugene Fuller Memorial Collection, Seattle (photo by Paul Macapia).

19—TOP: Johannes Vermeer (1632-1675), *Young Woman With a Water Jug.* The Metropolitan Museum of Art, Marquand Collection, New York. BOTTOM: Diego Velázquez (1599-1660), *Portrait of Juan de Pareja.* The Metropolitan Museum of Art, Fletcher Fund, Rogers Fund, and bequest of Miss Adelaide Milton de Groot, New York.

20—TOP: Claude Monet, *Sunrise,* 1872. Musée Marmottan, Paris (Giraudon/Art Resource, New York). BOTTOM: Paul Cézanne, *Chrysanthemums,* 1896-1898. Copyright © 1993 by The Barnes Foundation, Merion, Pennsylvania.

21—Salvador Dali, *The Persistence of Memory.* 1931. The Museum of Modern Art, New York. Copyright © 1995 by Demart Pro Arte, Geneva/Artists Rights Society, New York.

31—TOP LEFT: Photo courtesy of the French Government Tourist Office, New York. TOP RIGHT: Photo by Sheilah Scully. BOTTOM LEFT: Photo courtesy of the Vermont Travel Office, Montpelier, Vermont. BOTTOM RIGHT: Photo by Scully/Daly.

33—TOP: Paul Cézanne, *The Bridge of Trois-Sautets,* ca. 1906. Cincinnati Art Museum, gift of John J. Emery, Cincinnati, Ohio. BOTTOM: Alfred Sisley, *The Bridge at Moret.* 1893. Musée d'Orsay, Paris (Giraudon/Art Resource, New York).

35—Fran Geary, *Biddleford Shacks.*

43—Edward Hopper, *Early Sunday Morning,* 1930. Whitney Museum of American Art, New York.

53—TOP: Camille Pissarro, *Boulevard des Italiens, Morning, Sunlight,* 1897. Chester Dale Collection, Copyright © 1995 by the Board of Trustees, National Gallery of Art, Washington, D.C. BOTTOM: Georges Pierre Seurat, *Study for "A Sunday on La Grande Jatte,"* 1884. The Metropolitan Museum of Art, bequest of Sam A. Lewisohn, New York.

54—Mary Greene LaForge, *Untitled.*

61—Jean-Baptiste-Siméon Chardin (1699-1779), *The Copper Cauldron.* Musée Cognacq-Jay, Paris (Erich Lessing/Art Resource, New York).

69—ABOVE: Winslow Homer, *A Wall, Nassau,* 1898. The Metropolitan Museum of Art, Amelia B. Lazarus Fund, New York. BELOW: John Singer Sargent (1856-1925), *Venetian Doorway.* The Metropolitan Museum of Art, gift of Mrs. Francis Ormond, New York.

85—TOP: Vincent van Gogh, *Bedroom at Arles,* 1889. Vincent van Gogh Museum, Amsterdam. BOTTOM: Johannes Vermeer, *The Painter and His Model as Clio* (also known as *Allegory of Painting*), 1665-1666. Kunsthistorisches Museum, Vienna (Erich Lessing/Art Resource, New York).

86—TOP: Leonardo da Vinci (1452-1519), *Self-Portrait.* Biblioteca Reale, Turin, Italy (Scala/Art Resource, New York). BOTTOM: Rembrandt Harmensz van Rijn, *Self-Portrait,* ca. 1660. The Metropolitan Museum of Art, bequest of Benjamin Altman, New York.

87—Zygmund Jankowski, *Trawler.*

115—Paul Cézanne, *Gardanne,* 1885-1886. Copyright © 1994 by The Barnes Foundation, Merion, Pennsylvania.

135—Paul Cézanne, *Ginger Jar and Fruit,* ca. 1895. Copyright © 1994 by The Barnes Foundation, Merion, Pennsylvania

139—Claude Lorrain, *Tiber Valley,* 1643. Petit Palais, Paris.

142—Photo courtesy of Federated Department Stores.

150—Pieter de Hooch, *A Dutch Courtyard,* ca. 1660. Andrew W. Mellon Collection. Copyright © 1995 by the Board of Trustees, National Gallery of Art, Washington, D.C.

151—Betty Reeves Klank, *Untitled.*

155—Mary Greene LaForge, *Anticipating Connecticut.*

185—Raoul Dufy, *Piazzetta di San Marco, Venice,* 1938. Louis Carré Collection, Paris.

188—Mary Greene LaForge, *Untitled.*

193—Frank Webb, *Whitney Working,* 1992.

Bibliography

You could look it up.

—Casey Stengel

Who has ever had an original thought? —Goethe

Austin, Phil. *Capturing Mood in Watercolor.* North Light Books, Cincinnati, Ohio, 1984.

Barr, Alfred H. Jr. *What Is Modern Painting?* 9th ed. The Museum of Modern Art, New York, 1968.

Bartlett, John. *Familiar Quotations*, 14th ed. Little, Brown and Company, Boston, 1968.

Barzun, Jacques. *Teacher in America.* Little, Brown and Company, New York, 1945.

Barzun, Jacques. *The Use and Abuse of Art.* Princeton University Press, Princeton, New Jersey, 1973.

Bethers, Ray. *Art Always Changes: How to Understand Modern Painting.* Hastings House Book Pubishers, New York, 1958.

Bethers, Ray. *Pictures, Painters, and You.* Pitman Publishing Company, New York, 1948.

Birren, Faber. *History of Color in Painting.* Reinhold Publishing Corporation, New York, 1965.

Brandt, Rex. *The Artist's Sketchbook and Its Uses.* Reinhold Publishing Corporation, New York, 1966.

Brandt, Rex. *Notes on the Composition of Landscape Painting.* Brandt Painting Workshops, Corona del Mar, California, 1959.

Brandt, Rex. *Seeing with a Painter's Eye.* Van Nostrand Reinhold Company, New York, 1984.

Brandt, Rex. *Watercolor Landscape.* Reinhold Publishing Corporation, New York, 1963.

Brandt, Rex. *Watercolor Landscape in 15 Lessons.* Rex Brandt, Corona del Mar, California, 1953.

Brandt, Rex. *The Winning Ways of Watercolor.* Van Nostrand Reinhold Company, New York, 1973.

Carlson, John F. *Carlson's Guide to Landscape Painting.* Dover Publications, Inc., New York, 1958.

Clifton, Jack. *The Eye of the Artist.* North Light Books, Westport, Connecticut, 1973.

Cole, Rex Vicat. *Perspective for Artists.* Dover Publications, Inc., New York, 1976 edition.

Coop, Dr. Richard, with Fields, Bill. *Mind Over Golf.* Macmillan Books, New York, 1993.

Couch, Tony. *Watercolor: You Can Do It!* North Light Books, Cincinnati, Ohio, 1987.

Couch, Tony. *Tony Couch's Keys to Successful Painting.* North Light Books, Cincinnati, Ohio, 1992.

Crawshaw, Alwyn. *You Can Paint Outdoors in Watercolor.* North Light Books, Cincinnati, Ohio, 1986.

Dobereiner, Peter. *Golf a la Carte.* Lyons & Burford Publishers, New York, 1991.

Dodson, Bert. *Keys to Drawing.* North Light Books, Cincinnati, Ohio, 1985.

Dow, Arthur Wesley. *Composition.* Doubleday, Doran & Co., Inc., Garden City, New York, 1931.

Frayling, Christopher; Frayling, Helen; and Van der Meer, Ron. *The Art Pack.* Alfred A. Knopf Inc., New York, 1993.

Goffstein, M. B. *An Artist's Album.* Harper and Row, New York, 1985.

Goldwater, Robert and Treves, Marco. *Artists on Art from the XIV to the XX Century.* Pantheon Books Inc., New York, 1945.

Gombrich, E. H. *The Story of Art,* 11th ed. Phaidon Publishers Inc., London, 1966.

Graham, Donald W. *Composing Pictures.* Van Nostrand Reinhold Company, New York, 1970.

Graves, Maitland. *The Art of Color and Design.* McGraw-Hill Book Company Inc., New York, 1951.

Graves, Maitland. *Color Fundamentals.* McGraw-Hill Book Company Inc., New York, 1952.

Gruppé, Emile. *Gruppé on Painting,* ed. by Movalli, Charles and Lavin, John. Watson-Guptill Publications, New York, 1976.

Helm, McKinley. *John Marin.* Pellegrini & Cudahy in association with the Institute of Contemporary Art, Boston, 1948.

Hilder, Rowland. *Starting with Watercolors.* Watson-Guptill Publications, New York, 1966.

Hill, Tom. *The Watercolorist's Complete Guide to Color.* North Light Books, Cincinnati, Ohio, 1992.

Hunt, Morton. *The Story of Psychology.* Doubleday Anchor Books, New York, 1993.

Kelen, Emery. *Leonardo da Vinci: Advice to Artists.* Thomas Nelson Publishing, Nashville, Tennessee, 1972.

Kunz, Jan. *Painting Watercolor Portraits That Glow.* North Light Books, Cincinnati, Ohio, 1989.

Lee, Stan and Buscema, John. *How to Draw Comics the Marvel Way.* Simon & Schuster, New York, 1978.

Lofland, Donald J., Ph.D. *Powerlearning.* Longmeadow Press, Stamford, Connecticut, 1992.

Lurie, Patty. *A Guide to the Impressionist Landscape.* Little, Brown and Company, Boston, 1990.

Marin, John. *John Marin by John Marin,* ed. by Gray, Cleve. Holt, Rinehart and Winston, Inc., New York, 1977.

McClelland, Gordon T. and Zornes, Milford. *Milford Zornes.* Hillcrest Press Inc., Beverly Hills, California, 1991.

McCluggage, Denise. *The Centered Skier.* Bantam Books, Toronto, 1983.

Nicklaus, Jack with Bowden, Ken. *Playing Lessons with Jack Nicklaus.* Golf Digest Books, Norwalk, Connecticut, 1978.

Nofer, Frank. *How to Make Watercolor Work for You.* North Light Books, Cincinnati, Ohio, 1991.

O'Hara, Eliot. *Watercolor Fares Forth.* Minton, Balch & Company, New York, 1938.

Penick, Harvey with Shrake, Bud. *Harvey Penick's Little Red Book.* Simon & Schuster, New York, 1992.

Penick, Harvey and Shrake, Bud. *And If You Play Golf, You're My Friend.* Simon & Schuster, New York, 1993.

Pepper, Stephen C. *Principles of Art Appreciation.* Harcourt, Brace and Company, Inc., New York, 1949.

Powell, William F. *Perspective.* Walter Foster, Tustin, California, 1989.

Ranson, Ron. *Learn Watercolor the Edgar Whitney Way.* North Light Books, Cincinnati, Ohio, 1994.

Reid, Charles. *Painting What You Want to See.* Watson-Guptill Publications, New York, 1983.

Rey, Robert. *Manet.* Crown Publishers, Inc., New York, 1988.

Richardson, John Atkins. *Art: The Way It Is.* Harry N. Abrams, New York, 1973.

Robb, Margaret D. *The Dynamics of Motor Skill Acquisition.* Prentice-Hall, Englewood Cliffs, New Jersey, 1972.

Robinson, Adam. *What Smart Students Know.* Crown Publishers, Inc., New York, 1993.

Rybczynski, Witold. *Looking Around: A Journey Through Architecture.* Viking Penguin Books, New York, 1992.

Safire, William and Safir, Leonard. *Good Advice.* The New York Times Books, New York, 1982.

Schmalz, Carl. *Watercolor Lessons from O'Hara.* Watson-Guptill Publications, New York, 1974.

Taubes, Frederic. *Better Frames for Your Pictures.* Viking Press, 1968.

Taylor, John F. A. *Design and Expression in the Visual Arts.* Dover Publications, Inc., New York, 1964.

Techniques of Military Instruction. Department of the Army, Washington, D. C., 1954.

Tufte, Edward R. *Envisioning Information.* Graphics Press, Cheshire, Connecticut, 1990.

Tufte, Edward R. *The Visual Display of Quantitative Information.* Graphics Press, Cheshire, Connecticut, 1983.

Van Wyk, Helen. *Welcome to My Studio.* Art Instruction Associates, Rockport, Massachusetts, 1989, 1990.

Wagner, Judi and Van Hasselt, Tony. *The Watercolor Fix-It Book.* North Light Books, Cincinnati, Ohio, 1992.

Ward, Edward North. *First Impressions.* Watson-Guptill Publications, New York, 1990.

Webb, Frank. *Webb on Watercolor.* North Light Books, Cincinnati, Ohio, 1990.

Whitney, Edgar A. *Complete Guide to Watercolor Painting.* Watson-Guptill Publications, New York, 1974.

Williams, Guy R. *Paint Now, Learn Later.* Emerson Books, Buchanan, New York, 1975.

Williams, Jay and the Editors of Time-Life Books. *The World of Titian c. 1488-1576.* Time-Life Books, New York, 1968.

Williams, Robin. *The Non-Designer's Design Book.* Peachpit Press, Berkeley, California, 1994.

Wölfflin, Heinrich, trans. by Hottinger, M. D. *Principles of Art History: The Problem of the Development of Style in Later Art.* Dover Publications, Inc., New York, 1950.

Wood, Robert E., and Nelson, Mary Carroll. *Watercolor Workshop.* Watson-Guptill Publications, New York, 1974.

Young, James Webb. *A Technique for Producing Ideas.* 18th printing. Crain Books, Chicago, Illinois, 1979.

The ever importunate murmur,
"Dramatize it, dramatize it!"
— Henry James

The only thing worth
teaching is a principle.
— Jacques Barzun

No one can draw more out
of things, books included, than
he already knows. A man has no
ears for that to which experience
has given him no access.
— Nietzche

Give a man a fish and
you feed him for a day;
teach a man to fish and
he will eat for a lifetime.

The whole art of teaching
is only the art of awakening
the natural curiosity of young
minds for the purpose of satisfying
it afterwards.
— Anatole France

The life so short, the craft
so long to learn.
— Chaucer

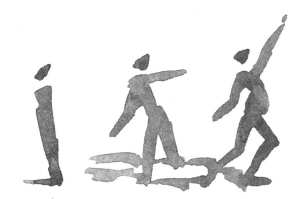

Nothing is so poor and melancholy
as an art that is interested in itself
and not its subject.
— Santayana

The artist teaches us how to
see. Nothing is beautiful until
an artist tells us that it is.

No one looked like that until
Renoir painted them. Then,
suddenly, the streets of Paris
were filled with beautiful
girls.